LONDON'S STATUES AND MONUMENTS

Peter Matthews

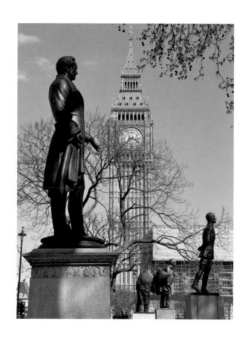

Shire Publications, an imprint of Osprey Publishing Ltd
c/o Bloomsbury Publishing Plc
PO Box 883, Oxford, OX1 9PL, UK

Or

c/o Bloomsbury Publishing Inc.
1385 Broadway, 5th Floor, New York, NY 10018, USA

E-mail: shire@bloomsbury.com

www.shirebooks.co.uk

SHIRE is a trademark of Osprey Publishing Ltd, a division
of Bloomsbury Publishing Plc.

First published in Great Britain in 2012 as Shire Library
No. 599. This Revised edition published in 2018 as SLI 839.

A CIP catalogue record for this book is available from the
British Library.

Shire Library no. 839.

ISBN: PB: 978 1 78442 256 1
ePub: 978 1 78442 257 8
ePDF: 978 1 78442 258 5
XML: 978 1 78442 259 2

17 18 19 20 21 10 9 8 7 6 5 4 3 2 1

Peter Matthews has asserted his right under the Copyright,
Designs and Patents Act, 1988, to be identified as the
author of this book.
Typeset in Perpetua by Deanta Global Publishing Services,
Chennai, India
Printed in China through World Print Ltd.

COVER IMAGE

Front cover: The Albert Memorial in Kensington Gardens
(iStock) — see page 142. Back cover: detail of the
memorial to Joseph Bazalgette — see pages 50–51.

TITLE PAGE IMAGE

The statues in Parliament Square are dominated by the
Houses of Parliament.

ACKNOWLEDGEMENTS

All the photographs in the book were taken by the author.
The City of London's London Metropolitan Archives are
acknowledged for permission to reproduce the images on
pages 4, 132 (bottom), 145 (right), 176 (top). The City of
Westminster Archives is acknowledged for permission to
reproduce the image on page 101 (right).

Shire Publications supports the Woodland Trust, the UK's leading woodland conservation charity. Between 2014 and 2018 our donations are being
spent on their Centenary Woods project in the UK.

CONTENTS

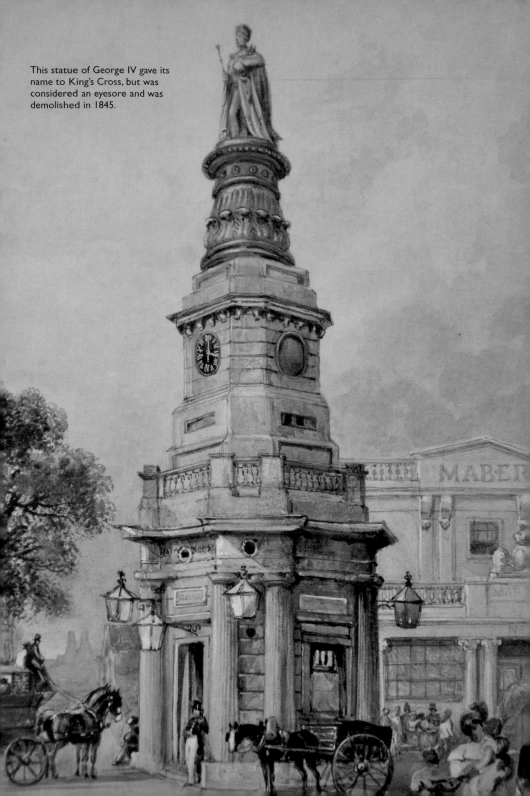

This statue of George IV gave its name to King's Cross, but was considered an eyesore and was demolished in 1845.

INTRODUCTION

LONDON PROBABLY HAS more statues than any other major city in the world. Its streets, squares, parks and gardens are filled with monuments to kings and queens, politicians, military heroes and other notables considered worthy of such acclaim. However, tastes and attitudes change, and many people considered important enough in their day to be publicly commemorated are today obscure historical figures whose contribution to the country's history is long forgotten. Ken Livingstone, former Mayor of London, once suggested that the statues of Napier and Havelock in Trafalgar Square should be removed, as nobody knew who they were. I hope this book will enlighten the reader about the significance of the more than four hundred statues and monuments dotted around the capital.

As well as being an outdoor portrait exhibition, the sculptures are also an open-air art gallery, with work by the country's greatest sculptors from Grinling Gibbons to Alfred Gilbert, and they illustrate changing artistic styles and tastes through the ages. In the seventeenth and eighteenth centuries, and even into the nineteenth, it was considered appropriate to portray kings as Roman emperors or drape politicians in togas. It was felt that depicting them in contemporary dress did not ennoble the subject, and many sculptors found it difficult to make trousers look good on a statue. Even when greater realism was accepted, the poses were often formal and stiff, until the so-called New Sculpture brought in a greater naturalism towards the end of the nineteenth century. Today's statues are often more dynamic and have a low plinth, or no plinth at all, making the sculpture more approachable.

The earliest statues are of royalty and almost every monarch since Charles I has a statue in London, with Victoria topping the list with five. Some of their consorts are also commemorated, especially Prince Albert, whose vast number of national memorials so annoyed Charles Dickens that he wrote to a friend, 'If you should meet with an inaccessible cave ... to which a hermit could retire from the memory of Prince Albert, pray let me know.' With a few exceptions, it was not until the nineteenth century that statues of politicians and military heroes began to appear, and by the end of the century London was full of monuments to creators and defenders of the Empire. Bravery and leadership in war continued to be commemorated, but after the Crimean War memorials began to include the ordinary soldier, and from then on war memorials would be less triumphalist, culminating in Jagger's great Royal Artillery Memorial at Hyde Park Corner and Lutyens' Cenotaph in Whitehall. In the twenty-first century we are still putting up memorials commemorating the heroes of the Second World War, prompted by a number

of anniversaries, including the controversial Bomber Command Memorial in Green Park, which was unveiled in 2012. The most recent trend, though, is for sporting legends, such as Bobby Moore, to be commemorated. Perhaps in a hundred years' time they will be as forgotten as many of the nineteenth-century generals.

Most of London's outdoor statues are of bronze, which looks good in sunshine, but less so on a gloomy day in winter. Sculptors have also used various types of stone, including Portland stone and marble, but in London's polluted atmosphere many of these statues have become badly weathered over the years. Granite has been much used for plinths, as it is hard-wearing, but few statues are made from it, as it is a very hard stone to carve; the main examples are Lord Baden-Powell and William IV.

This book includes all the outdoor statues and busts in Greater London, as well as some plaques with portrait reliefs, a few memorial fountains, and a selection of war memorials, mostly the national ones in central London. Statues inside buildings are not included, with the exception of those in railway stations. The façades of many public buildings, such as the Houses of Parliament and the Victoria and Albert Museum, are covered in decorative sculpture, and these are not included, though some individual commemorative statues on buildings are.

London has always been a city which has evolved, rather than being designed, so the street layout has regularly been reconfigured to allow for new developments. For this reason, statues have often been re-located, such as those of Jenner (page 141) and Gordon (page 48), which once stood in Trafalgar Square, and the memorial to Robert Peel (page 222), which originally stood in Cheapside. A few have disappeared for good, most famously the gigantic statue of Wellington which once stood on the Wellington Arch at Hyde Park Corner, and can now be seen in Aldershot. Less well known, as it has been destroyed, is a statue of George IV; this once stood at King's Cross, which was named after it. More recently, war memorials in Woolwich associated with the Royal Artillery were taken to Wiltshire when the regiment moved there in 2008.

It looks likely that, in the future, fewer statues will be raised in central London, as it is an expensive undertaking. In addition, there is little space in London's streets and parks for new ones, and some local councils, especially in central London, are being much more circumspect about granting planning permission. However, since the first edition of this book, a number of new statues have been erected, mostly outside central London.

I would like to acknowledge the work of Margaret Baker, whose *Discovering London's Statues and Monuments* was in print for over forty years. Although this book replaces hers, it is not a new edition, but a completely new book, with different criteria for the inclusion of memorials, and with more emphasis on the stories of the statues. I must also acknowledge the expertise of the late Paul Taylor, architect and City of London Guide, and Philip Ward-Jackson, author of books on London sculpture, who pointed out a few factual errors in the first edition, which I have now amended. I am also grateful to John Clark, formerly Medieval Curator at the Museum of London, for updating me on the latest research into the statue of Alfred the Great in Trinity Square.

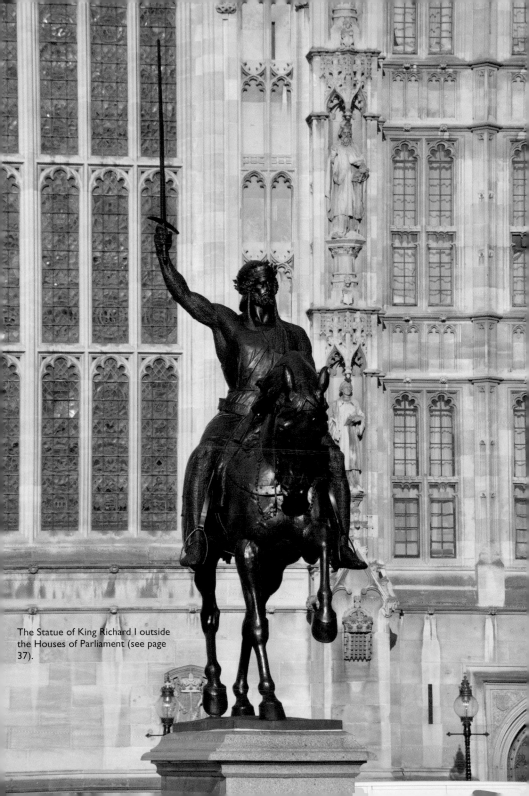

The Statue of King Richard I outside the Houses of Parliament (see page 37).

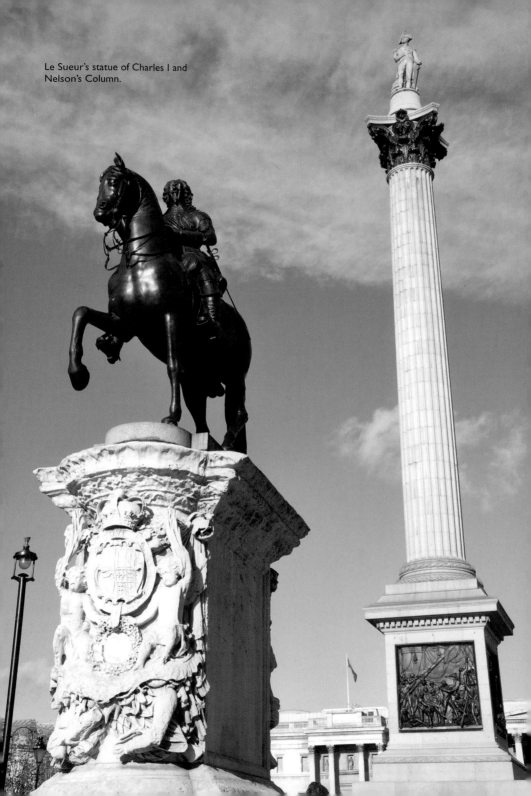

Le Sueur's statue of Charles I and
Nelson's Column.

TRAFALGAR SQUARE

A T THE HEART of Trafalgar Square is London's best-known monument, **Nelson's Column**, which commemorates the country's greatest admiral, **Horatio, Viscount Nelson** (1758–1805), who defeated the French fleet at Trafalgar, but died at the moment of victory. Soon after Nelson's death was announced, there were calls for him to be commemorated in some way, but it was to be sixty-two years before his monument would be finished. Although monuments were soon erected in Dublin and Great Yarmouth, London was slow in creating a national memorial to the great admiral, and it was only in 1816 that the idea was first seriously discussed, though the government, after an expensive war, felt unable to carry out the proposal at the public expense.

John Nash, as part of his grand plans for London, created an open space looking down Whitehall, with work beginning in 1830. At first a statue of William IV was to be the centrepiece and, although the proposed name of the new public space was Trafalgar Square, there were no plans at this stage for a monument to Nelson. In 1837, a letter to *The Times* suggested that the square would be the perfect location for such a memorial, and the idea was taken up when a committee was formed to raise money through public subscription, with Queen Victoria one of the first to contribute.

In 1838 designs for the monument were invited from artists and architects for what became known as the 'Nelson Testimonial'. Around 150 designs were submitted, and the proposals included a model of the *Victory* with Nelson on deck, several temples, and Nelson standing at the base of a ship's mast. William Railton's design, for a 174-foot Corinthian column with a 17-foot statue of Nelson on top, won first prize, though some members of the committee were concerned that a statue on top of such a tall column would not be clearly visible at ground level. Second prize went to Edward Hodges Baily for his sculpture of Nelson, and it was this that was finally chosen to stand on top of Railton's column. Funding problems caused considerable delays, and a number of changes had to be made to the plans. The steps round the base were dispensed with and the column was shortened; in 2006 the column was measured with lasers, and the whole memorial, including the statue, measures 169 feet, 5 inches.

In 1840 work began on laying out the square, to the designs of Charles Barry, who was not in favour of the monument. The construction of the column began in 1841, using granite from Dartmoor. Tradition has it that the capital was made using bronze from guns recently salvaged from the *Royal George,* which had sunk in Portsmouth in 1782. The Duke of Buccleuch, who was one of the commissioners, offered a huge block of Craigleith sandstone from his quarry for the statue of Nelson, which was installed in 1843.

As funds had now run out, the Government offered to pay for the rest of the work, and it was some years before the monument was completed. The four

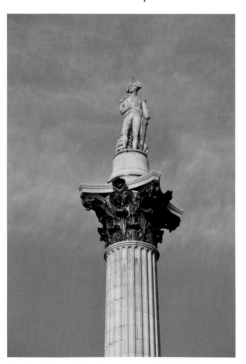

Shortly before Nelson's statue was installed a group of workmen had dinner on top of the column.

bronze reliefs on the plinth, using bronze supplied by the government, and taken from cannons captured from the French, were not installed until 1849–52. On the south side, facing Whitehall, is John Edward Carew's plaque showing the death of Nelson, the first to be installed. On the side facing Pall Mall is the Battle of St Vincent by Musgrave Watson; facing the National Gallery is William Woodington's Battle of the Nile; and the east side has the Battle of Copenhagen by John Ternouth.

The four lions took even longer to install. They were part of the original design, and various sculptors had been approached to produce them, but nothing came of this part of the scheme until, in 1858, the commission was given, surprisingly, to the artist Sir Edwin Landseer, who had never created a sculpture before. Landseer was a busy man, with a number of commissions for Queen Victoria, and there were many complaints about his delay in beginning work. He started work in 1862, using casts of a lion supplied by the Albertine Academy of Turin, and a corpse supplied by London Zoo. He produced the clay models, which were cast by Baron Marochetti, and Nelson's memorial was finally complete when they were unveiled in 1867. The lions are not identical, but are of two designs, with the tails falling on opposite sides of the body.

For many years the column was impressively decorated to celebrate Trafalgar day on 21 October, with flags and wreaths, and with garlands spiralling round it from top to bottom. After the horrors of the First World War it was felt that such triumphalism was out of place, and today's celebrations are more muted.

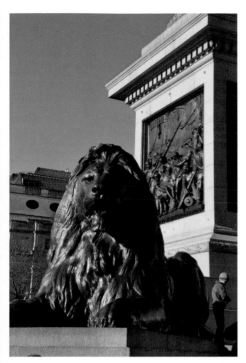

One of Landseer's lions, with Carew's plaque of *The Death of Nelson.*

The memorial was not universally liked, and the French writer, Hippolyte Taine, said Nelson looked 'like a rat impaled at the top of a pole'. A seaman, on first seeing it, said the Admiral had been 'mast-headed', which was a form of punishment in the navy. Adolf Hitler, however, was planning on taking it to Berlin if he had won the war. It is also very popular with pigeons, and the statue is now covered in a special anti-pigeon gel to protect it. The column has been climbed on a number of occasions as publicity stunts, and in 2003 a man parachuted off it.

As part of Barry's design for the square, two large plinths were added on the north side to take sculpture. The equestrian statue of **George IV** (1762–1830) was installed on the plinth in the northeast corner in 1843. The statue was commissioned by the king in 1829 from Sir Francis Chantrey, the most celebrated and successful sculptor of the age. It was intended to stand on top of Nash's Marble Arch, though it never did. The king's costume is a compromise between the classical look and contemporary fashion and, like Chantrey's statue of the Duke of Wellington in the City, he has no saddle or stirrups. Unusually, the horse is at rest, with all four feet on the ground.

The other plinth in the north-west corner was originally intended to carry an equestrian statue of William IV, but as there was not enough money for it, the

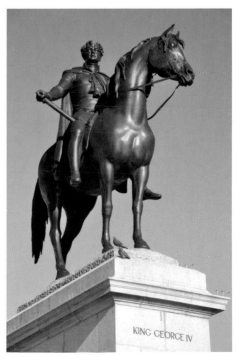

KING GEORGE IV

Chantrey's flattering portrayal of the famously obese George IV.

plinth remained empty until relatively recently. During the 1990s there were various proposals for a statue for the so-called **Fourth Plinth** but, as no decisions could be made on a permanent statue, it has since been occupied by alternating modern sculptures and, in 2010, Antony Gormley's *One and Other*, when ordinary people spent an hour on it, doing whatever they wanted.

On either side of Nelson's Column are statues of two of the country's forgotten military figures, though they were so famous in their day that a number of the capital's streets were named after them. In 2000 the Mayor of London, Ken Livingstone, wanted to have them

Napier is remembered for a punning telegram he never sent.

removed, as he claimed that no one knew who they were. The statue of **Sir Charles James Napier** (1782–1853) was installed in 1856. He is best known for the years he spent in India at the end of his career. It is said that, when he captured the province of Sind, he sent a punning telegram with the Latin word *peccavi,* meaning 'I have sinned', but the story is apocryphal, the invention of a Punch cartoonist. The statue, by George Gammon (or Gamon) Adams, was highly praised by the *Illustrated London News,* but the *Art Journal* called it 'perhaps the worst piece of sculpture in England'. Napier was very popular with his men, and the inscription says the statue was raised by public subscription, 'the most numerous contributors being private soldiers'.

On the eastern side the statue of **Sir Henry Havelock** (1795–1857) was added in 1861. Havelock spent most of his military career in India, where he was considered both courageous and a good tactician. He was also very religious, and his supporters were nicknamed 'Havelock's saints'. He is best known for his actions during the Indian Mutiny of 1857, in particular the relief of Lucknow. William Behnes' statue was the first to be made using a photograph. It depicts Havelock in undress uniform, and is said to be a good likeness, though *The Times* considered it to be dull and mediocre.

On the right-hand back wall of the square are memorials to three great twentieth-century admirals. In 1935–6 new fountains were proposed for the square, to be built as memorials to **David Beatty, 1st Earl Beatty** (1871–1936) and **John Rushworth Jellicoe, 1st Earl Jellicoe** (1859–1935), naval heroes

sculpture, and William McMillan that of Jellicoe and the mermaids. Work began in 1939, but was delayed by the war, and it was later decided to place the busts against the north wall of the square. They were finally unveiled in 1948 by the Duke of Gloucester. In 1967 they were joined by a bust of **Andrew Browne Cunningham, Viscount Cunningham of Hyndhope** (1883–1963), the great Second World War admiral. The bust, by Franta Belsky, was unveiled by the Duke of Edinburgh.

Havelock is best known for the relief of Lucknow.

of the First World War. Sir Edwin Lutyens designed the fountains, which would include bronze busts of the admirals at their centres. Charles Wheeler was to make the bust of Beatty and the mermen

In the north-west corner of the square, in front of the National Gallery, stands a bronze statue of **James II** (1633–1701), a particularly fine statue of one of Britain's least popular monarchs. It is by Grinling Gibbons and, like his statue of Charles II in Chelsea, it shows the king dressed as a Roman emperor. It is probably the most travelled statue in London: in 1686 it was put up behind the Banqueting House in Whitehall, moved in 1897 to the garden of Gwydyr House in Whitehall, and again in 1903 to St James's Park, near the Admiralty. When the site was needed for the wartime

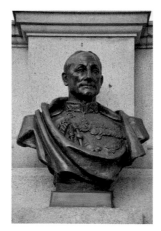
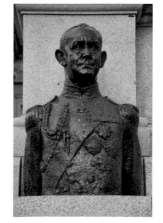

Twentieth-century naval heroes Beatty, Jellicoe and Cunningham.

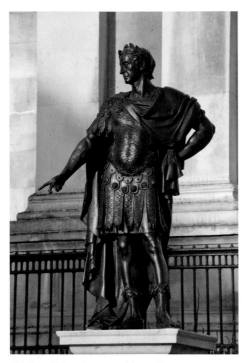

Grinling Gibbons's statue of James II.

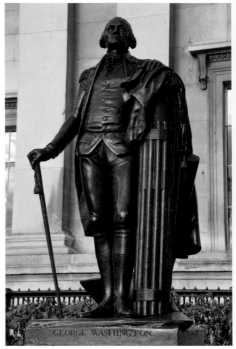

George Washington stands at the eastern end of the National Gallery.

Citadel it was put into storage and moved to its present location in 1947.

At the eastern end of the National Gallery is the bronze statue of **George Washington** (1732–99), the first President of the United States of America. It is a copy of the famous marble statue by Jean-Antoine Houdon which stands in the Capitol in Richmond, Virginia, and was a gift from the State of Virginia. The offer was originally made in 1914, but because of the First World War, the statue did not make it across the Atlantic until 1921, when it was unveiled by Judith Brewer, the daughter of the Speaker of the House of Delegates of Virginia. Washington stands next to a column of thirteen rods (or fasces, a symbol of power and strength through unity), representing the states of the new union. There is a story that, because Washington said he would never set foot on British soil, American earth was brought over and placed under the statue. This is probably an urban myth, as there is no evidence for it.

Slightly to the west of the square, in Pall Mall East, is Matthew Cotes Wyatt's equestrian statue of **George III** (1738–1820). Today it is a much-loved statue, but in its day it was highly controversial. The sculptor had proposed in 1822 to have the king standing in a quadriga, accompanied

by figures of Fame and Victory, but the money raised was not enough to pay for such a grand memorial and the project was postponed. In 1832 Wyatt was commissioned to produce something less ambitious, controversially without the usual competition. Choosing a location for the statue also proved difficult. Original plans to erect it in Waterloo Place were abandoned when it was pointed out that the Duke of York, on his column, would be turning his back on his father. A short time before its planned erection, a problem in casting, possibly sabotage, damaged the statue, causing a delay. Further delay was caused when a banker made a legal challenge to the statue being erected outside his premises. The statue was finally unveiled in 1836 by one of the king's sons, the Duke of Cumberland. The king is shown riding his favourite horse, Adonis, which is portrayed with great spirit, but the king's pigtail was much ridiculed. A leader in *The Times* spoke of the 'burlesque effigy', and referred to the sculptor as 'Sir Pigtail Wyatt'.

In St Martin's Place, north east of the square, is the memorial to **Edith Cavell** (1865–1915), the British nurse who became an unlikely heroine in the First World War. She was running a nurses' training school in Brussels when the Germans occupied Belgium, and she soon

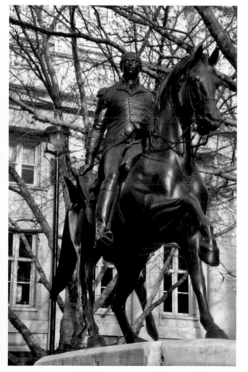

George III looks as if he is about to ride down Pall Mall.

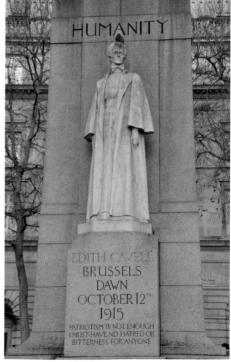

The monument to Edith Cavell, the reluctant heroine.

became involved in helping allied soldiers to escape. She was arrested in 1915 and court-marshalled along with eight others. Being deeply religious, she could not lie and confessed, was found guilty, and was shot five days later. Her execution caused worldwide shock and she became an instant heroine and martyr. In 1919 her body was returned to Britain, and she was given a funeral service in Westminster Abbey before being buried in Norwich Cathedral. The memorial was paid for by readers of *The Daily Telegraph,* and was created by George Frampton, who gave his services for free. He had been able to begin work on the granite column soon after the commission, but the Carrara marble for the main figure did not arrive until after the war was over. She is shown in her matron's uniform beneath the inscription *For King and Country.* On the four sides of the column are inscribed her virtues: Humanity, Sacrifice, Devotion and Fortitude. On top of the column is a sculpture of a woman and child, symbolising Humanity, and on the back is the British Lion trampling on a serpent. The memorial was unveiled by Queen Alexandra in 1920. A few years later Cavell's last words were inscribed on

Oscar Wilde waiting for someone to talk to.

the plinth: 'Patriotism is not enough; I must have no bitterness or hatred for anyone'.

In Adelaide Street, behind St Martin-in-the-Fields Church, is a memorial to **Oscar Wilde** (1854–1900), the writer, playwright and wit. The sculpture, by Maggi Hambling, takes an unusual form. The bronze head of Wilde, complete with a cigarette in his hand, rises from a dark granite sarcophagus, and the sculpture is called *A Conversation with Oscar Wilde,* inviting you to sit and talk to him. The memorial also carries one of his best lines: 'We are all in the gutter, but some of us are looking at the stars', from *Lady Windermere's Fan.* Wilde was a hugely successful writer, whose plays are still enjoyed today, but, following his prosecution for gross indecency, he spent his final years in prison and exile. The memorial's unveiling in 1998 was attended by Wilde's grandson, Lucian Holland, his great-grandson, Merlin Holland, and the actor, Stephen Fry, who starred in the film *Wilde.* The cigarette has been stolen on a number of occasions.

On a traffic island on the south side of the square is London's oldest equestrian statue, of **Charles I** (1600–49), who looks down Whitehall to the site of his execution; it stands, appropriately, where eight of the regicides were executed. In 1633 the king's Lord Treasurer, Lord Weston, commissioned the statue from the French sculptor, Hubert Le Sueur, to adorn his house in Roehampton, though he died two years later and the statue was never erected there. The statue may well have been inspired by Van Dyck's famous equestrian portrait, as the contract states that the figure of the king was to be 'full six feet', disguising the king's real

height of just over five feet. After the king's execution the statue was seized, and stood for a while in the churchyard of St Paul's, Covent Garden. It was later sold to John Rivett, a brazier from Holborn, who was given instructions to melt it down. Instead he buried it in his garden and sold souvenirs supposedly made from the metal. At the Restoration in 1660 he surprised everyone by producing the statue completely intact. The statue was sold to the king, who had it erected in 1676 where it now stands, on the site of the medieval Charing Cross. The plinth, of Portland stone, is by Joshua Marshall, after a design by Sir Christopher Wren, and is decorated with a rather eroded Stuart coat of arms. During the First World War the statue was surrounded by sandbags and an iron frame to protect it from bomb damage. In 1939 it was similarly protected, but in 1941 it was moved to Mentmore Park in Buckinghamshire. When it was re-erected in 1947 the sword, which had been stolen in 1844, was replaced. In 1955 a bronze plaque was set into the pavement behind the statue marking the official centre of London, the spot from which all distances from London are measured. There are people who consider Charles I to be a martyr, and the anniversary of his death is commemorated each year on 30 January with a short ceremony at the statue, when wreaths are laid.

Where the Charles I statue now stands is where the original **Charing Cross** (or Eleanor Cross) used to stand. This was the last of the twelve crosses commissioned by Edward I to mark the resting places of the funeral cortège of his wife, Eleanor of Castile, who died in 1290 at Harby, near Lincoln. It stood here until it was demolished by the Puritans in 1647. In 1865 a replica of the cross was erected outside the newly opened Charing Cross Station. It was designed by the station's architect, E. M. Barry, using the few images available of the original, and the sculpture was executed by Thomas Earp. On the upper level are eight statues of Eleanor, four showing her as queen, with royal emblems, and four with Christian symbols. Below are kneeling angels and beneath that are shields with the royal arms, the arms of Ponthieu and of Castile and Leon, all copied from existing Eleanor Crosses at Waltham Cross and Northampton.

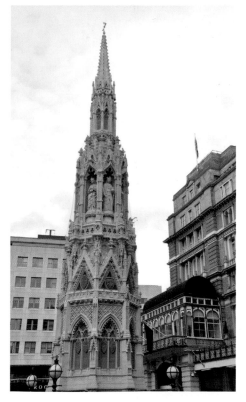

The replica Eleanor Cross in front of Charing Cross Station.

WHITEHALL
AND HORSE GUARDS

O N THE CORNER of Whitehall Place and Whitehall Court is the memorial to the **Royal Tank Regiment**, which is a tribute to all those who have served in

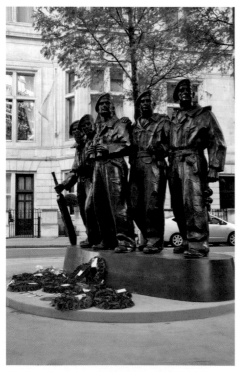

The Royal Tank Regiment memorial in Whitehall Place.

tanks since they were first used in 1916. The monument consists of five crewmen from a Second World War tank, and the regimental badges are set into the base. Along the front of the sculpture is the phrase 'From mud through blood to the green fields beyond', which is attributed to Brigadier General Elles, who led the tanks into battle at Cambrai in 1917; the words reflect the colours of the regimental flag: brown, red and green. The memorial was sculpted by Vivien Mallock, and is based on a design by George Henry Paulin. The memorial was unveiled by the Queen, the Regiment's Colonel-in-Chief, in 2000.

In Horse Guards Avenue is the **Gurkha Memorial**, which remembers the many years of faithful service the Gurkha regiments have given, fighting alongside the British Army in many theatres of war. The 9-foot bronze statue of a Gurkha in First World War uniform was sculpted by Philip Jackson, and is based on a sculpture by Richard Goulden erected in India in 1924. It was unveiled in 1997 by the Queen, accompanied by the Duke of Edinburgh and Prince Charles, Colonel-in-Chief of the Royal Gurkha Rifles. A plaque lists the battles of the two world

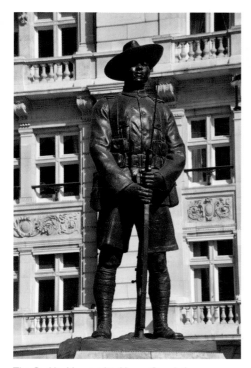

The Gurkha Memorial in Horse Guards Avenue.

uniform of a Field Marshal, with the many medals and Orders he was granted. At the front and back of the plinth are bas reliefs of soldiers from the 17th Lancers and the Grenadier Guards, regiments in which the Duke served. The statue was unveiled in 1905 by Edward VII.

At the Whitehall end of Horse Guards Avenue is a statue of the **8th Duke of Devonshire** (1833–1908), a politician of some importance but little renown. The memorial stands close to the old War Office, where he was Secretary of State for War. He is best known for having sent Gordon to the Sudan and failing to persuade Gladstone to send a relief

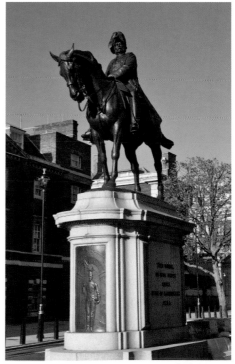

The Duke of Cambridge was Commander-in-Chief of the Army for nearly forty years.

wars in which they fought, and carved into the plinth, beneath a pair of crossed Gurkha knives, or *khukuris,* are words of tribute from Sir Ralph Turner: 'Bravest of the brave, most generous of the generous, never had country more faithful friends than you.'

In the middle of Whitehall, appropriately opposite the old War Office, is the bronze equestrian statue of **Prince George, 2nd Duke of Cambridge** (1819–1904), grandson of George III. He fought in the Crimea, and from 1856 to 1895 was Commander-in-Chief of the Army. The statue is by Adrian Jones, and stands on a granite plinth designed by John Belcher. The Duke is depicted in the

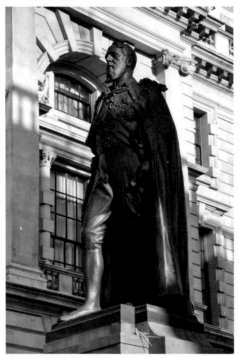

The Duke of Devonshire turned down the chance of being prime minister three times.

who was the Secretary of the Society of King Charles the Martyr. It was through a window of the Banqueting House that the king stepped to his execution on 30 January 1649, and every year on the anniversary of the event wreaths are placed on the railings.

In the middle of Whitehall opposite the Banqueting House is the equestrian statue of **Douglas Haig, 1st Earl Haig** (1861–1928). Haig fought in the Boer War and served in India before becoming Commander-in-Chief of the British Forces during the First World War. His tactics eventually won the war, but he was much criticised for his refusal to change a strategy which led to the massive loss of human lives. The statue raised to him

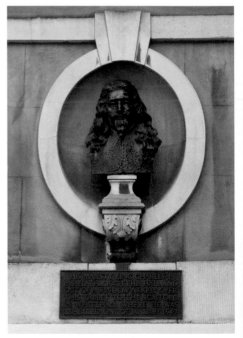

This bust of Charles I is close to the spot where he was executed in 1649.

expedition in time to rescue him. For a time he was leader of the Liberal Party, and turned down the chance to become prime minister on three occasions. The statue is by Herbert Hampton, and it was unveiled in 1911. On the back of the plinth is the family coat of arms with its motto *Cavendo tutus* ('safety through caution'), which seems to be an appropriate comment on his political career.

Above the entrance to the Banqueting House is a bust of **Charles I** (1600–49) by an unknown sculptor and dating from around 1800. It is one of three busts of the king found in a Fulham builder's yard in 1945 by Hedley Hope-Nicholson,

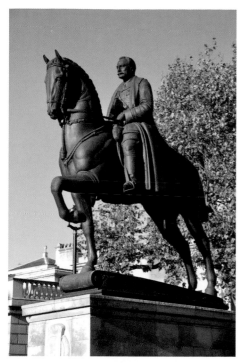

The equestrian statue of Earl Haig was highly controversial when it was erected.

model, this time accepted by Parliament, which was paying for the memorial. However, even this version did not please Haig's widow, who found the cloak too theatrical and later complained that he should be wearing a hat with his uniform. Hardiman had, in fact, compromised, and the head of Haig was now highly realistic, while the horse was clearly inspired by his study of Renaissance sculpture. The memorial was unveiled on 10 November 1937 by the Duke of Gloucester, but Lady Haig, rather pointedly, did not attend the ceremony. The following day, Armistice Day, the king laid a wreath at the statue.

In front of the Ministry of Defence is Raleigh Green, named after the statue of Sir Walter Raleigh which stood here until

was to prove as controversial as his career. There was a limited competition for the statue, and designs were presented by William McMillan, Gilbert Ledward and Alfred Frank Hardiman. Hardiman was given the commission, but his first model was much criticised, especially by Lady Haig, because the horse looked nothing like Haig's horse, Poperinghe, and Haig's posture was incorrect. There were letters of complaint to *The Times* from, among others, Robert Baden-Powell and A. J. Munnings, an artist famous for his paintings of horses. Hardiman stated that he had produced a 'symbolic horse, not a realistic one', but he agreed to produce a second

Viscount Slim's statue on Raleigh Green in Whitehall.

21

2001, when it was moved to Greenwich (see page 208). The space is now occupied by the statues of three Second World War heroes. On the left is the statue of **William Joseph Slim, 1st Viscount Slim** (1891–1970). He fought at Gallipoli in the First World War, where he was badly wounded, and was awarded the Military Cross for his service in Mesopotamia. He was known as a great strategist, and during the Second World War, as commander of the Fourteenth Army, he led a highly successful, if often unconventional, campaign to recapture Burma from the Japanese. In 1948 he succeeded Montgomery as Chief of the Imperial General Staff and from

1952–9 was Governor-General of Australia. The statue is by Ivor Roberts-Jones and was unveiled in 1990 by the Queen.

In the centre is the statue of **Alan Francis Brooke, 1st Viscount Alanbrooke** (1883–1963). He came from a family with a long military tradition and distinguished himself in the First World War. During the Second World War he played an important part in the evacuation from Dunkirk, and was later chief adviser on strategy to the War Cabinet. Although he and Churchill never got on, the combination of Alanbrooke's clear, quick brain and eye for detail, and Churchill's energy and drive, made for a

Ivor Roberts-Jones's statue of Viscount Alanbrooke.

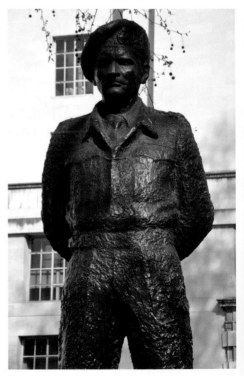

'Monty' in a typical pose and wearing his favourite beret.

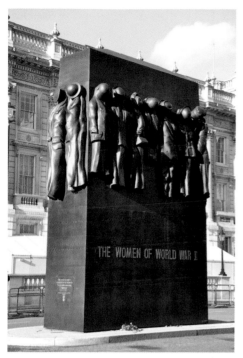

This unusual memorial remembers the part played by women in the Second World War.

Landings was probably an even greater achievement. Montgomery was ruthless, vain and arrogant, but he was also a brilliant teacher, and an inspirational leader who cared greatly for the men under his command, who revered him. The statue, by the Croatian sculptor, Oscar Nemon, was unveiled in 1980 by Queen Elizabeth the Queen Mother. It shows him in battledress and wearing his familiar beret. Above his full name and title, and in larger letters, is the name he was generally known by, Monty.

In the middle of Whitehall, opposite Raleigh Green, is the memorial to **The Women of World War II.** The 22-foot

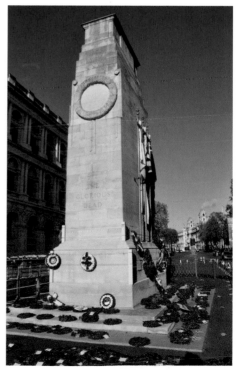

The Cenotaph in November, after the annual Remembrance Day ceremonies.

hugely successful partnership. After the war he retired in favour of Montgomery, and spent more time on his favourite hobby of ornithology. The statue, by Ivor Roberts-Jones, was unveiled by the Queen in 1994.

The third of the statues is of **Viscount Montgomery of Alamein** (1887–1976). Montgomery was considered to be Britain's finest military leader since the Duke of Wellington, and he was responsible for some of the finest victories in the Second World War. He is probably best remembered for his triumph against Rommel at El Alamein, which was one of the most important victories of the war, but his leadership of the D-day

bronze sculpture is the work of John Mills, and commemorates the important role played by over seven million women during the war, in many different roles. Hanging on pegs on all four sides are the uniforms and work clothes they wore, both in the armed forces and in factories and hospitals. The memorial was unveiled in 2005 by the Queen, who had herself, as a young princess, joined the Auxiliary Territorial Service and taken a course in vehicle maintenance during the war.

At the bottom end of Whitehall is the **Cenotaph**, which commemorates all those who have died in the two world wars and all wars in which British troops have fought since. The word 'cenotaph' derives from two Greek words meaning 'empty tomb'. The original memorial, designed by Sir Edwin Lutyens, was of timber and plaster, and took only a week to design and build. It was created for the Peace Day parade in July 1919, and it caused such a strong impression that the Cabinet decided almost immediately that it should be replaced by a permanent version in stone. There were safety concerns about it being sited in such a busy thoroughfare, and locations such as The Mall and Parliament Square were put forward as alternatives, but these were soon cast aside because of the memories the Whitehall site already inspired. On the first anniversary of Armistice Day later that year, Whitehall was packed with dignitaries and ordinary people, many carrying wreaths or bunches of flowers to place at the base of the Cenotaph, and the first two-minute silence was observed. The new stone Cenotaph was unveiled by George V on 11 November

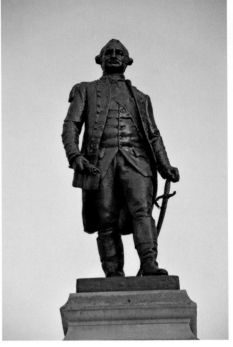

Clive of India had to wait 133 years for his national memorial.

1920, when the coffin of the Unknown Warrior stood in front of it before being taken to Westminster Abbey to be buried. The moving Remembrance Day service is still carried out today, with the sovereign, politicians and veterans laying wreaths to remember the fallen in all wars. The Cenotaph is a simple and dignified memorial, built of Portland stone, and it carries no religious symbolism. There are carved wreaths at each end and on the tomb-shaped top of the memorial, and on each side are flags of the British Army, Royal Navy and Royal Air Force. At one end are carved the words 'The Glorious Dead', chosen by Rudyard Kipling, who

lost his own son in the First World War. There are replicas of Lutyens's Cenotaph in Canada, New Zealand, Australia and Hong Kong.

At the end of King Charles Street, overlooking St James's Park, is the statue of **Robert Clive, 1st Baron Clive of Plassey** (1725–74). Clive first went to India at the age of seventeen to work as a clerk with the East India Company, and spent most of his working life there, as a successful military officer and administrator. When he retired to England he had to defend himself against accusations of profiteering from his position. Although a controversial figure, he had been instrumental in developing a British empire in India, and he had to wait a long time for a national memorial. In 1907 Lord Curzon invited subscriptions for a statue and soon had enough money to select a sculptor and get permission to erect it at a location very close to the India Office, at the top of the steps due to be built down to St James's Park from King Charles Street. The chosen sculptor was John Tweed, and the statue was ready in 1912, but it had to be placed temporarily in the garden of Gwydyr House in Whitehall until 1917, when work on the steps was completed. Clive wears the military uniform of the period, complete with a sword hanging from his belt. Around the plinth are three reliefs depicting significant scenes from his life: the siege of Arcot, the eve of the battle of Plassey, and Clive receiving the Grant of Bengal.

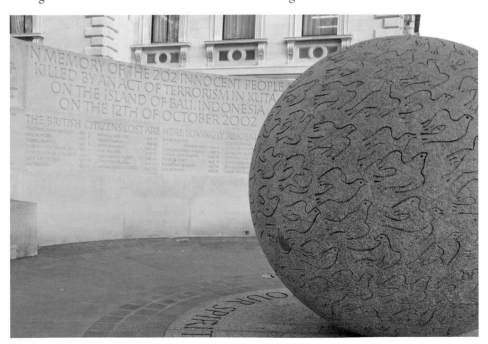

The Bali Memorial commemorates the victims of the terrorist bombing in 2002.

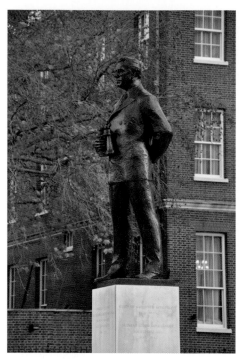

Earl Mountbatten on Foreign Office Green.

facing the Admiralty, is a statue of **Earl Mountbatten of Burma** (1900–79). Mountbatten, or Dickie as he was known to his friends, was born Prince Louis of Battenberg, with close connections to the British and German royal families. He joined the Navy as a teenager and in the inter-war years rose through the ranks. His exploits as a wartime captain were immortalised in the film *In Which we Serve,* starring Noël Coward. After the war he was made the last Viceroy of India, responsible for the handover of British power. He was killed by an IRA bomb in Ireland. The statue, by Franta Belsky, a Czech-born sculptor, was unveiled by the Queen in 1983. He is shown in the uniform of Admiral of the Fleet.

At the bottom of Clive Steps is the **Bali Memorial**, which remembers the victims of the terrorist bombings in Bali in 2002. It was unveiled by the Prince of Wales and the Duchess of Cornwall on the fourth anniversary of the attack. It consists of a granite globe carved with 202 different doves, representing each individual who died, including twenty-eight Britons, as well as people from twenty other countries. Behind is a Portland stone wall with the names and ages of the victims carved into it. The simple and moving memorial is the work of artist Gary Breeze and sculptor Martin Cook.

On Foreign Office Green, on the south side of Horse Guards Parade and

Kitchener is today best known for a famous recruiting poster.

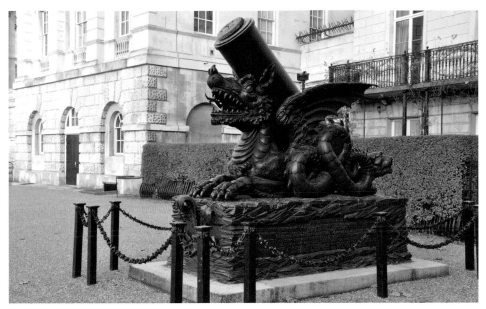

The Cádiz Memorial, also known as 'The Regent's Bomb'.

On the south side of Horse Guards Parade is the statue of **Horatio Herbert Kitchener, Earl Kitchener of Khartoum** (1850–1916), appropriately close to memorials to Roberts and Wolseley. He first came to prominence on Wolseley's unsuccessful expedition to save Gordon in Khartoum, and increased his reputation in the Boer War as Roberts's deputy. During the First World War he was Secretary of State for War, but in 1916 he died when the ship he was taking to negotiate with the Russians hit a German mine and sank off the Orkneys. He is probably best known today for the famous 'Your Country Needs You' recruiting poster. A controversial figure, he nevertheless became a popular hero, despite being disliked in many quarters; Margot Asquith once called him 'a great

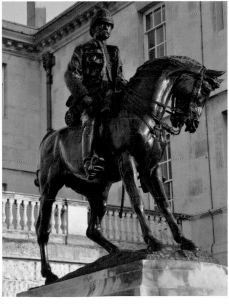

Earl Roberts's horse is one of the most spirited in London.

On either side of the main gateway are equestrian statues of two military rivals. To the right is the statue of **Frederick Sleigh Roberts, 1st Earl Roberts** (1832–1914). He won the Victoria Cross in the Indian Mutiny, fought in the Afghan War, and was in command of the troops in the Boer War. In 1900 he succeeded Wolseley as Commander-in-Chief of the British Army and received the Order of the Garter. He was known as 'Bobs', and Kipling wrote an affectionate poem about him of that name. He was an excellent horseman, and the statue shows him riding his favourite horse, a grey Arab called Volonel. It is one of the liveliest depictions of a horse in London. The memorial is a reduced replica of the original by Harry Bates, which was erected in Calcutta in 1898, a year before the sculptor's death. There is another, full-size, copy in Glasgow, but for the London version, made by Bates's assistant, Henry Poole, the plinth is lower and lacks the symbolic sculpture, as the memorial had to be scaled down to match the size of the Wolseley statue. It was unveiled in 1924 by the Duke of Connaught.

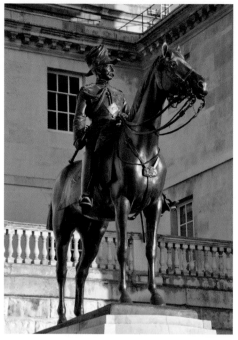

Wolseley was the original of the 'Modern Major-General' in *The Pirates of Penzance*.

poster but not a great man'. His statue is by John Tweed, and was unveiled in 1926 by the Prince of Wales.

Nearby is the **Cádiz Memorial**, a French mortar resting on the back of a splendid Chinese dragon. The mortar was presented to the Prince Regent by the Spanish Government to commemorate the raising of the siege of Cádiz in 1812 by the Duke of Wellington. On the front are the Prince of Wales feathers. It was soon nicknamed 'The Regent's Bomb' (pronounced 'bum'), and there were many cartoons by George Cruikshank and others using it for their political satire, including one image where the Prince Regent is himself the mortar.

The equestrian statue to the left of the archway is that of **Garnet Joseph Wolseley, 1st Viscount Wolseley** (1833–1913). Wolseley's family could not afford to buy him a commission, but he rapidly rose through the ranks on ability alone. He saw action in Burma, India and the Crimea, where he met Gordon, and he later led the ill-fated expedition to relieve Gordon in Khartoum. In 1894 he became Commander-in-Chief of the British Army. He was famous for his efficiency, and the phrase 'All Sir Garnet' came to mean that everything was in order. He was also the inspiration for

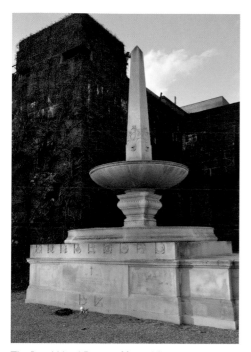

The Royal Naval Division Memorial spent over sixty years in Greenwich.

Major-General Stanley, the 'Modern Major-General' in Gilbert and Sullivan's *Pirates of Penzance*. Wolseley never took offence at this and would often sing the song at family gatherings. The statue is by Sir William Goscombe John, and was cast from guns captured during Wolseley's campaigns. It was originally intended to stand in Trafalgar Square, replacing either Napier or George IV, but in the end Horse Guards Parade was felt to be more appropriate. Wolseley is shown in full Field Marshal's uniform, the choice of Lady Wolseley (others had wanted him to be depicted wearing regular combat gear). The statue was unveiled in 1920 by the Duke of Connaught.

On the north side of the parade ground is the **Royal Naval Division Memorial**, which remembers the 45,000 men of the RND who died in the First World War. The Division was formed by the First Sea Lord, Winston Churchill, in 1914 and was disbanded in 1919. The memorial was

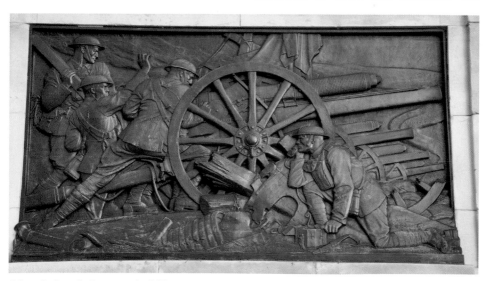

Gilbert Ledward's depiction of a field gun in action on the Guards Division Memorial.

designed by Sir Edwin Lutyens, and unveiled by Winston Churchill in 1925 on the tenth anniversary of the landings at Gallipoli. It takes the form of an obelisk in a fountain basin, with the badges of the various units around the rim of the plinth. On one side is carved a stanza from the poem *1914 III: The Dead* by Rupert Brooke, who died in 1915 on active service with the RND. The memorial originally stood on this site, but in 1939 it was taken down to make way for the Citadel and re-erected in 1951 at Greenwich. It returned here in 2003, when Greenwich ceased to be a naval establishment, and it was rededicated by the Prince of Wales.

Facing Horse Guards on the western side is the **Guards Division Memorial**, commemorating soldiers of the Guards regiments who lost their lives in the two world wars. It is a most apposite location for the memorial, as Horse Guards is the parade ground for the Guards regiments, who take part in Trooping the Colour here every year. The memorial was designed by the architect Harold Chalton Bradshaw and the sculptor Gilbert Ledward, and is in the form of a cenotaph of Portland stone. The five bronze figures, cast from guns captured during the First World War, represent the Guards regiments, and were modelled on guardsmen from each of the regiments. On the back of the memorial is a very fine bas relief of a field gun in action. The inscription on the upper part of the memorial was written by Rudyard Kipling. The memorial was unveiled in 1926 by the Duke of Connaught, assisted by General Sir George Higginson, 'Father of the Guards', who was over a hundred years old.

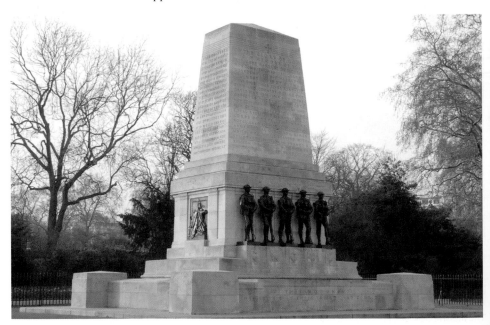

The Guards Division Memorial overlooking Horse Guards Parade.

PARLIAMENT SQUARE AND VICTORIA TOWER GARDENS

PARLIAMENT SQUARE WAS laid out in 1868 as an approach to Charles Barry's Houses of Parliament. Since it was created it has been filled with statues of politicians and statesmen, including seven prime ministers.

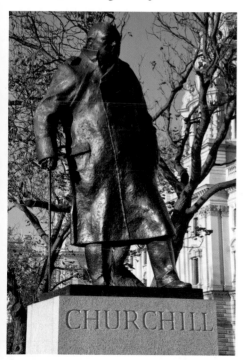

The massive bulk of Churchill's statue looms over Parliament Square.

The most prominent statue is that of **Sir Winston Churchill** (1874–1965), Britain's charismatic leader during the Second World War and Nobel Prize-winning author. He faces the House of Commons, where he spent so many years of his political career. There was much debate about where a statue to Churchill should be sited, but Grey Wornum, who redesigned the square in the 1960s, set aside a plot in its north-east corner for the purpose, and it seems Churchill had his eye on the same spot for himself. An appeal fund was set up in 1970 and the money was raised very quickly. A competition was held for the design of the statue, and the winner was Ivor Roberts-Jones. The statue was due to be unveiled in 1973 by the Queen, but on the day she invited Churchill's widow, Clementine, to do the honours. The statue shows Churchill bareheaded in a military greatcoat, striding forwards with determination, walking stick in hand. During the May Day demonstration in 2000, the monument was badly vandalised, with graffiti daubed all over the plinth and Churchill himself suffering the indignity of being given a green Mohican haircut.

Behind is a memorial to **David Lloyd George** (1863–1945), the Welsh Liberal

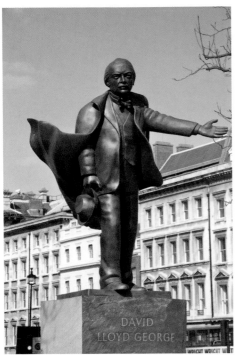

Glyn Williams's dynamic statue of David Lloyd George.

unveiled in 1956 by Sir Winston Churchill, but he was indisposed and W. S. Morrison, the Speaker of the House of Commons, stepped in at the last moment. Smuts was prime minister of South Africa during the Second World War, and was often called on to advise the War Cabinet in London. More controversially, he was also responsible for the introduction of Apartheid. The statue is by Jacob Epstein, and shows Smuts striding energetically forwards, his hands behind his back. The granite pedestal was specially ordered from South Africa, and its late arrival delayed the erection of the statue. Epstein was a controversial choice for the commission, but the statue proved to be

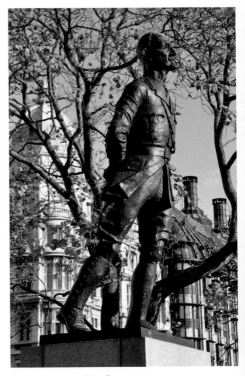

Epstein's statue of Jan Smuts.

politician who was prime minister from 1916 to 1922. Although a great wartime leader and a social reformer, there were many complaints about the proposal to erect the statue, because Lloyd George had tarnished his reputation by selling honours to boost his party's coffers. The statue, by Glynn Williams, shows Lloyd George as a dynamic figure, with his coat billowing out behind him, and is very different from the more formal statues in the square. The plinth is a piece of Welsh slate from Penrhyn. The statue was unveiled in 2007 by the Prince of Wales.

The statue to **Field Marshal Jan Christian Smuts** (1870–1950), South African statesman and soldier, was due to be

much less contentious than some of his earlier work.

In the north-west corner is a statue to **Henry John Temple, 3rd Viscount Palmerston** (1784–1865). Palmerston was a hard-working and supremely self-confident Foreign Secretary, successfully using gunboat diplomacy to get his way at times. He became prime minister during the Crimean War, at the age of seventy, and held the office twice. He was a great womaniser, with many mistresses, one of whom he married when she was widowed. His last words were said to be, 'Die, my dear doctor? That's the last thing I shall do!' His statue, by Thomas Woolner, was erected in 1876, and is one of the best-dressed statues in the square. Unusually, the plinth gives his name, but no dates.

The first memorial on the western side is to **Edward George Geoffrey Smith Stanley, 14th Earl of Derby** (1799–1869), perhaps the least charismatic nineteenth-century prime minister. He was, however, an excellent debater, helped to abolish slavery, and was the first person to be prime minister three times. He still holds the record as the longest-serving leader of the Conservative party. His statue is by Matthew Noble, and was unveiled in 1874 by Disraeli. Around the granite plinth are four bas reliefs by Horace Montford depicting important moments in Derby's career.

Next is the statue of **Benjamin Disraeli, Earl of Beaconsfield** (1804–81), who was an important politician as well as a popular novelist. He was Chancellor of the Exchequer three times and prime minister twice. Born into a Jewish family, he was baptised at an early age, and yet remained proud of his Jewishness. He was a colourful figure, a flamboyant dresser in

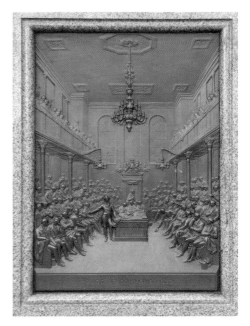

Plaque on the plinth of the Earl of Derby's statue, showing him speaking in the Commons chamber in St Stephen's Chapel, which burnt down in the fire of 1834.

his youth, always the egotist, but a great charmer and he was a favourite of Queen Victoria, who much preferred him to his dour opponent, Gladstone. The statue is by Mario Raggi, and is an excellent likeness, as the sculptor had made a bust from the life shortly before Disraeli died. It was unveiled on 19 April 1883, the second anniversary of his death, a date known as 'Primrose Day', after Disraeli's favourite flower. For many years primroses would be left by the statue each year on that date. He is shown in peer's robes and wearing the Garter regalia.

Nearby is a statue of the great Indian leader **Mahatma Gandhi** (1869–1948). The 9-foot statue stands slightly lower than the others in the square to reflect the

fact that he humbly considered himself to be a man of the people. The sculpture, by Philip Jackson, shows him bare legged and wearing a shawl, and is based on a photograph of Gandhi standing outside No 10 Downing Street after a meeting with Prime Minister Ramsay MacDonald. It stands among many defenders of the British Empire, including Churchill, who opposed Indian independence, and once called Gandhi, 'a seditious Middle Temple lawyer'. The statue was unveiled in 2015 by Arun Jaitley, the Indian finance minister, to mark the one hundredth anniversary of Gandhi's return from South Africa to India to begin the fight for independence from British rule.

The statue of **Sir Robert Peel** (1788–1850) is by Matthew Noble. Peel was prime minister twice, but is better known as the creator, as Home Secretary, of the first united police force in 1829. Despite initial doubts, the public came to accept the new system, and the policemen were soon affectionately referred to as 'Bobbies' or 'Peelers' after their founder. Soon after his death, statues of Peel were erected in many other cities, and also in the City of London, but the national memorial took considerably longer to arrange. The first statue was made by Marochetti in 1853, but it was considered too large, so he made a smaller version, but this was also rejected and it was removed in 1868 and melted down. Noble was then

Benjamin Disraeli in his peer's robes.

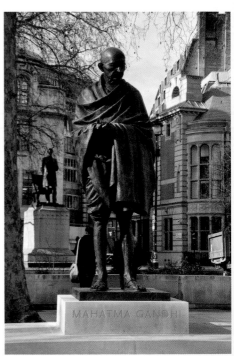

Gandhi's statue stands close to Nelson Mandela in Parliament Square.

commissioned to make a new statue, and this was unveiled in 1877.

Amid all the stiff-backed statesmen of the square, Ian Walters' statue of **Nelson Mandela** (1918–2013), former president of South Africa, is considered by some to be an intruder, and by others as a breath of fresh air. He is shown addressing a crowd, dressed in one of his trademark floral shirts. It stands on a much lower plinth than the other statues, reflecting his status as a man of the people. The statue was originally intended for the more appropriate setting of Trafalgar Square, close to South Africa House and the spot where, for many years, anti-Apartheid protesters campaigned for his release from prison on Robben Island. Westminster Council, however, felt that it would cause an obstruction, but gave permission for it to be erected here. Mandela was present when the statue was unveiled in 2007, and he spoke of a visit to London forty-five years earlier when he and fellow activist, Oliver Tambo, had jokingly wondered if a statue of a black person would ever stand next to that of Smuts. Ian Walters also created a bust of Mandela in the 1980s, which stands outside the Royal Festival Hall (see page 197), and there is a bust of Tambo in Muswell Hill (see page 221).

On a patch of grass on the corner of Great George Street is the oldest statue in the square, to the politician **George Canning** (1770–1827). At a time when, to make your way in politics, you had to have a title and plenty of money, Canning was unusual in succeeding by hard work and talent. He was twice Foreign Secretary, when he recognised the newly liberated Latin American countries, and for the last few months of his life was prime minister. The statue, by Sir Richard Westmacott, is

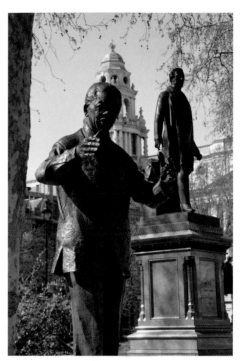

Nelson Mandela's statue is much less formal than the others in Parliament Square, including that of Robert Peel behind him.

neo-classical in style, with Canning wearing distinctly non-contemporary clothes. It was originally put up in 1832 in a garden near St Margaret's Church looking out over New Palace Yard. Because of the construction of new roads and the Underground railway, the statue was moved to its present position in 1867. The statue was considered by some to be one of Westmacott's best, though it was also criticised by others. According to the *Observer*, 'Nothing so vile in taste, or so defective in execution, has outraged public opinion for some years'.

Further south, in front of the Supreme Court, is the impressive statue of **Abraham Lincoln** (1809–65), the

sixteenth president of the United States. It is a copy of a statue in Chicago by Augustus Saint-Gaudens, and was presented by the American people, but London very nearly received a very different statue. The original offer of a statue, to celebrate the anniversary of the Treaty of Ghent in 1814 and one hundred years of peace between the United States and Great Britain, was made in 1914. It was assumed that the statue was the one by Saint-Gaudens, but in 1917 the American Committee ordered a casting of a statue by George Gray Barnard, which had recently been erected in Cincinnati. There were protests on both sides of the Atlantic, as it was considered to be a poor likeness and an unworthy gift, and was known in American art circles as 'The Tramp with the Colic'. The final decision was delayed until after the war, and in the end it was the replica of the Saint-Gaudens that was sent to London, a statue which Sir George Frampton claimed was 'perhaps the most beautiful monument in America'. The Barnard statue was presented instead to Manchester, where it can still be seen. The London unveiling took place in 1920, carried out by the Duke of Connaught, the president of the Anglo-American Society. The statue is a dignified and powerful representation of Lincoln, showing him standing, head bowed in thought, in front of a chair.

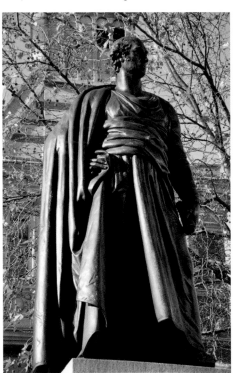

Westmacott's statue of Canning portrays him in antique apparel.

The dignified statue of Abraham Lincoln is a copy of the one in Chicago.

On the east side of the square, in front of Westminster Hall, is a monument to **Oliver Cromwell** (1599–1658), Parliamentary leader during the Civil War and Lord Protector from 1653 to 1658 (see overleaf). Cromwell has always been a controversial figure, as he had a hereditary monarch, Charles I, beheaded and became something of a despot himself. He was also much hated by the Irish because of the brutality of his troops in the last days of the Civil War. During the construction of the new Houses of Parliament he was denied a statue among the monarchs adorning the exterior of the building. John Bell put forward a proposal for a statue to be erected outside the Houses of Parliament, but he died in 1895, and Sir (William) Hamo Thornycroft was commissioned to produce one. However, the scheme was abandoned when its funding was opposed by Irish MPs. An anonymous donor, most probably Lord Rosebery, offered to pay for the statue, and it was erected in 1899 to celebrate the tercentenary of Cromwell's birth. The statue stands on a lawn well below the pavement, but it stands on a tall plinth so that it is clearly visible at street level. The Protector is shown bareheaded and carrying a sword and Bible, to symbolise the two aspects of his character, and on the front of the plinth is a crouching lion. His gaze is lowered, as if to avoid eye contact with the bust of **Charles I** which occupies a niche above the doorway of St Margaret's Church opposite. It is one of the busts found by Hedley Hope-Nicholson (see page 20) and was given to the church in 1956. When Cromwell died, he was buried in Westminster Abbey, but after the Restoration in 1660, Charles II had his body exhumed and hanged at Tyburn. His head was stuck on a spike on the roof of Westminster Hall, where it stayed for some twenty years until it was blown down in a gale. It was retrieved by a sentry and it then passed through many hands, but is now buried at Sidney Sussex College, Cambridge. Every year on 3 September, the anniversary of Cromwell's death, the Cromwell Association holds a service at the statue.

In Old Palace Yard, by the entrance to the House of Lords, is Baron Marochetti's highly romantic equestrian statue of **Richard I, Coeur de Lion** (1157–99). Although king for ten years, Richard spent very little time in England, and is best known for the part he played in the Crusades. He died after being shot by an archer when attacking the castle of Chalus in France, and was buried at Fontrevault Abbey. A plaster model of Marochetti's statue was displayed at the Great Exhibition of 1851 and was greatly admired. The ambitious Italian sculptor was not popular with the artistic establishment, but had the patronage of Queen Victoria, and Prince Albert himself chose the setting for the bronze version of the statue. It was erected here in 1860, even though Charles Barry, the architect of the new Houses of Parliament, objected to it being placed in front of his new building. It shows Richard as a crusader knight, sword held high as if about to lead a charge. The two bas reliefs which, according to Marochetti, were in the style of Ghiberti's Baptistery doors in Florence, were added to the plinth in 1866–7.

The one visible to the public shows Richard on his deathbed, forgiving the archer who shot him, though he was treacherously flayed alive after the king's death. A charming

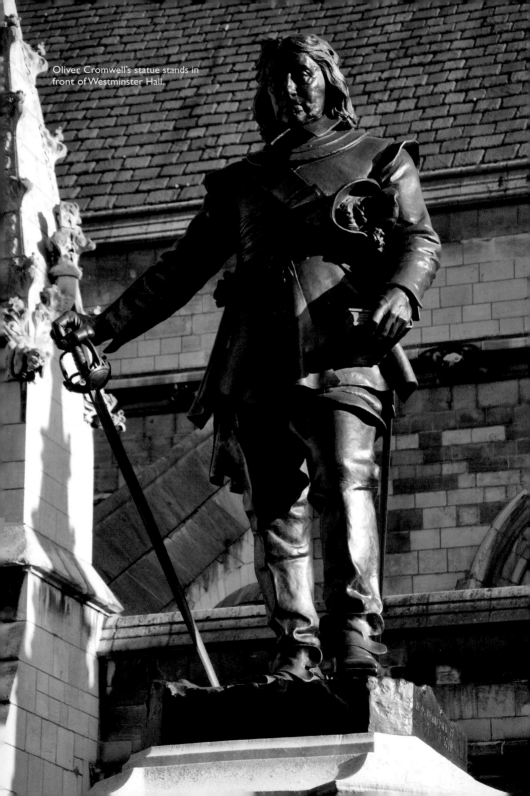

Oliver Cromwell's statue stands in front of Westminster Hall.

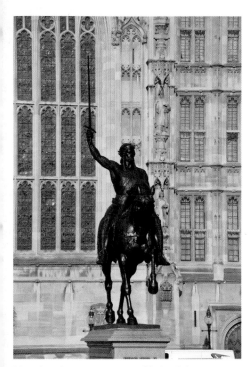

Marochetti's romantic image of Richard the Lionheart.

the Portland quarries, but the outbreak of war delayed its erection, and it spent the war years in a tunnel at the quarry. It was finally unveiled in 1947 by George VI, who was accompanied by members of the royal family, including Queen Mary. The king is shown in the uniform of a Field Marshal and Garter robes, and holds the Sword of State. The figure is set well forward on the high plinth, and the long, flowing cloak is a strong architectural element of the design.

Just inside the entrance to Victoria Tower Gardens is a memorial to **Emmeline Pankhurst** (1858–1928) and her favourite daughter **Christabel Harriette Pankhurst** (1880–1958), two of the leading figures in the women's

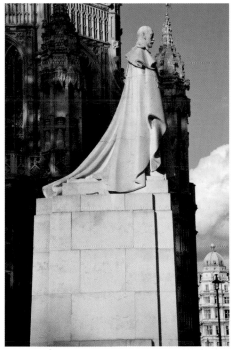

George V's statue at the east end of Westminster Abbey.

detail is the cat sleeping under a chair. The other relief shows Crusaders fighting the Saracens. During the Second World War a bomb landed very near the statue, but the only damage caused was to the sword, which was bent by the blast.

On the opposite side of the road, on a small patch of grass at the east end of Westminster Abbey, is the statue of **George V** (1865–1936). The statue, of Portland stone, was created by Sir William Reid Dick, and Sir Giles Gilbert Scott acted as architect. The original model, which included a Gothic canopy, was much criticised, and the design was simplified. The statue was carved in one of

suffrage movement. Emmeline formed and led the Women's Social and Political Union, and Christabel worked as an organiser and the organisation's lawyer. They began by campaigning peacefully, but, frustrated by a lack of progress, became more militant, and Emmeline and many of her followers were arrested many times. In 1918 women over the age of thirty were given the vote, but full equality only came a couple of weeks after Emmeline's death. The statue of Emmeline, by Arthur George Walker, was unveiled in 1930 by the prime minister, Stanley Baldwin. In 1959 the low curved wall was added, with plinths at each end, one carrying a bronze replica of the WSPU prison badge, the other a relief portrait of Christabel by P. Hills.

Inside the gardens is Auguste Rodin's famous sculpture **The Burghers of Calais**. It shows a scene from 1347 when, after a long siege, the six burghers, with halters round their necks, surrendered themselves to Edward III to save their town. The first sculpture was erected in Calais in 1895, and this version is a replica supervised by the artist. It was bought for the nation by the National Art Collections Fund (now the Art Fund) and erected here in 1915. Its original location, on a 16-foot-high plinth in a corner of the gardens, was much criticised at the time, as it made the sculpture inaccessible, but as the setting had been agreed with the sculptor, it remained there for many years. During the Second World War the sculpture was put in storage to save it from bomb damage, and in 1956 it was moved to a more open space and on a much lower plinth, allowing it to be more easily appreciated in the round. However, the new plinth allowed people

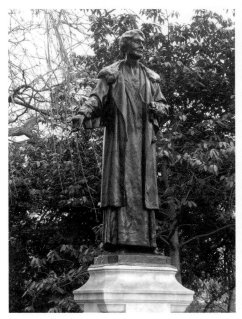

The statue of Emmeline Pankhurst shows her addressing a meeting.

to climb onto it and the sculpture was damaged. In 1999 it was taken away for restoration and in 2003 it was unveiled on a new plinth.

Towards the southern end of the gardens is a curious, multi-coloured structure, which often appears in the background on television news broadcasts. This is the **Buxton Memorial Fountain**, erected to commemorate the abolition of slavery in 1834, and in particular the work of Sir Thomas Fowell Buxton (1786–1845), a politician who worked tirelessly in the campaign against slavery. It was commissioned by his son, Charles Buxton, and was designed by Samuel Sanders Teulon. In 1865 it was installed in Parliament Square, in the corner where Palmerston now stands. In the 1950s, when

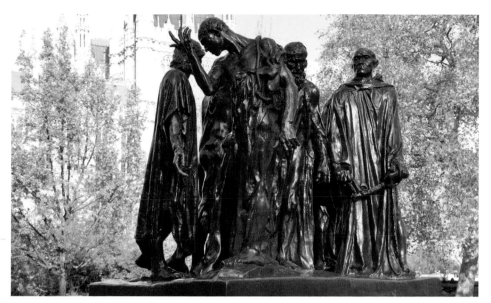

Rodin's *Burghers of Calais* in Victoria Tower Gardens.

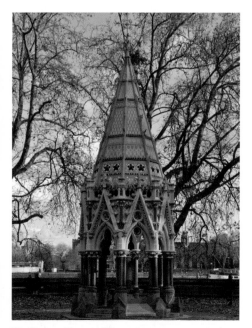

The Buxton Memorial Fountain commemorates the work of those who worked to abolish the slave trade.

plans were made for the rearrangement of Parliament Square, it was proposed to move it to a new location and the suggestion provoked much debate. Some felt it should stay where it was, while others considered the fountain to be an eyesore and did not want it to be rebuilt anywhere. In 1957 it was moved to its present location. The structure was built using many different stones, including granite, sandstone, limestone and marble, and the detailing is Gothic in style, with medieval-style carving and colourful mosaics. After restoration by the Royal Parks, it was unveiled in 2007 to commemorate the 200th anniversary of the 1807 Act which abolished the slave trade. Originally eight bronze figures of English monarchs stood on the pinnacles, but they were stolen in the 1960s and '70s. In 1980 they were replaced with fibreglass copies, but these were not installed in 2007.

VICTORIA EMBANKMENT

ONE OF THE best places in London to study statues is along the Victoria Embankment. When it opened in 1870, it not only offered a new route from the City to Westminster, but new gardens were created on land reclaimed from the Thames. These gardens are now filled with a great variety of statues, and there are a number of memorials on the river wall as well.

One of the capital's best known statues is **Boadicea** by Thomas Thornycroft, which stands at the north end of Westminster Bridge, opposite the Houses of Parliament. Boadicea (or Boudicca) was the queen of the Iceni who raised a rebellion against the Romans, destroying the cities of Colchester (Camulodunum), St Albans (Verulamium) and London (Londinium). After being defeated in battle in AD 62 she committed suicide. Her burial place is not known, but there is a tradition that she is either under platform 10 of King's Cross Station or buried at Parliament Hill; it was the London County Council's decision to investigate the latter site in 1894 that prompted John Thornycroft to offer them his father's sculpture. Thomas Thornycroft, who died in 1885, had spent fifteen years on the work and the plaster cast had been stored at his home in Chiswick. The LCC were very impressed by the work and were keen to accept the offer, but there were problems raising the necessary funding, due to the high cost of casting such a large sculpture. Even when the problem was resolved in 1898 there was still the problem of finding a good site for it. Originally it was planned to erect it on Parliament Hill, but a plaster model was placed on the Embankment as an experiment. There was considerable criticism of the statue's old-fashioned design, and the inappropriateness of the site for such a monumental sculpture, but the LCC went ahead and the statue was unveiled in 1902. It is a very dramatic composition, with the queen, accompanied by her two daughters, driving her horse-drawn chariot at the Roman army. However, the costume and chariot are fantastic inventions of the sculptor, rather than historically accurate, especially the anachronistic scythes on the wheels.

The building next to the modern Portcullis House is the Norman Shaw Building, now parliamentary offices, but built as New Scotland Yard by **Richard Norman Shaw** (1831–1912), his only major public

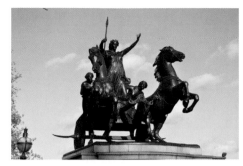

The dramatic, but historically inaccurate, statue of Boadicea by Westminster Bridge.

This portrait of Richard Norman Shaw marks his only major public building.

back of which are inscribed the names of the 2,936 pilots and ground crew who took part, seventy of whom attended the unveiling. One of the friezes shows the various activities of Fighter Command, including observers and mechanics, with the 'scramble' at its centre, the pilots dramatically rushing out of the monument. The other panel concentrates on people on the ground, some watching the dogfights, women in the munitions factories, and St Paul's amid the ruins. Underneath is Winston Churchill's famous phrase which gave the pilots their nickname: 'Never in the field of human conflict was so much owed by so many to so few'.

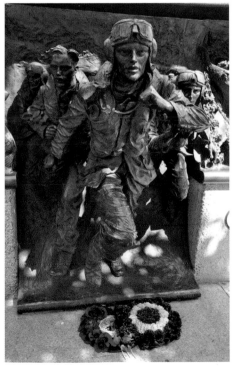

The 'scramble' is dramatically portrayed on the Battle of Britain Memorial.

building. Under an upper balcony is a memorial plaque to Shaw by W. R. Lethaby, with a portrait relief by Sir (William) Hamo Thornycroft, installed in 1914.

The next section of the Embankment is dedicated to military memorials of various kinds. On a wide section of the Thames-side footpath is the substantial **Battle of Britain Memorial**, which was unveiled in September 2005 by Prince Charles. It commemorates the fighter pilots known as 'the few', as well as the ground crew, who between them won the aerial Battle of Britain against the Luftwaffe in 1940. The £1.65m memorial was commissioned by the Battle of Britain Historical Society and paid for by public subscription. It consists of two bronze friezes by Paul Day, on the

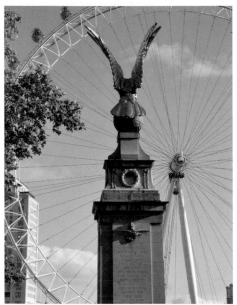

The Royal Air Force Memorial, topped by a golden eagle.

A further inscription was unveiled by Lord Trenchard in 1946 to remember those who lost their lives in the Second World War. The RAF Benevolent Fund had originally wanted the memorial to stand between Westminster Abbey and St Margaret's Church, so this location was their second choice, but it has since been joined by a number of related memorials, creating a place of special significance.

At the Westminster end of the gardens in front of the Ministry of Defence is the **Chindit Memorial**, erected in memory of the Chindits, a force made up of British and Gurkha soldiers, who fought against the Japanese in the Burmese jungle in 1943–4. Their name comes from the *Chinthe,*

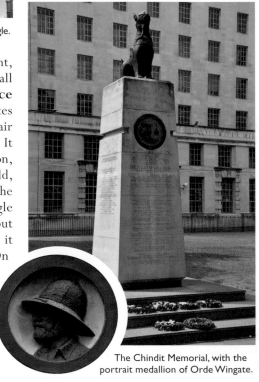

The Chindit Memorial, with the portrait medallion of Orde Wingate.

Further along the Embankment, overlooking the Thames at Whitehall Stairs, is the **Royal Air Force Memorial**, which commemorates those serving in the RAF and other air forces who died in both world wars. It consists of a simple Portland stone pylon, designed by Sir Reginald Blomfield, surmounted by a gilded bronze eagle, the work of Sir William Reid Dick. The eagle was originally meant to face the road, but Blomfield changed his design so that it faces, symbolically, towards France. On the Embankment side is the winged badge of the RAF and its motto, *Per ardua ad astra,* and below is the dedication to those who served in the First World War. The memorial was unveiled in 1923 by the Prince of Wales (the future Edward VIII).

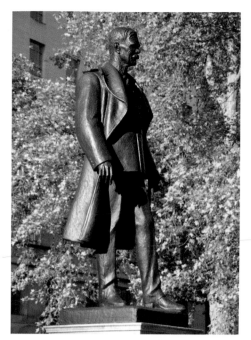

McMillan's statue of Trenchard, 'father of the RAF'.

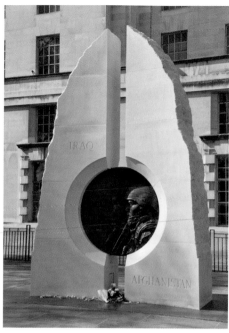

The Iraq and Afghanistan Memorial.

a mythical beast that guards Burmese temples, and a bronze statue of one stands on top of the memorial. The Chindits were led by Major General Orde Wingate, an unorthodox but dynamic leader, who died in action in March 1944, and there is a portrait medallion of him on the reverse of the monument. The memorial was unveiled in October 1990 by the Duke of Edinburgh. It was designed by the architect David Price and the sculpture is by Frank Foster.

Nearby is the statue of **Hugh Montague Trenchard, Viscount Trenchard** (1873–1956), known as 'the father of the Royal Air Force', appropriately standing in front of the former Air Ministry. He was clumsy, inarticulate and had a famously loud voice, earning him the nickname 'Boom', but he also had limitless energy, was a stern disciplinarian and a great organiser. His first career was in the army, but later he learned to fly and became the first Chief of the Air Staff of the newly formed Royal Air Force in 1918, building it into a powerful force. The statue, by William McMillan, shows Trenchard in RAF uniform, and was unveiled in 1961 by the prime minister, Harold Macmillan.

At the back of the gardens is the **Iraq and Afghanistan Memorial**, which was unveiled by the Queen in 2017. It commemorates all those who served in the conflicts in Iraq and Afghanistan from 1990 to 2015, as well as the contribution of civilians at home and in the Gulf. It is the work of Paul Day, and consists of two

Portland stone structures, representing the two countries, supporting a large bronze medallion. On one side of the medallion is a scene of soldiers in action, and on the reverse are civilians, including doctors and nurses.

Close by is the **Korean War Memorial**, which commemorates the British troops who fought in the 3-year war, in particular the 1,106 men who died in the conflict, which lasted from 1950–53. The memorial was paid for by the government of the Republic of Korea, and is the work of Philip Jackson. A bronze statue of a British soldier stands in front of a Portland stone obelisk, with inscriptions giving information on what is often referred to as the 'forgotten war'. The memorial was unveiled in 2014 by the Duke of Gloucester and Yun Byung-Se, the Republic of Korea's Minister of Foreign Affairs, in a ceremony which was attended by many war veterans.

Not far away is a rather different kind of monument, the **Fleet Air Arm Memorial**, which was unveiled in 2000 by the Prince of Wales. It is dedicated to the thousands of men and women who lost their lives while serving in the Fleet Air Arm of the Royal Navy, and lists the wars and battles in which they fought, from the First World War to the first Iraq war of 1991. On top of a column of Portland stone is the bronze figure of Daedalus, the Greek inventor who made wings for himself and his son, Icarus, who flew too close to the sun and died. The figure is clearly of an airman in uniform, and he has an air of sadness about him, with his head bowed as he remembers the many colleagues who have died in action. The sculpture is by James Butler,

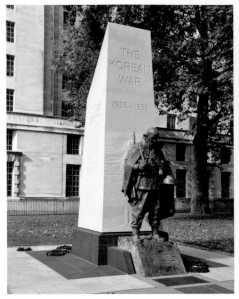

The memorial to the men who fought in the Korean War.

who worked with architects Trehearne & Norman.

Further along the gardens is Oscar Nemon's larger-than-life statue of **Charles Frederick Algernon Portal, Viscount Portal of Hungerford** (1893–1971), who was Chief of the Air Staff during most of the Second World War. Portal served in the Royal Flying Corps in the First World War, and earned three decorations by the time he was twenty-five. Between the wars his potential was recognised by Trenchard and he was rapidly promoted. In April 1940 he ran Bomber Command and in October was made Chief of the Air Staff, remaining in charge throughout the rest of the war. According to Eisenhower, he was the greatest British war leader, 'greater even than Churchill', and Churchill himself claimed that 'Portal has everything'.

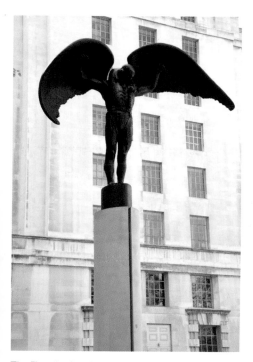

The Fleet Air Arm Memorial with a winged airman.

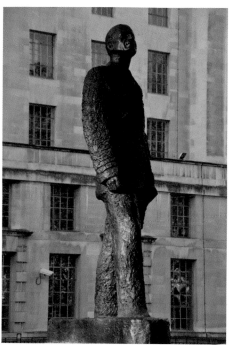

Oscar Nemon's statue of Portal is in his distinctive rugged style.

The statue was unveiled in 1975 by Harold Macmillan, on what would have been Portal's eighty-second birthday.

The last statue in this section of the gardens is of **General Charles George Gordon** (1833–85). Gordon was a career soldier, serving in the Crimea, India and China, and was often referred to as 'Chinese Gordon'. As well as being a fanatical Christian, he was opinionated, self-righteous and insubordinate, and he himself said, 'I know if *I* was chief I would never employ myself, for I am incorrigible.' His most famous exploits were in the Sudan: he was sent there to rescue the Egyptian forces from an insurrection by the Mahdi in Khartoum, where he in turn was besieged.

He defended Khartoum for a year, and the British Government dithered over sending relief troops, who finally arrived on 28 January 1885, two days after he had been killed. Gordon became a martyr and a national hero, and in October 1888 this statue, by Sir (William) Hamo Thornycroft, was unveiled, with no ceremony or speeches, in the centre of Trafalgar Square. In 1943 the statue was removed to make way for a Lancaster bomber, as part of a 'Wings for Victory' display. The statue returned after the war, but in 1947 it was proposed to move the statue permanently to make way for the new fountains being built as part of the Beatty and Jellicoe memorials. Plans to send it to Sandhurst led to a public

outcry, and the Government finally agreed to place it in the new gardens being created on the Victoria Embankment by the new Air Ministry offices, where it was installed in 1953. It is a fine statue, the sculptor following Gordon's brother's request that it be 'as little military as possible'. Instead it shows Gordon in pensive mood, carrying a Bible in his left hand and with his famous 'whangee' cane under his right arm. On the sides of the plinth are bronze plaques of Fortitude, Faith, Charity and Justice. Although Gordon is a military hero of the old school, he is still remembered, and wreaths are laid at the foot of the statue to this day.

The gardens north of Horse Guards Avenue contain a more varied selection of memorials. The first is to **William Tyndale** (*c.* 1494–1536), an important figure of the English Reformation. He translated the Bible into English, but was persecuted for his work and forced to flee to Germany, where his New Testament was printed. Copies were smuggled into England, though many of them were burned. He later worked on the Old Testament in Antwerp, but in 1525 he was arrested and burned as a heretic. His last words at the stake were, 'Lord, open the king of England's eyes'. Ironically, within a year of his death a complete English Bible could be found in every parish church, on the King's orders. The statue, by Sir Joseph Edgar Boehm, was unveiled in 1884 by

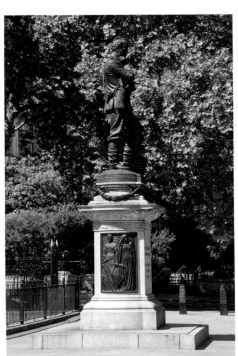

Thornycroft's statue of Gordon used to stand in Trafalgar Square.

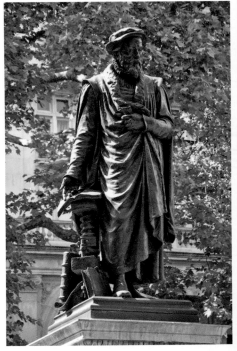

William Tyndale was persecuted for translating the Bible into English.

Lord Shaftesbury. Tyndale rests his right hand on a copy of his New Testament, which stands on a printing press copied from a contemporary one in the Plantin Museum in Antwerp.

Nearby is the statue of **Sir Henry Bartle Edward Frere** (1815–84), by Sir Thomas Brock. Frere was a statesman and administrator who spent thirty-three years working in India, where he developed the cities of Sind and Bombay, improving harbours, transport, sanitation and trade. He later managed to abolish the Zanzibar slave trade, but his time as High Commissioner in South Africa was less successful. Brock's statue, unveiled in 1888 by the Prince of Wales, shows Frere in the robes of a Knight Commander of the Star of India.

At the far end of the gardens is the impressive memorial to **General Sir James Outram** (1803–63). He first went to India aged sixteen and remained there for most of his life. At the relief of Lucknow he was happy to serve under Havelock, despite his more senior rank. He also served with Napier, who called him the 'Bayard of India', though they were later to fall out. A Bayard was a knight without fear or reproach, and the epithet has been used to refer to him ever since. The 14-foot bronze statue by Matthew Noble was unveiled in 1871, and was the first statue to be erected in the Embankment gardens.

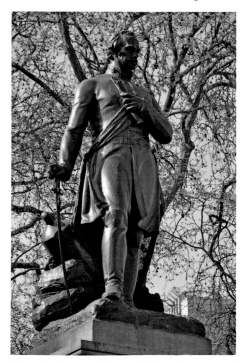

Frere was an administrator who spent most of his working life in India.

The colossal statue of General Outram is surrounded by military symbols.

Outram wears the Star of India and has a cannon at his feet, and there are Indian trophies around the 19-foot granite plinth.

Outside the gardens, overlooking the Embankment, is a memorial to **Samuel Plimsoll** (1824–98), the 'Sailors' Friend'. Plimsoll campaigned long and hard against the 'coffin-ships' – poorly maintained and overloaded ships that often disappeared without trace, and with great loss of life. He faced much opposition, but his persistence led to the Merchant Shipping Act of 1876, which forced ship owners to mark their vessels with a load-line, still known as the 'Plimsoll Line'. The memorial, by Ferdinand Blundstone, was unveiled in 1929, and was funded

The memorial to Samuel Plimsoll, the 'Sailors' Friend'.

by members of the National Union of Seamen. Below a bust of Plimsoll are the figures of Justice and a sailor, and the railings on either side feature seahorses and the Plimsoll Line.

On the Embankment wall facing Northumberland Avenue is a memorial to **Sir Joseph William Bazalgette** (1819–91), one of the truly great Victorian engineers. He left a massive legacy in London, including three Thames bridges, major new streets such as Shaftesbury Avenue and Northumberland Avenue, and the Victoria, Albert and Chelsea Embankments, but his most important and least visible achievement was the building of a huge network of sewers which is still in use today. Part of it runs under the Victoria Embankment itself, which was also designed to house the District Line. His memorial could therefore not be better placed. It was designed by George Symonds and was unveiled in 1901. It consists of a bronze portrait bust within a rather classical temple structure, containing many sculptural details such as dolphins representing the Thames and surveying and engineering implements on the two columns. In the pediment is the Bazalgette coat of arms, and beneath it the Latin phrase, *Flumini vincula posuit* ('he put the river in chains').

On the river wall on the northern side of Hungerford Bridge is a memorial to the playwright **Sir William Schwenck Gilbert** (1836–1911). Gilbert trained as a barrister, but found fame as a wit and dramatist of both comedy and tragedy. In 1869 he met the composer, Arthur Sullivan, and they soon teamed up as 'Gilbert and Sullivan', writing the Savoy operas for Richard D'Oyly Carte, who

The memorial to Bazalgette stands on the Embankment he built.

The memorial to the writer W. S. Gilbert is one of three by Frampton on the Embankment wall.

built the Savoy Theatre to stage them. They were a highly successful partnership, producing such operettas as *The Mikado* and *The Gondoliers,* which are still regularly performed today. In 1907 Gilbert was the first dramatist to be knighted. The bronze memorial is by Sir George Frampton and it was erected in 1915. It has a profile portrait of Gilbert, flanked by the figures of comedy and tragedy, and below is the apt epitaph, 'His foe was folly and his weapon wit'. Sullivan's memorial is in Victoria Embankment Gardens, only a few hundred yards away.

Further along the Embankment is **Cleopatra's Needle** which, despite its name, does not commemorate the great Egyptian queen. It was originally erected in Heliopolis in around 1475 BC, but was later moved to Alexandria. Its original dedication was to Tuthmosis III, though the names of Ramses II and Cleopatra were added at a later date. In 1820 Mohamed Ali, the Turkish Viceroy, presented the 69-foot granite obelisk to Britain in recognition of its efforts to free Egypt from occupation by the French forces, and a plaque on the river side states that it is 'a worthy memorial of our distinguished countrymen Nelson and Abercromby'. Because of the technical difficulties of moving the obelisk, it lay for many years abandoned in the desert. It was

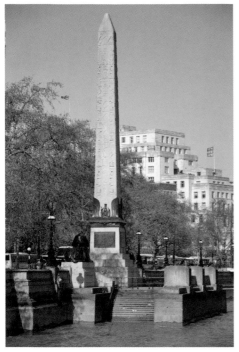

Cleopatra's Needle is over three thousand years old, and has stood by the Thames since 1878.

This sculpture by Victor Rousseau is part of the Anglo-Belgian Memorial.

finally collected in 1877, and towed by sea to London, though it was nearly lost in a storm in the Bay of Biscay. It was erected on the Embankment in 1878, using hydraulic jacks. To give it stability, four bronze corner pieces in the form of wings were added by George Vulliamy, who also made the two sphinxes that guard it. One of the sphinxes was damaged during an air raid in 1917, and the scars can still be seen.

Opposite Cleopatra's Needle is the **Anglo-Belgian Memorial**, a gift from the Belgian nation in gratitude for the help given to the thousands of Belgian refugees who lived in England during the First World War. It was unveiled in 1920 by Princess Clementine of Belgium. The memorial was designed by Sir Reginald Blomfield, and the bronze sculpture, by the Belgian sculptor, Victor Rousseau, represents a Belgian woman with a boy and girl carrying garlands.

The section of the Victoria Embankment Gardens between the Hungerford and Waterloo Bridges contains a diverse collection of memorials. The first one, near the York Watergate, is of the great Scottish poet, **Robert Burns** (1759–96 – see page 54), and is a thoroughly Scottish affair. The statue itself is by Sir John Steell, the most important Scottish sculptor of the nineteenth century, and is a variant of his

statues in Dundee, New York and Dunedin. It was donated by John Gordon Crawford, a retired Glasgow merchant, and stands on a pedestal of pink Peterhead granite, with a base of Aberdeen granite. The poet is seated, in pensive mood, on the broken stump of a tree. He holds a pen in his right hand and at his feet is a scroll with the words, 'O sweet to stray and pensive ponder a heart-felt song'. The memorial was unveiled in 1884 by Lord Rosebery, the Commissioner of Works.

Close by is the unusual and attractive memorial to the **Imperial Camel Corps** (see overleaf), commemorating those who died during the First World War fighting in the deserts of Egypt, Sinai and Palestine. It was unveiled in 1921. The sculptor was Major Cecil Brown, himself a member of the Corps, and the memorial shows a yeoman on a camel. Bronze plaques on each side show scenes from the campaigns.

A short distance away, on a tall plinth, is the statue of **Sir Wilfrid Lawson** (1829–1906), a long-forgotten nineteenth-century politician. He was an MP for nearly fifty years, and was an indefatigable campaigner for temperance, but also supported women's rights and religious equality. With his long beard, he looks a strict and dour figure, but he was an excellent public speaker and a great wit, and it amused him that he was referred to as 'the old cracked teapot'. The funds for the statue were collected by the United Kingdom Alliance, the temperance organisation of which Lawson had been President, and it was unveiled by Herbert Asquith, the prime minister, in 1909. David McGill's statue shows Lawson holding notes in his right hand, about to make a speech. Originally there were bronze figures of Temperance, Peace, Fortitude and Charity around the base, but these were stolen in 1979.

Opposite is a monument designed by Sir Edwin Lutyens and erected in 1930 to commemorate **Herbert Francis Eaton, Baron Cheylesmore** (1848–1925), who was Mayor of Westminster in 1904 and from 1912 to 1913 was Chairman of the London County Council. It is a very simple memorial, with no portrait, but with the family crest and a small pond.

A few metres away is a drinking fountain in memory of **Henry Fawcett** (1833–84), who was blinded in a shooting accident when still a young man, but came to terms with his blindness and had a long and successful political career. In 1880 he was made Postmaster General, and during his tenure he introduced the parcel post. He was also a supporter of women's rights and the memorial fountain was erected by 'his grateful countrywomen' in 1886. It was designed by Basil Champneys and the bronze plaque is an early work of George Frampton, incorporating a portrait medallion of Fawcett by Mary Grant.

On the other side of the path is a statue of **Robert Raikes** (1736–1811), a newspaper proprietor from Gloucester who is often considered to be the founder of Sunday Schools. In fact, he did not set up the first school, but was very active in promoting them, leading to the creation of the Sunday School Society in 1786. In July 1880, during the Sunday School centenary celebrations, the bronze statue,

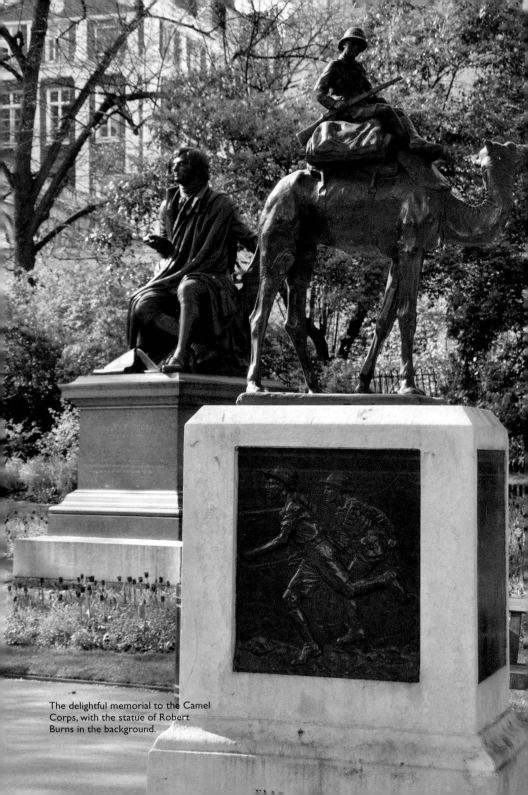

The delightful memorial to the Camel Corps, with the statue of Robert Burns in the background.

Lawson is making a speech, hand in pocket – a very lifelike pose.

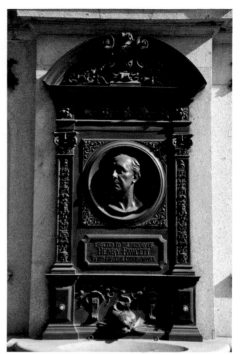

Fawcett became Postmaster-General, despite his blindness.

by Thomas Brock, was unveiled by the Earl of Shaftesbury. Raikes is portrayed in eighteenth-century clothes, pointing at a Bible in his left hand. In 1930 two replicas were made of the statue, which now stand in Gloucester, Raikes's birthplace, and in Toronto.

A memorial to **Sir Arthur Sullivan** (1842–1900) is nearby. Sullivan is best known for the comic operas he composed in partnership with W. S. Gilbert, but he composed much else, including a symphony, choral works and songs such as 'The Lost Chord', which made him both popular and rich, though they are rarely performed today. The memorial,

the work of Sir William Goscombe John, was unveiled in 1903 by Princess Louise, Duchess of Argyll. A bust of the composer sits on a pillar, and on one side are lines from *The Yeoman of the Guard*:

> Is life a boon?
> If so it must befall
> That death whene'er he call
> Must call too soon.

Against the pillar reclines a semi-nude bronze female figure representing grief-stricken Music, considered by some to be the most erotic sculpture in London. Around the base, also in bronze, are

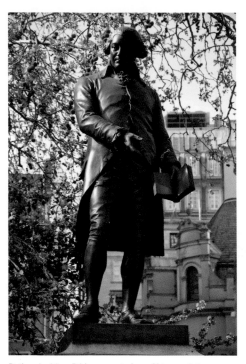

Raikes holds a Bible, a reminder of his work in promoting Sunday Schools.

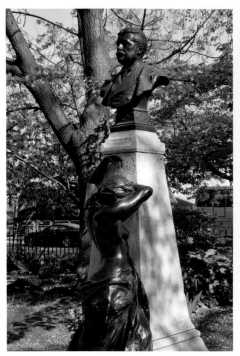

The semi-nude figure on Sullivan's memorial symbolises grief-stricken Music.

musical instruments, a music score and the mask of comedy. The commission was for a bust only, but the sculptor added the female figure to make the memorial more striking, which it certainly is.

On the corner of Savoy Street and Savoy Place, in front of the Institute of Electrical Engineers, is a statue of **Michael Faraday** (1791–1867), the famous experimental scientist whose most important discoveries related to electricity. He wears the gown of Doctor of Civil Law of Oxford, and holds the coil with which he created the first magneto-electric spark. The statue is a copy of a marble sculpture of 1874 by John

Foley, which stands in the Royal Institution in Albemarle Street, where Faraday carried out many of his experiments.

On the riverside wall, almost opposite, is a bronze plaque to **Sir Walter Besant** (1836–1901), writer, London historian and campaigner for authors' rights. The Society of Authors, which he helped to found, arranged for this copy of the memorial in St Paul's Cathedral to be placed here in 1904. It is by Sir George Frampton, and the relief portrait is the first in London to wear spectacles.

Beyond Waterloo Bridge in Temple Place is a statue of **Isambard Kingdom**

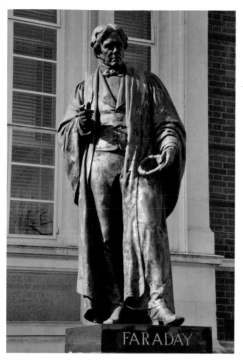

The statue of the great scientist Faraday is a copy of an original in the Royal Institution.

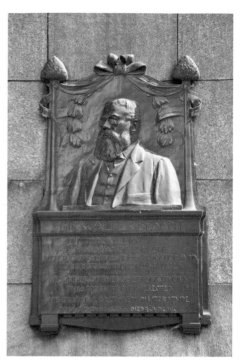

Walter Besant is, unusually, shown wearing glasses.

Brunel (1806–59), one of the greatest engineers of the nineteenth century. His London legacy includes the Thames Tunnel, built with his father, Marc, and now used by the London overground railway; Paddington Station; and Hungerford Bridge, a pedestrian bridge that was converted into a railway bridge. He is best remembered for the Clifton Suspension Bridge in Bristol, which was completed after his death. The statue, by Baron Marochetti, was one of three statues of engineers he created in the 1860s to be erected in the churchyard of St Margaret's, Westminster, but his plans were rejected, and the statue of Brunel was erected here in 1877 (his statue of Robert Stephenson is now at Euston Station (see page 187). The pedestal and background were designed by Richard Norman Shaw.

In the quiet gardens to the east of Temple Station are three of London's lesser-known memorials. The first is to **William Edward Forster** (1818–86), a politician whose claim to fame was the introduction of a national system of elementary education. He also worked for the abolition of slavery with his uncle, Thomas Fowell Buxton, whose memorial

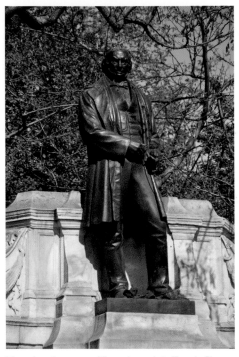

Marochetti's statue of Brunel stands in Temple Place.

Forster, though little known today, was an important reformer of the British education system.

stands in Victoria Tower Gardens (see page 40). The statue, by Henry Richard Hope-Pinker, was unveiled in 1890, in front of what were then the offices of the London School Board, of which Forster could be considered to be the founder.

On the other side of the path is the charming memorial fountain to **Lady Henry Somerset** (1851–1921), in the form of a young girl, who represents Temperance, holding a bowl that doubles as a bird bath. Lady Somerset was an advocate of temperance and a campaigner for women's rights. In 1890 she became President of the British Women's Temperance Movement, and the statue, by

G. E. Wade, was put up in 1897. The figure of the girl was stolen in 1970, but was replaced in 1999 with a copy by Philomena Davidson Davis.

At the end of the gardens is a statue of **John Stuart Mill** (1806–73), the celebrated economist and philosopher. John Foley was commissioned to produce a bronze statue, but he died before starting work, and the task was entrusted to Thomas Woolner, who was one of the original members of the Pre-Raphaelite Brotherhood. The location was chosen because of its close proximity to the offices of the London School Board, and it was unveiled in 1878. Mill is portrayed sitting,

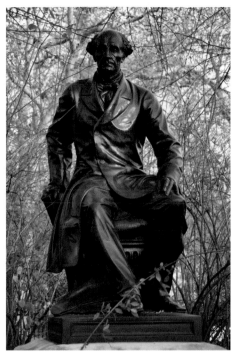

This charming drinking fountain commemorates the social reformer, Lady Henry Somerset.

John Stuart Mill sits in contemplation under the trees.

deep in thought, with a portfolio under his feet and a book in his hand.

On the Embankment wall opposite is a bronze plaque commemorating **William Thomas Stead** (1849–1912), a controversial and outspoken journalist whose concerns included the defence of civil liberties and women's rights. While running the *Pall Mall Gazette,* he had a series of sensational scoops and was once imprisoned because of his unorthodox methods of obtaining information for an article on white slavery. He died on the *Titanic,* and was last seen helping women and children into a lifeboat. The bronze memorial by George Frampton, installed in 1920, has a relief portrait, with figures of Fortitude and Sympathy to left and right.

Nearby is the **National Submarine War Memorial**, a large bronze plaque in memory of those who lost their lives in submarines during the two world wars. The work of sculptor Frederick Brook Hitch, and designed by the architect A. H. Ryan Tenison, it was unveiled in 1922. A new inscription was added in 1959 to include those who died in the Second World War. The central relief shows the control room of a submarine, with swimming nereids on either side. To left and right are figures of Truth and

Justice. There is much marine symbolism, including dolphins and anchors, and at the bottom is a relief of a submarine on the surface. The names of submarines lost in the two wars are listed on both sides. On the walls on either side are forty small anchors used for hanging wreaths.

The campaigning journalist, W. T. Stead, has a memorial on the wall of the Embankment.

The National Submarine War Memorial on the river wall of the Embankment.

STRAND, ALDWYCH AND HOLBORN

O N THE FAÇADE of 27 Southampton Street is a plaque to **David Garrick** (1717–79), the great eighteenth-century actor, who lived there from 1750 to 1772. Garrick was a pupil of Samuel Johnson in Lichfield, and remained his friend for life. He came down to London, where he first worked in the wine trade, before becoming the greatest actor of the age. He was famous for his naturalistic style of acting, and was manager of the Drury Lane Theatre for nearly thirty years. The plaque has a relief portrait of the actor, flanked by Melpomene and Thalia, the muses of tragedy and comedy. The memorial was paid for by the 11th Duke of Bedford and erected in 1901. It is by

Henry Charles Fehr, after a sketch by the architect C. Fitzroy Doll.

In Catherine Street, on the front wall of the Drury Lane Theatre, is a drinking fountain in memory of **Sir Augustus Harris** (1852–96),

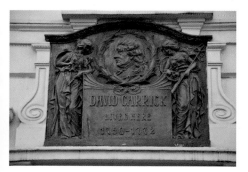

The plaque to Garrick on his home in Southampton Street.

The drinking fountain in memory of Augustus Harris outside the Drury Lane Theatre.

which was put up in 1897. Harris managed the theatre for many years, offering spectacular productions, including opera and Shakespeare. The ornate fountain has classical columns and putti, and on top is a symbolic lyre. The fountain was designed by Sydney R. J. Smith, and the bronze bust of Harris is by Sir Thomas Brock.

In India Place, off the Aldwych, next to the Indian High Commission, is a bust of **Jawaharlal Nehru** (1889–1964), the first prime minister of an independent India. The bust is by Latika Katt and stands on a stone pedestal. It was unveiled in 1990 by the Indian High Commissioner.

In the main courtyard of Somerset House is a statue of **George III** (1738–

1820) by John Bacon the Elder. It was erected in 1780, as part of the design of William Chambers's new building, possibly commissioned by the Royal Academy in recognition of the king allowing them to occupy part of the premises. The king stands on a high plinth, dressed in classical garb, holding a ship's rudder, and accompanied by a lion and the prow of a Roman ship. To continue the maritime theme, below him is a figure of Father Thames, with a water jar and a cornucopia. The figure of the king is not a good likeness, making him look more than a little feminine, and Queen Charlotte was disappointed by it. Towards the end of the nineteenth century the pedestal was converted into a public urinal, which was

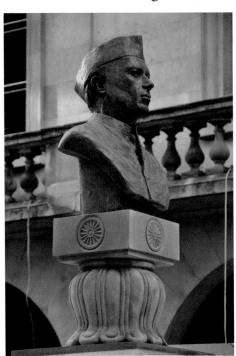

The bust of Nehru is close to the Indian High Commission.

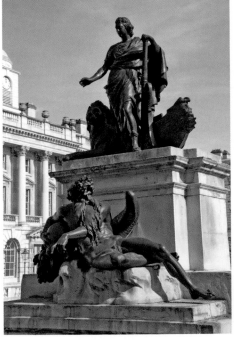

George III was known as 'Farmer George', but the theme here is maritime.

in use for about forty years until it was removed in 1922, following protests.

At the eastern end of the Aldwych, close to St Clement Danes Church, is the magnificent memorial to **William Ewart Gladstone** (1809–98) by Sir (William) Hamo Thornycroft. Gladstone was a major figure in Victorian politics, serving four times as Chancellor of the Exchequer, and four as prime minister. Prime ministers were traditionally commemorated in Parliament Square, but the monument to Gladstone was planned to be rather more grandiose than usual, so a new location had to be found. Kingsway, the new road from Holborn to the Strand, was being built, and the London County

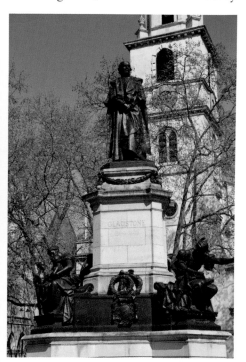

This grand memorial to Gladstone stands at the eastern end of the Aldwych.

Council agreed to the memorial being erected near the west end of St Clement Danes Church. Gladstone stands on a tall pedestal, wearing the robes of Chancellor of the Exchequer, and around the plinth are sculptural groups representing what were considered to be his strengths and ideals: Brotherhood, Aspiration, Education and Courage. The coats of arms are of some of the constituencies he represented. The statue was unveiled in 1905 by the MP John Morley, a supporter and biographer of Gladstone.

Wren's St Clement Danes Church was badly damaged during the Blitz and was restored with money donated by members of the RAF. It is now the central church of the Royal Air Force, and outside its west end are bronze statues of two of the RAF's key players in the Second World War. On the right stands Faith Winter's statue of **Air Chief Marshal Hugh Dowding, 1st Baron Dowding** (1882–1970). Dowding was in charge of Fighter Command during the Battle of Britain, and his efficiency and hard work ensured that it was well equipped and able to do the job against all the odds. He was not an easy man to get on with, as his lifelong nickname 'Stuffy' would suggest, but he was much loved by the pilots working for him ('Dowding's chicks', as Churchill referred to them). The statue, which shows him in uniform and looking rather severe, was unveiled in 1988 by Queen Elizabeth the Queen Mother.

In 1992 the Queen Mother unveiled the statue of **Sir Arthur Harris** (1892–1984), also by Faith Winter. Harris was Commander-in-Chief of Bomber Command, and he was responsible for carrying out many bombing raids against

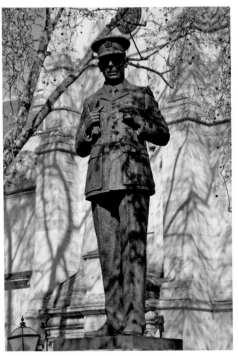

Faith Winter's statue of Dowding stands by the RAF church, St Clement Danes.

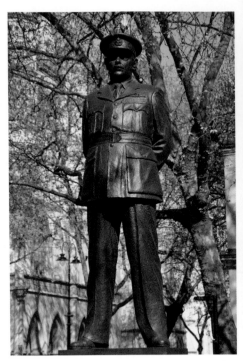

The erection of a statue to 'Bomber' Harris caused much controversy.

industrial and urban targets in Germany. The bombing of Dresden in 1945, with the loss of forty-thousand lives, was particularly controversial, and the affectionate nickname, 'Bomber' Harris, given to him by his colleagues, has now taken on a more sinister meaning. He always maintained that bombing cities was justified, but that he was not responsible for choosing the targets. There were protests at the unveiling of the statue, and it has been vandalised on several occasions.

At the east end of the church, looking down Fleet Street, is a statue of **Dr Samuel Johnson** (1709–84), the famous writer and lexicographer. The location is appropriate, as Johnson lived and worked at several locations off Fleet Street, including the house in Gough Square where he compiled his Dictionary, and he regularly attended services at St Clement Danes Church. The statue is the work of Percy Fitzgerald, who also unveiled it in 1910. Based on Sir Joshua Reynolds' portrait, it shows the great writer in the traditional costume of the period, wearing a full-bottomed wig, with a book in his left hand, and seeming to make a point with his right. At his feet are more books and an inkwell. On the front of the plinth is a bronze relief portrait of **James**

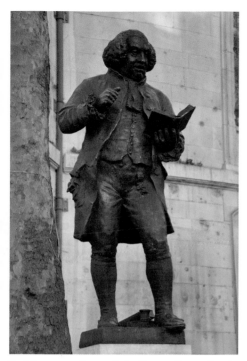

Dr Johnson stands outside St Clement Danes church, where he was a regular worshipper.

Boswell's profile on the plinth of Dr Johnson's Statue.

Boswell, Johnson's biographer, and on the sides are scenes of Johnson and Boswell in the Highlands, and Johnson and his great friend, Hester Thrale. In 1995 the book Johnson was holding was stolen, and it was replaced with a replica by Faith Winter.

On the corner of Serle Street and Carey Street, to the north of the Law Courts, is a statue of **Sir Thomas More** (1478–1535). The stone statue, by Robert Smith, stands in a niche at first-floor level, and was erected in 1886. More studied law at nearby Lincoln's Inn.

In the south-west corner of the gardens of Lincoln's Inn Fields is a bust of **John Hunter** (1782–93), the great Scottish surgeon and founder of scientific surgery.

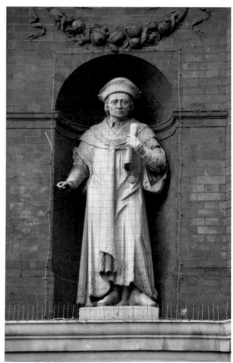

Sir Thomas More studied law at Lincoln's Inn.

The bust of the surgeon John Hunter is close to the Hunterian Museum, which houses his collections.

He left his vast collection of anatomical specimens to the Government, and it now forms the basis of the Hunterian Museum, which is housed in the Royal College of Surgeons on the south side of the square. The College erected the bust in 1979 to commemorate the Silver Jubilee of Elizabeth II. It is by Nigel Boonham, who based it on Hunter's death mask and a portrait by Sir Joshua Reynolds.

On the north side of the gardens is a highly original monument to **Margaret Ethel MacDonald** (1870–1911), the wife of James Ramsay MacDonald, the first Labour Prime Minister. It is close to their home at 3 Lincoln's Inn Fields. She was noted for her charity work with children, and the memorial takes the form of a large granite seat, on top of which is her bronze figure surrounded by a group of children. The sculpture is by Richard Goulden, and it was unveiled in 1914.

Margaret MacDonald's memorial doubles as a seat.

In the north-east corner of Lincoln's Inn Fields is a memorial to **William Frederick Danvers Smith, 2nd Viscount Hambledon** (1868–1928). Hambledon was head of W. H. Smith, the stationers, an MP and Chairman of King's College Hospital. The memorial was designed by Sir Edwin Lutyens and erected in 1929. The Portland stone pedestal includes a seat, and on top there was originally a bust by Arthur George Walker, but this was stolen in the 1970s.

On the east side of Southampton Row, just north of Holborn Underground station, on the corner of a building that was once the headquarters of the Baptist Union, is a statue of **John Bunyan** (1628–88), preacher and author of *The Pilgrim's Progress,* the first line of which is inscribed below the statue. The statue, by Richard Garbe, dates from 1903, when the building was constructed.

In Red Lion Square are memorials to two radical political figures. At its western end is a lively statue of **Fenner Brockway, Baron Brockway** (1888–1988), the left-wing politician. Brockway was a pacifist, who was imprisoned during the First World War, and a founder of the Campaign for Nuclear Disarmament. The statue is by Ian Walters and was unveiled in 1985 by Michael Foot, in the presence of its ninety-six-year-old subject. Brockway was a fine orator and often spoke at nearby Conway Hall. The statue shows him in full flow, with his arm flung out to make a point.

At the eastern end of the square is a bust of **Bertrand Arthur William Russell,**

John Bunyan's statue on a building that was once the headquarters of the Baptist Union.

Fenner Brockway's statue was damaged by a fallen tree in the hurricane of 1987.

Bertrand Russell's bust in Red Lion Square.

Francis Bacon's statue stands in Gray's Inn, where he spent most of his life.

3rd Earl Russell (1872–1970), the philosopher, mathematician and winner of the Nobel Prize for literature. He was also a political activist and pacifist and, like Brockway, was a founder member of CND and was imprisoned during the First World War. The bust, by Marcelle Quinton, was unveiled in 1980 by his second wife, Dora.

A gateway next to the Cittie of Yorke pub in High Holborn is the entrance to Gray's Inn, one of the four Inns of Court. In South Square is a statue of **Francis Bacon, Viscount St Alban** (1561–1626). Bacon was a philosopher and lawyer, and a politician who rose to be Lord Chancellor.

In 1576 he entered Gray's Inn, where he lived for most of his life. He was a keen gardener, and was responsible for the gardens at the Inn. Tradition has it that he died of a chill after stuffing a chicken with snow to see if it preserved the flesh. In 1609 he was elected Treasurer of Gray's Inn, and the statue, by Frederick W. Pomeroy, was due to be erected in 1909 to celebrate the tercentenary of his election. Pomeroy's first model showed Bacon seated, but this was not much liked, so the present statue was not ready until 1912, when it was unveiled by Arthur Balfour, the one-time Prime Minister.

THE CITY: WEST

At the western end of Fleet Street, opposite the Royal Courts of Justice, is the **Temple Bar Memorial**, erected in 1880, marking the boundary between the Cities of Westminster and London. It replaces and commemorates the old Temple Bar, which stood here from 1672 until 1878, when it was considered to be an obstruction and banished to Theobald's Park, Hertfordshire. (It has now been restored and stands next to St Paul's Cathedral – see page 78.) The memorial was designed by Horace Jones and the foundation stone was laid in August 1880. It was unveiled by Prince Leopold in November of the same year. It consists of a tall rectangular structure surmounted by a dragon, the work of Charles Bell Birch, holding the City of London coat of arms with the City motto, *Domine dirige nos.* In niches on the south and north sides are statues by Joseph Edgar Boehm of Queen Victoria and the Prince of Wales. Beneath them are bronze reliefs, the one on the south side, by C. H. Mabey, showing Victoria's procession to the City after her accession; the other, by C. S. Kelsey, depicts the queen and the Prince of Wales on their

Temple Bar marks the boundary between the Cities of Westminster and London.

way to St Paul's Cathedral for a service of thanksgiving for the prince's recovery from a serious illness. On the east side of the memorial is a bronze relief of Time

and Fortune drawing a curtain over the old Temple Bar. On special occasions, it is here that the Lord Mayor offers the sovereign the ceremonial sword, which is always returned to him as a symbol of his authority within the City.

A short way along Fleet Street is St Dunstan-in-the-West Church. In a niche above the vestry door is a fine statue of **Elizabeth I** (1533–1603), which originally stood on Ludgate, one of the ancient gateways into the City. When Ludgate was demolished in 1760, the statue was placed in a niche at the east end of the old church, but when the church

The mythical King Lud and his sons.

was rebuilt, the statue was nearly sold off. Fortunately sense prevailed and it was placed in its present location in 1839. The date 1586 is carved on the base of the statue and William Kerwin, who rebuilt Ludgate in that year, has traditionally been thought to be the sculptor, but on stylistic grounds it now seems more likely to have been made in the following century.

Inside the vestry porch are the badly worn statues of **King Lud and his sons**, pagan figures from London's mythological past. They also once stood on Ludgate, and probably date from the 1586 reconstruction. When Ludgate was demolished the three figures were stored in the churchyard of St Dunstan's, but in 1831 they were moved to the Marquess of Hertford's new villa in Regent's Park. In 1935 they were returned to the church and installed in the inconspicuous position they still occupy.

On the wall of the church is a memorial to **Alfred Charles William Harmsworth, Viscount Northcliffe** (1865–1922), the influential journalist and newspaper proprietor. He more or less created popular, accessible journalism, and became a powerful figure

The statue of Elizabeth I originally stood on the old Ludgate.

The memorial to Lord Northcliffe outside the church of St Dunstan-in-the-West.

The statue of the radical politician John Wilkes in Fetter Lane.

in the newspaper world, founding the *Daily Mail* and later owning the *Daily Mirror* and *The Times*. The bronze bust is the work of Kathleen Scott (Lady Hilton Young) and the plinth was designed by Sir Edwin Lutyens. It was unveiled in 1930 by Lord Riddell, a fellow press baron. When the memorial was erected, Fleet Street was still very much at the heart of the newspaper industry.

A little way up Fetter Lane is a statue of **John Wilkes** (1727–97). Wilkes was a radical politician, serving as both MP and Lord Mayor of the City of London, but also a promiscuous rake. He is best known for his campaigns for voters'

rights and the freedom of the press. He used his newspaper *North Briton* as his mouthpiece, and one article brought him into conflict with the establishment, but also made him a popular hero. He was imprisoned and exiled for his principles, but gained a reputation as a champion of freedom – 'Wilkes and liberty' was a popular cry of the time. The statue was proposed by Dr James Cope, who gathered support for it in the City and Fleet Street. The chosen sculptor was James Butler, and Dr Cope unveiled the statue in 1988. Wilkes stands as if making a speech to Parliament, holding a sheaf of papers in his left hand, on the underside

of which are the words, 'A Bill for a Just and Equal Representation of the People of England'. The sculptor studied existing portraits of Wilkes, and has included his well-known squint.

North of Fleet Street, in Gough Square opposite Dr Johnson's House, is a statue of **Hodge**, Johnson's cat. Johnson had several cats, but he was very fond of Hodge, which he described to Boswell as 'a very fine cat indeed'. Hodge is sitting on a copy of Johnson's *Dictionary* – which was created at 17 Gough Square – next to a couple of oysters, which Johnson used to buy for it. The sculpture is the work of Jon Bickley, and it was unveiled by the Lord Mayor in 1997. It was paid

for by Richard Caws, and dedicated to his grandfather, Byron C. Caws, who had worked on the *Concise Oxford Dictionary*.

On the north side of Fleet Street, opposite Whitefriars Street, and somewhat incongruously over a sandwich bar, is a statue of **Mary, Queen of Scots** (1542–87), who was considered a threat to the English throne and executed on the order of Elizabeth I. Despite numerous persistent legends to the contrary, she never set foot in London. The sculptor is not known, but the statue is an integral part of a Gothic building erected in 1905 by R. M. Roe for Sir Tollemache Sinclair, who was an ardent admirer of the queen.

On the south side of the street, almost

Outside Dr Johnson's House is a statue of Hodge, his favourite cat.

Mary, Queen of Scots adorns the façade of a sandwich bar in Fleet Street.

opposite, on what used to be the *News Chronicle* building, is a bust of **Thomas Power O'Connor** (1849–1929), the Irish journalist and politician. O'Connor wrote for several different newspapers, and even created a few of his own. He was elected MP for Galway in 1880 and was a member of the Parnell party. The bust, by F. W. Doyle-Jones, was unveiled in 1936 by Lord Camrose, owner of the *Daily Telegraph,* for which O'Connor had worked.

In Salisbury Square, to the south of Fleet Street, is the **Waithman Memorial.** The granite obelisk commemorates the radical politician Robert Waithman (1764–1833), who served as MP for the City and was Lord Mayor in 1823–4. The memorial was designed by James Elmes, and was originally erected in 1833 in Farringdon Street, close to the location of Waithman's draper's shop, but in 1951 it was moved to Bartholomew Close in Aldersgate. In 1975 it was moved to its present location, which is close to where Waithman and his wife are buried in St Bride's Church. In 1990, following the redevelopment of the square, the memorial was dedicated to mark the eight-hundredth anniversary of the mayoralty of the City of London.

In the north-west corner of Ludgate Circus is a bronze plaque with a relief profile of **Edgar Wallace** (1875–1932),

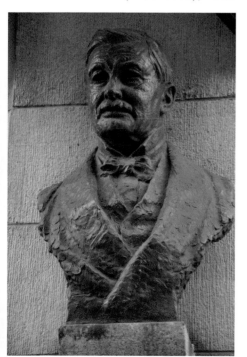

O'Connor was both politician and journalist.

A plaque to Edgar Wallace near the spot where he sold newspapers as a boy.

the journalist and author. Wallace's life story is a classic 'rags to riches' tale. As a young man, one of his many low-paid jobs was selling newspapers in Ludgate Circus. He started writing while in South Africa during the Boer War, and on his return to England worked as a reporter on the *Daily Mail*. He soon started writing his series of best-selling thrillers, which he was able to turn out at a phenomenal rate; he is said to have written one novel in just three days! He died in Hollywood, where he was working on the film *King Kong*. The memorial, by F. W. Doyle-Jones, was erected in 1934, near the spot where he used to sell newspapers.

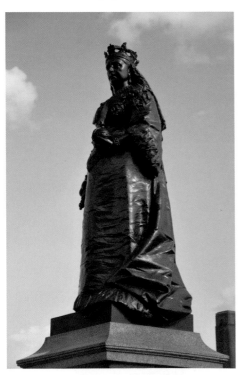

Queen Victoria stands on Blackfriars Bridge, which she opened in 1869.

At the north end of Blackfriars Bridge, looking up New Bridge Street, is a statue of **Queen Victoria** (1819–1901) by Charles Bell Birch. It was presented to the City of London by Sir Alfred Seale Haslam, a City Liveryman. The City assumed that Haslam had commissioned the statue from Birch, but they later discovered that there were other versions of the statue in Aberdeen as well as Adelaide in Australia, and that the marble original had been erected in 1889 at Udaipur in India to celebrate the queen's Golden Jubilee. The statue was erected in 1896 on an island between the Embankment and Queen Victoria Street and was unveiled by the Duke of Cambridge. The road layout at the north end of Blackfriars Bridge has been changed on a number of occasions, so the statue has been moved several times.

In the middle of the road, close to the junction of Holborn with the Gray's Inn Road, is the memorial to the **Royal Fusiliers (City of London Regiment)**, in memory of the 22,000 officers and men of the regiment who died in the First World War. It is the work of Albert Toft, and was unveiled by the Lord Mayor in 1922. New inscriptions were later added to include those who died in the Second World War and in later campaigns.

The red brick and terracotta building on the north side of Holborn was built for the Prudential Assurance Company. At the rear of the internal courtyard is a bust of **Charles Dickens** (1812–70). This was the site of Furnival's Inn, where Dickens lived from 1834–7, and where he wrote part of *The Pickwick Papers*. The bust is of 'Kupronised' plaster and

The Royal Fusiliers memorial stands in the middle of the road in Holborn.

was made by Percy Fitzgerald, who was a personal friend of the author. It was erected in 1907, originally under the entrance archway. It is currently not seen to its best advantage, as it is encased in an ugly acrylic box, presumably for security reasons. It may seem odd that this modest sculpture is almost the only London memorial to the great writer, but Dickens stipulated in his will that he did not want to be 'the subject of any monument, memorial or testimonial whatever', as he wished to be remembered only by his writing.

Overlooking Holborn Circus is a bronze equestrian statue of **Prince Albert** (1819–61) by Charles Bacon. It was a gift to the City from an anonymous benefactor, generally considered to be Charles Oppenheim, a rich merchant. The site was chosen because the statue could be seen from the many streets radiating from the Circus. The prince is dressed in the uniform of a Field Marshal and he raises his hat as if returning a salute. On either side of the granite plinth are bronze reliefs, one showing the prince opening the Royal Exchange, the other with Britannia giving out awards at the Great Exhibition of 1851. At each end are bronze statues – Peace, holding a palm branch, and History, recording the history of the Prince's life in a book. The statue was unveiled in 1874 by the Prince of Wales. Charles Bacon is a rather obscure sculptor, and the statue was not particularly well received. The *Art Journal* said rather pointedly that, 'on the principle that one must not too narrowly examine a gift horse, we abjure criticism'.

When Queen Victoria opened Holborn Viaduct in 1869, there were buildings at the four corners, each with a niche containing a stone statue of an important figure from the City's history, all created by Henry Bursill. The two on the north side were destroyed by bombs during the Second World War, but the one at the north-west corner was recreated in 2000 and the north-west pavilion was rebuilt in 2015. The statue on the south-west building is of **Henry FitzEylwin** (or FitzAylwin), the first Mayor of London, a position he held from around 1189 until 1215. On the south-east building is a statue of **Sir Thomas Gresham** (1519–79), who founded the Royal Exchange. The building at the

The equestrian statue of Prince Albert overlooks busy Holborn Circus.

north-west corner carries a rather clumsy replica of Bursill's statue of **Sir William Walworth** (d. 1385). Walworth was Lord Mayor of London, and is famous for bringing about the end of the Peasants' Revolt by stabbing Wat Tyler. The fourth building has a statue of **Sir Hugh Myddleton** (c. 1560–1631), founder of the New River Company, which brought a supply of fresh water into the City.

The statue of William Walworth on a building overlooking Holborn Viaduct.

THE CITY: CENTRAL

IN FRONT OF St Paul's Cathedral is a statue of **Queen Anne** (1665–1714). The original statue was by Francis Bird, and it was erected in 1712 to commemorate the completion of Wren's new church. By the 1870s the statue was in a very poor condition, and was considered by many to be an eyesore and a disgrace to the City, so in 1884 the authorities decided to replace it with a replica. The sculptor Richard Belt was asked to produce the statue in Sicilian marble. Belt was a controversial choice, as he had recently won a protracted libel case over the statue of Byron (see page 107). In fact Belt carried out very little of the work before withdrawing, as he was convicted and imprisoned for fraud, though he later tried unsuccessfully to have his name inscribed on the finished statue. The completion of the work was supervised by Louis-Auguste Malempré, and it was unveiled in 1886 by the Lord Mayor. The queen stands on a tall plinth, wearing the Order of St George and holding an orb and sceptre. Around the statue are allegorical figures representing Britain, Ireland, America and France, of which she was still considered to be sovereign. Britannia carries a trident, Ireland a harp and France a truncheon and

crown. The figure of America holds a bow and has a quiver on her back, while her right foot rests on a severed head (said to represent a European), behind which is a curious lizard. The original statue was the subject of many satires, the most famous one, attributed to John Arbuthnot, the queen's physician, being the rhyme:

> Brandy Nan, Brandy Nan, you're
> left in the lurch
> Your face to the gin-shop, your back
> to the church.

Bird's statue was taken to a stonemason's yard to be broken up, but was rescued by the writer Augustus Hare, who had it installed in the grounds of his country house in Sussex, where it remains to this day.

To the north is the old **Temple Bar**, which now acts as a gateway into the modern Paternoster Square development. It is the only surviving City gateway, and until 1878 stood where the Strand meets Fleet Street. It is thought to have been designed by Sir Christopher Wren and was built of Portland stone in 1672 to replace the old timber gate. For a time during the

Queen Anne donated the marble for her statue outside St Paul's Cathedral.

Charles I, Charles II, James I and his queen, Anne of Denmark, were restored, and new statues of the royal beasts and coats of arms were carved by Tim Crawley. Temple Bar was officially opened by the Lord Mayor in 2004.

By the north transept of St Paul's Cathedral is a statue of **John Wesley** (1703–91), the founder of Methodism. It is a copy of an earlier sculpture by Samuel Manning the Elder and his son, and it was commissioned to celebrate the 250th anniversary of Wesley's conversion in 1738, and erected here in 1988. The statue's location may seem surprising, especially as there is another statue of him outside Wesley's Chapel (see page 214), but Wesley

eighteenth century the heads of traitors were displayed on spikes on top of the arch. By the late nineteenth century it had become an obstruction to road traffic and was removed, to be replaced by the present Temple Bar Memorial (see page 69). It was dismantled carefully and the stones were stored, though no one could decide what to do with it. Ten years later it was bought by Lady Meux, who had it rebuilt at Theobalds Park, the family estate in Hertfordshire. Over the years its condition deteriorated and plans were made to return it to the City. It needed a considerable amount of restoration and the whole project cost over £3m. The four statues by John Bushnell, of

Temple Bar is now the gateway to Paternoster Square.

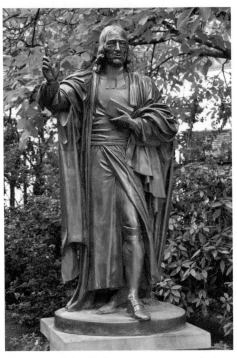

The statue of John Wesley was erected to mark the 250th anniversary of his conversion.

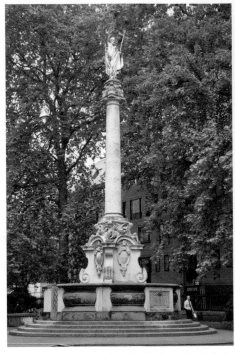

Paul's Cross in the churchyard of St Paul's Cathedral.

used to attend services at St Paul's on a regular basis.

In the north-east corner of the churchyard once stood **Paul's Cross**, an open-air pulpit which had served since the twelfth century as a place for sermons to be given and important national declarations to be made. It was destroyed by the Puritans in 1643, but in 1874 its foundations were uncovered, and it is now marked by a plaque by the north-east corner of the cathedral. When Henry Charles Richards, MP and amateur archaeologist, died in 1905, he left money in his will for the cross to be rebuilt. As a reproduction of the medieval pulpit would be stylistically incongruous

alongside Wren's cathedral, Sir Reginald Blomfield was commissioned to design a memorial to it instead, and it was unveiled in 1910. At the top of a column of Portland stone stands a gilded statue of St Paul, the work of Bertram Mackennal. The bronze plaque on the north side proclaims the cross to be in memory of the Richards family.

In the south-east garden is a sculpture of **St Thomas Becket** (1118–70) by Edward Bainbridge Copnall. It is an appropriate site, as Becket was born in nearby Cheapside, where the Mercers' Hall now stands. The statue was originally created for the eight hundredth anniversary of Becket's death in

A modern statue of London's saint, Thomas Becket, on the south side of St Paul's.

Canterbury Cathedral, but was acquired by the City Corporation in 1973. It is made of fibreglass resin, but made to look like bronze. It shows the saint falling with arms raised as if fending off the blows of the four knights who murdered him.

In a garden to the south of the cathedral is a bust of **John Donne** (1572–1631), the great poet who was born in nearby Bread Street and was Dean of St Paul's Cathedral, where he is buried. The sculpture is by Nigel Boonham, and it was erected in 2012. The poet is looking over his left shoulder towards his birthplace. Lines of his poetry are inscribed on the plinth.

On the south side of St Paul's Cathedral, at the top of Peter's Hill, is **Blitz, The National Firefighters' Memorial**, which remembers the men and women of the Fire Service who gave their lives to defend the country during the Second World War. Winston Churchill referred to them as 'heroes with grimy faces'. Its location is most appropriate, as the area around the cathedral was subjected to massive bombing during the war, and the cathedral itself was only saved by the dedication and bravery of firewatchers. The

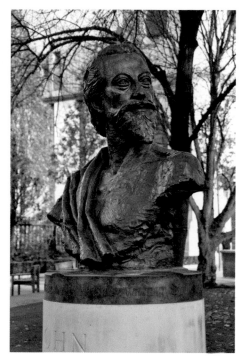

The bust of poet John Donne outside St Paul's Cathedral.

memorial is the work of John Mills, and depicts three firemen, a sub-officer and two branch-men, working as a team to put out a fire. The two figures holding the hose are from a photograph taken in Cannon Street in 1941, and the standing figure is based on Cyril Demarne, who had been a fire officer in the war, and who had the idea for the memorial. The statue was unveiled in 1991 by Queen Elizabeth the Queen Mother. At first the octagonal plinth carried the names of the 1,027 firefighters who had died, as well as reliefs of two female firefighters. In 2003 the plinth was doubled in height to add the names of 1,192 firemen who died in action during peacetime, and the

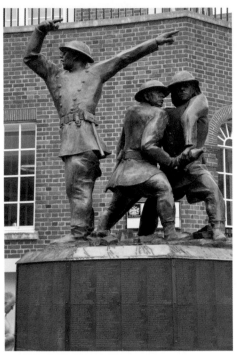

The Firefighters' Memorial commemorates members of the fire services who have died on duty.

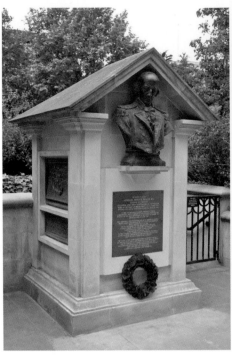

Admiral Phillip founded the colony of Australia in 1788.

memorial was re-dedicated by the Princess Royal.

East of St Paul's, in Watling Street, is a memorial to **Admiral Arthur Phillip** (1738–1814). Phillip was the first Governor of Australia, which he founded at Sydney Cove after arriving with a fleet of eleven ships carrying 240 marines and 760 convicts. There were to be many problems in setting up the new colony, but his humane rule meant that it survived, and by the time he returned to England in 1792 it was well established, and was later to become New South Wales. The memorial was unveiled in 1932 by the Duke of Kent at the Church of St Mildred, Bread Street, the parish in

which Phillip was born. The church was destroyed in the Blitz, but the bronze parts of the memorial were salvaged from the ruins. In 1968 it was re-erected on the wall of Gateway House in Cannon Street, but when the building was replaced it was moved to its present location in 2000. The original bust, by C. L. Hartwell, is now in St Mary-le-Bow Church, and that on the memorial is a resin copy.

Further along Watling Street is the statue of a **Cordwainer**, by Alma Boyes, in the heart of the ancient Ward of Cordwainer. A cordwainer was a shoemaker and in medieval times this area was the centre of the shoemaking trade.

The statue of a cordwainer in Watling Street.

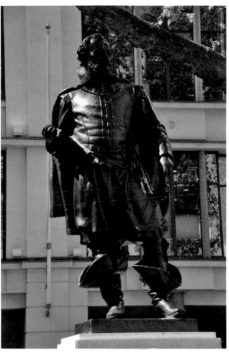

John Smith is best known for having been saved by Pocahontas.

The word derives from the top-quality leather which was imported from Córdoba in Spain. The statue was unveiled in 2002 in Bow Churchyard, and moved here a few years later.

In Bow Churchyard is a statue of **Captain John Smith** (1580 1631). Smith was on the 1607 expedition to Virginia, where he was elected president of the settlement. He attempted to make contact with the indigenous population, but was captured by Powhatan, whose daughter, Pocahontas, famously saved Smith's life. The statue is a copy by Charles Renick of an original by William Couper in Jamestown, and it was presented to the City by the Jamestown Foundation of Virginia to commemorate the 350th anniversary of Smith's return from Virginia. The location for the statue was chosen because Smith was a cordwainer, though nearby St Sepulchre's Church was also suggested, as that is where he is buried. Smith is shown in a swaggering pose, wearing seventeenth-century clothes. The statue was unveiled in 1960 by Queen Elizabeth the Queen Mother.

In Giltspur Street, on the wall of the watch house of St Sepulchre's Church, is a bust of **Charles Lamb** (1775–1834), the essayist, who wrote under the pen name Elia. Lamb spent most of his working life as a clerk in the East India Company, and

looked after his sister Mary who, in a fit of madness, had killed their mother. He had been educated at Christ's Hospital in Newgate Street, and the memorial was installed in 1935 on the west wall of Christ Church, which was the chapel of the school. The church was bombed in the Second World War, and only the tower and shell remain. In 1962 the memorial was moved to its present location. It is the work of Sir William Reynolds-Stephens.

On the early-eighteenth-century gatehouse to St Bartholomew's Hospital in West Smithfield is a statue of **Henry VIII** (1491–1547), probably by Francis Bird. The monastery and hospital were founded by Rahere in 1123, but after the dissolution of the monasteries by Henry, he re-founded the hospital in 1546. The statue is clearly based on Holbein's portraits of him, and was installed in about 1702. It has been restored on several occasions, and the gilded crown and sceptre are replacements added in 1988.

In King Edward Street, outside what used to be the General Post Office, stands a bronze statue of **Sir Rowland Hill** (1795–1879), the postal reformer who introduced the penny post and the postage stamp. Soon after his death a memorial fund was set up and twelve sculptors were invited to submit models for a statue,

Charles Lamb was educated at Christ's Hospital in Newgate Street.

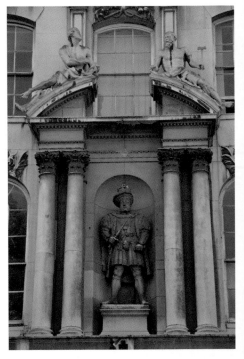

This sculpture on the gatehouse of St Bartholomew's Hospital is the only outdoor statue of Henry VIII in London.

which was to be set up behind the Royal Exchange. The winner of the competition was Edward Onslow Ford, and his statue was unveiled by the Prince of Wales in 1882. In 1920, it was removed to make way for a drinking fountain (which had to be moved from its site in front of the Royal Exchange to allow for the installation of the London Troops War Memorial). In 1923 it was relocated to its present position.

In Postman's Park (so named as it was much used by postmen before the nearby General Post Office closed down) is the **Memorial to Heroic Self-Sacrifice**, one of London's least known but most moving memorials. It was the brainchild

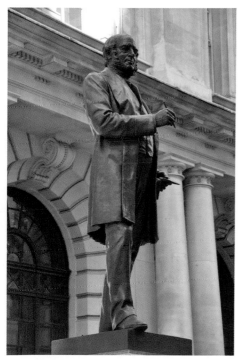

Sir Rowland Hill, who introduced the postage stamp, stands outside what used to be the General Post Office.

of the Victorian artist G. F. Watts (1817–1904), who wanted to celebrate 'heroism in every-day life' at a time when London was being flooded with statues to the great and the good. His original idea was put forward as a proposal to celebrate Victoria's Golden Jubilee in 1887, but it was not until 1900 that it came to fruition when this site became available. It was originally the joint graveyard of three churches, but had been converted into a public garden in 1880. The memorial consists of a 'cloister', with a tiled roof that protects plaques commemorating people who died saving others, in boating accidents, house fires or train crashes. The best known is probably Alice Ayres, a name adopted by a character in Patrick Marber's play *Closer,* and scenes from the screen version were filmed here. The first plaques were made by William de Morgan, but later ones were made by the Doulton factory. The first four plaques were unveiled in 1900 by the Lord Mayor, though Watts was too ill to attend. After Watts's death a terracotta plaque with a relief of the artist was added in the centre of the wall, made by T. H. Wren, one of the students at Watts's School of Arts and Crafts at Compton in Surrey. It shows him in a long gown, holding a scroll with the word 'Heroes' on it. Further plaques were added from time to time, many by Watts's widow, and by 1931 there were fifty-three memorials. In 2009 a new plaque was added, to Leigh Pitt, who died in 2007 saving a boy from a canal in Thamesmead.

In a garden off Love Lane, once the churchyard of St Mary Aldermanbury, stands the **Memorial to John Heminge**

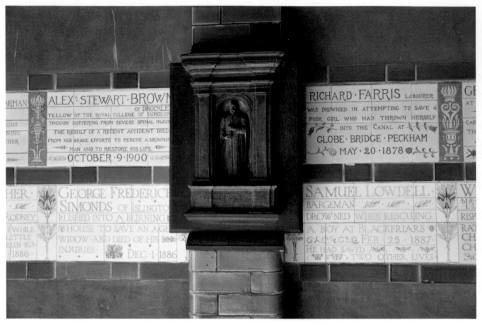

G. F. Watts's Memorial to Heroic Self-Sacrifice celebrates the heroism of ordinary people.

and Henry Condell. Although the memorial bears a bronze bust of Shakespeare, it actually commemorates Heminge (?1566–1630) and Condell (?1576–1627), rather than the playwright. They were both actors and close friends of Shakespeare; they collected his works after his death and published them in the First Folio, without which many of his plays might have been lost to posterity. The location for the memorial was chosen because both men were parishioners and were buried in the churchyard. It was designed and donated by Charles C. Walker, an industrialist who had a great interest in Shakespeare, and the bust of Shakespeare is the work of Charles J. Allen. The memorial was erected in 1896, when Sir Henry Irving gave a speech.

Along the front of the Guildhall Art Gallery are four large busts in Portland stone of **Samuel Pepys, Oliver Cromwell, William Shakespeare** and **Sir Christopher Wren**. They were carved by Tim Crawley and installed in 1999 for the opening of the new gallery. The choice of subjects reflects their importance in the history of the City, and Cromwell is included because there was much support for him in the City during the Civil War. At the far left is a sculpture of **Dick Whittington and his Cat** by Lawrence Tindall, which was also commissioned for the Art Gallery. Whittington is shown standing by the milestone on Highgate Hill and is accompanied by his cat. Richard Whittington (c. 1350–1423) was a

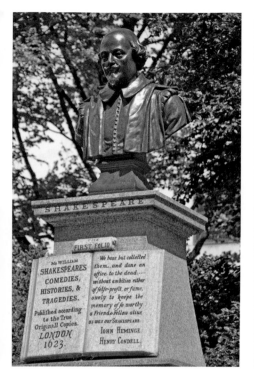

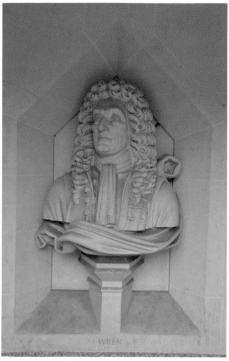

This memorial celebrates John Heminge and Henry Condell, who published the First Folio of Shakespeare's plays.

The bust of Sir Christopher Wren outside the Guildhall Art Gallery.

historical figure, though the reality and the legend have become somewhat confused over time. He was a wealthy mercer and moneylender who became Lord Mayor on four occasions. He was also a great philanthropist and left his fortune to charity; among other projects he rebuilt St Michael Paternoster Royal and paid for a public toilet at St Martin Vintry. The stories about his cat and hearing the Bow bells telling him to 'Turn again' are the stuff of legend, but are now somewhat hard to ignore.

THE CITY: EAST

IN FISH STREET Hill, to the east of the northern approach to London Bridge, is **The Monument**, built by Sir Christopher Wren and Robert Hooke as a memorial to the Great Fire of London, which in

After six people committed suicide from the gallery of The Monument, an iron cage was added.

September 1666 devastated vast areas of the city. It was completed in 1677 and stands on the site of St Margaret Fish Street, the first of eighty-seven churches to be destroyed in the conflagration. Its height of 202 feet is the distance to the bakery in Pudding Lane where the fire started. It takes the form of a fluted Doric column on a tall pedestal, all made of Portland stone, and inside are 311 steps up to a viewing gallery, which offers panoramic views over the City. The column is surmounted by a gilded urn with a flaming orb, symbolising the Fire. The column now stands in a small space surrounded by tall buildings, but originally it stood prominently on the approach to the old London Bridge.

At the four corners of the pedestal are City dragons, carved by Edward Pearce, each with a St George cross on its wings. On three sides of the base are inscriptions in Latin, with brass plaques giving a translation. On the western side is a large relief sculpture by Caius Gabriel Cibber, which shows Charles II offering his protection to the City. It is a highly symbolic image, with the female figure of the City of London in distress on the left, supported by Time, and the king on

the right sending his attendants to offer help. Burning buildings can be seen in the background, and new buildings are being constructed to the right. In 1680 an inscription was added which made the false claim that the Fire was caused by 'the Popish Faction'. It was removed during the reign of James II, reinstated by William III, and finally removed in 1831, after the Catholic Emancipation Act was passed. The inscription can now be seen in the Museum of London. In 1733 Alexander Pope, who was Catholic, described the place 'Where London's column, pointing at the skies, Like a tall bully, lifts the head and lies'.

Both Wren and Hooke were members of the Royal Society, and the Monument was built in such a way that it could be used for a number of scientific experiments. The internal stairs were cantilevered from the outer wall, leaving a hollow centre so that it could be used for experiments with pendulums, and a trapdoor in the orb allowed it to be used as a telescope. The Monument did not prove to be suitable for this purpose, but the basement room built for the research is still there, and can be seen through a grille in the floor.

In the garden of Fishmongers' Hall, visible from the Thames Path to the west of London Bridge, is a marble statue of **James Hulbert** (d. 1719). Hulbert was Prime Warden of the Fishmongers' Company when he died, leaving money to build an extension to the company's almshouses at Newington Butts, where the statue, by Robert Easton, originally stood. The almshouses were demolished in 1851, and the statue was brought to London and set up here in 1978.

In 1997 a bronze sculpture of a **LIFFE Trader** by Stephen Melton was erected in Walbrook, commemorating fifteen years of the London financial futures market. It showed a trader from the London International Financial Futures Exchange, where trading used to be carried on in what were called 'pits', with much shouting and hand signals. The traders wore colourful striped jackets, as suggested by the texturing of the bronze. Ironically, the traditional form of trading was soon replaced by desk-based online trading, and LIFFE has been taken over several times in recent years. When the area to the west of Walbrook was being developed the sculpture was removed, and at the time of

The LIFFE Trader.

writing it is not certain if it will be given a new location near Walbrook or be re-erected in Dowgate Hill, where LIFFE used to operate.

At Bank junction, in front of the Royal Exchange, stands Sir Francis Chantrey's equestrian statue of the **Duke of Wellington** (1769–1852). It was commissioned by the City of London in recognition of the Duke's help in getting the London Bridge Approaches Act through Parliament in 1827, which could explain why the Duke is not depicted in military uniform. The suggestion for the statue was raised in 1836, and Chantrey and Matthew Cotes Wyatt were approached to produce it. At a meeting in 1837 the vote was tied, with the Lord Mayor's casting vote in favour of Chantrey. Wyatt was later to produce

his own, highly controversial, statue of the Duke for the Wellington Arch (see page 131). The statue was always planned to stand opposite the Mansion House, but the Royal Exchange burnt down in 1838. A further complication arose when Chantrey died of a heart attack in 1841. Fortunately, he had left finished models, so that his assistant, Henry Weekes, was able to complete the work. The triangular space in front of the new Royal Exchange was cleared of its buildings, leaving a suitable space for the erection of the statue, which was unveiled on 18 June, 1844, the anniversary of the Battle of Waterloo. The statue was not universally praised. *The Times* called the portrait of the Duke 'admirable', but criticised the 'indefinite character of the costume, which is neither quite antique

Chantrey's statue of the Duke of Wellington lacks a saddle and stirrups.

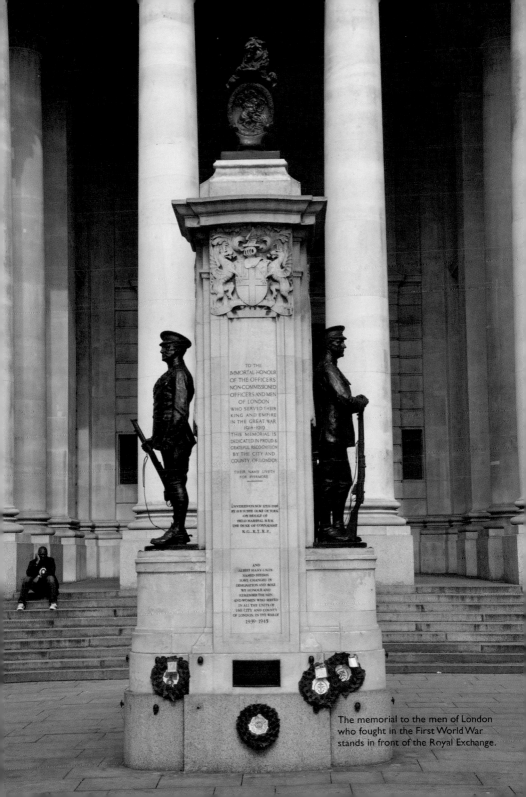

The memorial to the men of London who fought in the First World War stands in front of the Royal Exchange.

nor quite modern'. There were also those who disapproved of the lack of a saddle or stirrups, and the fact that the Duke was not wearing a hat.

In front of the main portico of the Royal Exchange is the **London Troops War Memorial**, which was designed by Aston Webb. It commemorates the men of London who served in the First World War. On either side of a Portland stone plinth are bronze statues of two soldiers, one young, the other middle-aged, the work of Alfred Drury. Surmounting the plinth is a lion holding a medallion of St George and the dragon. The memorial was unveiled in 1920 by the Duke of York. A new inscription was added to include those who fought in the Second World War.

In Cornhill is a monument to **James Greathead** (1844–96), the Chief Engineer of the City & South London Railway. He was the inventor of the Greathead Shield, which played an important part in the construction of the tunnels for London's underground railways. Greathead stands on a tall plinth which doubles as a ventilation shaft for Bank station below. On one side of the plinth is the coat of arms of the City & South London Railway, and on the other a relief of men working inside the tunnelling shield. The monument is the work of James Butler and was unveiled in 1994.

Standing in a niche in the curtain wall of the Bank of England in Lothbury is a statue of **Sir John Soane** (1753–1837), the great architect, whose best-known buildings in London are his house in Lincoln's Inn Fields, now a museum, and the Bank of England itself. Only the windowless external walls of his Bank remain, following reconstruction by Herbert Baker in the 1930s. It was

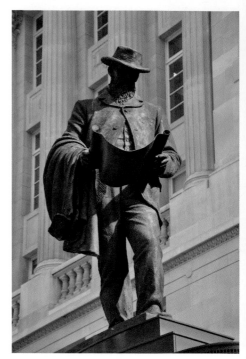

Greathead's Shield helped to build London's underground railways.

at Baker's suggestion that William Reid Dick was commissioned to produce the statue, which is of Portland stone. Soane is shown in a long cloak, holding plans and a set square in his left hand. The niche is decorated with typical motifs used by Soane in his architecture.

In niches on the north wall of the Royal Exchange are statues of **Sir Hugh Myddelton** (?1560–1631) by Samuel Joseph and, on the right, **Richard Whittington** (d. 1423) by John Edward Carew. They were added in 1844 to the new Royal Exchange, chosen as having provided important services to the City in their day. In a niche high up on the clock

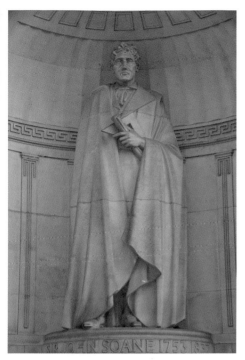

The Bank of England refused to pay for any ceremony when Sir John Soane's statue was installed in 1937.

Thomas Gresham founded the Royal Exchange.

tower at the east end of the building is a statue of **Sir Thomas Gresham** (?1519–79) by William Behnes, which was installed in 1845. Gresham was the founder of the first Royal Exchange, based on the Bourse in Antwerp, which enabled merchants to meet there to do business.

At the northern end of Royal Exchange Buildings is a statue of **George Peabody** (1795–1869), the American banker and philanthropist. A self-made man, Peabody first visited England as a partner in an importing business, and later settled here permanently. He became a successful merchant banker, entertaining the great and the good at sumptuous banquets, and spending his fortune on charitable activities. He is now best known for the Peabody Buildings, model dwellings for the working classes which can still be seen all over London. The statue, erected only a few months before his death, is by William Wetmore Story, an American sculptor, and it was unveiled by the Prince of Wales. A copy of the statue was erected in Baltimore in 1888.

A few yards away is the striking memorial to **Paul Julius de Reuter** (1816–99), who founded the news agency which still bears his name, and which first operated from Royal Exchange Buildings in 1851. It was erected in 1976 to commemorate the 125th

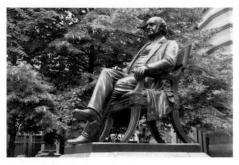

The sculpture of George Peabody stands behind the Royal Exchange.

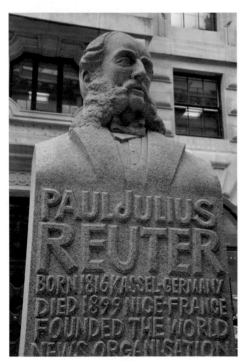

This sculpture of Reuter stands close to where his news agency first operated.

anniversary of the service's foundation. The monumental head, with its abundant whiskers, was sculpted by Michael Black in Cornish granite.

Outside the southern entrance to Liverpool Street Station is the poignant monument to the **Children of the Kindertransport.** It remembers the nearly ten thousand Jewish children who, following persecution in Germany in 1938, were allowed into Britain on temporary visas. They stayed with foster families or in hostels and most never saw their families again. After their ships docked at Harwich, they were dispersed throughout Britain, and many took the train into Liverpool Street Station. A memorial by Flor Kent was erected in 2003, a bronze statue of a girl standing next to a huge glass suitcase containing authentic personal items carried by the children. The objects began

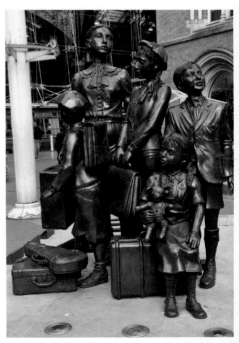

The *Kindertransport* monument remembers the thousands of Jewish children who arrived in Britain in 1938 to escape Nazi persecution.

94

to deteriorate, and in 2006 the memorial was replaced by the current sculpture by Frank Meisler, who was himself a child of the *Kindertransport*. It shows five children, each with a suitcase and wearing a number tag, in front of a piece of railway track, and on both sides are the names of German towns they came from. In 2011 Flor Kent's statue, accompanied by a boy, called **Für das Kind-Displaced**, was erected inside the station, by the entrance to the Underground.

At 31 Jewry Street, off Aldgate High Street, is the headquarters of the **Sir John Cass** Foundation. High up on the façade is a replica of Roubiliac's statue of Sir John Cass (1661–1718), which shows him in his Alderman's robes. Cass was a rich City merchant who, among many other charitable acts, endowed a school for poor children in Aldgate. The Foundation was set up in 1748, and in 1751 Roubiliac was commissioned to produce a statue to stand on the façade of the school. The statue was moved in 1869 to its present site, but in 1980 it was taken to the Guildhall, where it can still be seen, and in 1998 it was replaced by the present copy. Sir John Cass's name lives on in the primary school in Aldgate, a secondary school in Tower Hamlets and departments in the City University and London Metropolitan University.

In the churchyard of St Olave, Hart Street is a bust of the famous diarist **Samuel Pepys** (1633–1703). It is the work of Karin Jonzen and was commissioned by the Samuel Pepys Club. It originally stood in the garden in Seething Lane, which was the site of the Navy Office, where Pepys worked and lived from 1660 until 1673, when it burnt down. It was in his garden that he buried his important papers, along with a valuable Parmesan cheese, when the Great Fire of 1666 was at its height.

Sir John Cass founded a school for poor children in Aldgate.

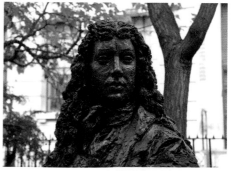

This bust of the famous diarist Samuel Pepys stands in St Olave's churchyard.

The Mercantile Marine Memorial on Tower Hill commemorates the men from the Merchant Navy who lost their lives in the two wars.

The sculpture was moved to the churchyard when construction of a new hotel began, and it is hoped it will be re-erected close to its original location.

The final part of this chapter is technically not in the City of London, but just outside its borders; however, it is more convenient for it to be included here. On Tower Hill is the **Mercantile Marine Memorial**, which commemorates the men of the Merchant Navy and fishing fleets who lost their lives in the two World Wars. The columned pavilion overlooking the road was designed by Sir Edwin Lutyens and was unveiled in 1928 by Queen Mary. The names of the twelve thousand dead are inscribed on bronze plates on both the exterior and interior walls. Behind is a sunken garden to remember the twenty-five thousand men who died in the Second World War. It was designed by Edward Maufe as a sympathetic extension to the earlier memorial, and has sculpture by Charles Wheeler. At the entrance to the garden are the figures of an officer and a seaman, both in greatcoats. The names of the fallen are listed on bronze plaques lining the walls of the garden, and between them are sculptures representing the Seven Seas. This extension to the memorial was unveiled in 1955 by the Queen.

To the east of Tower Hill station, standing in front of a section of the old City wall, is a bronze statue of the **Emperor Trajan** (53–117). It is a twentieth-century

The statue of Trajan in front of the old City wall at Tower Hill is a twentieth-century replica.

The statue of the Building Worker is the focus for International Workers' Memorial Day every April.

copy of a marble statue in Naples, and was discovered in a scrapyard by 'Tubby' Clayton, the rector of All Hallows Barking, and founder of Toc H, a Christian charity. It was placed here in 1980.

On the south side of Tower Hill is the **Building Worker** by Alan Wilson. The statue was commissioned by the Union of Construction, Allied Trades and Technicians to celebrate the work of construction workers and to remember the thousands who have died on building sites. The pose is based on Michelangelo's *David,* but the worker wears a hard hat and carries a spirit level. The statue has proved controversial, partly because of its prominent position, but it seems apt that he faces the City, where so many new buildings have been built in recent years. The statue was unveiled in 2006 by Ken Livingstone, Mayor of London, and Alan Ritchie of UCATT. Wreaths have been left each year on 28 April, International Workers' Memorial Day.

SOHO

O N THE SOUTH side of Piccadilly Circus is one of London's best loved, but least understood, memorials. It is usually referred to as **Eros**, but it should more correctly be called the **Shaftesbury Memorial**, as it is a monument to the great Victorian philanthropist **Anthony Ashley-Cooper, 7th Earl of Shaftesbury** (1801–85), after whom Shaftesbury Avenue is also named. A devout Christian, he was known as the 'poor man's Earl', as he spent much of his political career improving the conditions of factory workers. Soon after his death, plans were made to commemorate his life, and Edgar Boehm was approached to produce a statue, though Boehm instead suggested his pupil, Alfred Gilbert, for the commission. Gilbert was a key figure in what was known as the New Sculpture movement, and he said that he would not be willing to produce something conventional, in what he called the 'coat-and-trousers style'. He preferred to produce something symbolic of Shaftesbury's life and work, so he was commissioned to produce a memorial drinking fountain instead. He had trained in Paris, and his style always had a uniquely tactile, sensuous quality. He later claimed that he 'designed the fountain so that some sort of imitation of foreign joyousness might find place in our cheerless London'.

The bronze fountain is octagonal, with two levels of basins, and covered in lively organic detail. Water used to flow from the mouths of fish held by the 'merbabies', and aluminium cups were originally provided,

The Shaftesbury Memorial in Piccadilly Circus.

A detail of the fountain of the Shaftesbury Memorial.

be cast fairly cheaply, and it was modelled on Gilbert's assistant, the fifteen-year-old Angelo Colorossi. Around the base of the fountain is an inscription extolling the virtues of Lord Shaftesbury, composed by Gladstone. Originally a bust of Shaftesbury, produced by Boehm, was installed on the stone wall surrounding the monument, but it was felt to be out of character and was later removed.

When it was unveiled in 1893 by the Duke of Westminster, the memorial had a mixed reception. Some called it an exquisite work of art, while others declared it to be obscene or 'a big joke'. There were also complaints about the water drenching passers-by, and the water supply was soon turned off. Though it has functioned intermittently as a fountain, it is now many years since water has flowed from it. The fountain was certainly popular with Londoners, and it was soon a place where people gathered and flower sellers and newspaper vendors stood around it selling their wares.

Although this is Gilbert's most famous work, it was far from being a financial success for him, and he described it as 'both my crown of thorns and my crowning glory'. When he accepted the commission, the Government had promised to supply him with bronze from old cannons, but this was not forthcoming, and Gilbert had to buy the metal himself. In the end he spent about £7,000 on the work, but was paid only £3,000 for it. This caused him considerable financial hardship, and in 1908 he went into self-imposed exile in Bruges for nearly twenty years.

It is a much travelled monument. During the First World War the figure of Eros was removed for its protection after the first air

but they were soon stolen. Surmounting the structure is the winged figure Eros, or the Angel of Christian Charity, though Gilbert himself referred to it as Anteros, the symbol of selfless love. It is perched on one leg and about to shoot an arrow downwards, and it has been suggested that this is a play on the name Shaftesbury, as he is burying his shaft in the ground. Although the story is said to have come from Gilbert himself, he later denied it. According to Gilbert, the symbolism of the figure was to show 'blindfolded Love sending forth indiscriminately, yet with purpose, his missile of kindness'. The figure was the first public sculpture to be made of the new metal, aluminium, which could now

raid. During the 1920s it was taken away while the new Underground station was built, and Eros was displayed in the Victoria Embankment Gardens, returning in 1931. For the duration of the Second World War, Eros was in storage in Egham, while the rest of the fountain was protected by sandbags. In the 1980s Piccadilly Circus was redeveloped, with a new road layout, which did away with the central island, and Eros was moved to its present location in front of the Criterion theatre.

As aluminium is not as strong as bronze, the statue of Eros has suffered damage on a number of occasions, and it has had to be removed for repairs several times. Piccadilly Circus is much frequented by New Year's Eve revellers and football fans, who climb onto the figure of Eros, and it is often boarded up during major events to prevent any further damage.

High up on the façade of Soho Parish School in Great Windmill Street is a bust of the **14th Earl of Derby** (1799–1869), rather incongruously just a short walk from the old Windmill Theatre, once famous for its nude revues. The building was originally the St James's and St Peter's School, which was built as a memorial to the Earl, who

had been a major benefactor to St Peter's Church, which was demolished in 1954.

In the middle of Golden Square is a statue, dressed as a Roman emperor, which may be of **George II** (1693–1760). It has been in a poor condition for some time, and Dickens referred to it in *Nicholas Nickleby* as 'a mournful statue . . . the guardian genius of a little wilderness of shrubs'. The badly eroded Portland stone statue is said to be the work of John Van Nost, and probably came from the house of the Duke of Chandos at Canons. It may be one of the many allegorical figures which stood on the roof, but it was installed in the square in 1753 as a statue of the king.

In Soho Square is a statue of **Charles II** (1630–85) by the Danish sculptor Caius Gabriel Cibber. This sad wreck of a sculpture was once the principal element of a fountain

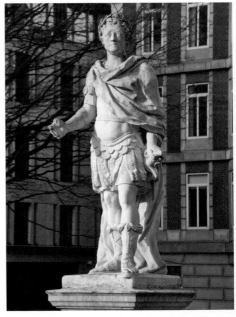

The weathered statue of George II in Golden Square.

The bust of the Earl of Derby in Great Windmill Street.

that was erected in the centre of the square in 1681. At its corners were statues of river gods representing the Thames, Severn, Humber and Tyne, and water flowed from jugs into a large basin, though, as the water was powered by a windmill in Rathbone Place, the flow could be somewhat irregular. By the nineteenth century the fountain was in a poor condition, and in 1875 it was replaced by the present half-timbered shed, while the statue was moved to the grounds of Grimsdyke, the house of the artist Frederick Goodall. The house was later owned by W. S. Gilbert (of Gilbert and Sullivan fame), and in 1938 his widow allowed the statue to return to the square, where it stands a little to the north of its original location.

In 1748 an equestrian statue of **George I**, made of lead, was installed in the gardens of what was then known as Leicester Fields (now Leicester Square). It may have been the work of John Van Nost and, like the statue in Golden Square, had come from Canons, the house of the Duke of Chandos, which was demolished in the previous year. By the middle of the nineteenth century the gardens had deteriorated badly, and the figure of the king had lost an arm and a leg, and the horse had to be supported with wooden props so that it did not topple over. The final insult came when it was painted white with black spots, making it a laughing stock. The statue was eventually removed, and in 1874 Albert Grant, the colourful MP for Kidderminster,

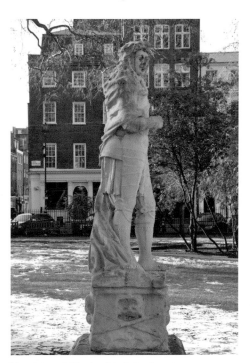

The statue of Charles II in Soho Square was once part of an ornamental fountain.

George I's statue in Leicester Square in 1866, by then a laughing stock and soon to be removed.

The Shakespeare fountain is the centrepiece of Leicester Square.

bought the square and paid for it to be completely refurbished and converted into a public square, beautified by statues, only one of which is still there today. Grant made his money by, among other things, selling shares in fraudulent businesses, but he finally went bankrupt and died in poverty. Leicester Square, however, is his legacy.

In the centre is a marble statue of **William Shakespeare** (1564–1616) by Giovanni Fontana, a copy of the memorial by Scheemakers in Westminster Abbey. It stands on a plinth in the middle of a fountain, whose dolphins spout water into the basin.

At the four corners of Leicester Square there were once busts of **Sir Joshua Reynolds**, **William Hogarth**, **John Hunter** and **Sir Isaac Newton**, all former residents of the area. They were part of

the 1874 design, but when the square was re-designed in 2010–12 the busts were removed and have not been re-erected. Although they had been damaged during an incompetent restoration in the 1990s, it would be a shame if the listed busts were not returned to their original location.

Beside Shakespeare stands a bronze statue of **Charlie Chaplin** (1889–1977) by John Doubleday, which was unveiled in 1981 by the actor, Sir Ralph Richardson. There were some objections to its location so close to Shakespeare but, given the square's intimate connections with the film industry, it could not be more appropriate. Chaplin was born in south London, but made his name in Hollywood, his most famous role being the Tramp, with his

A statue of Charlie Chaplin as the Tramp is at home in Leicester Square.

baggy trousers, derby hat and cane, which is how he is portrayed here.

In Charing Cross Road, behind the National Portrait Gallery, is a statue of **Sir Henry Irving** (1838–1905), the great Victorian actor-manager. For twenty-three years he ran the Lyceum Theatre, acting alongside Ellen Terry, with Bram Stoker, the author of *Dracula,* as his manager. Irving was considered to be the greatest actor of his time, and in 1895 he was the first actor to be knighted. The statue is by Thomas Brock and it was unveiled in 1910, paid for by 'actors and actresses and others connected with the theatre'. During the Second World War the statue was enclosed in a brick box to save it from bomb damage. In 1951 the garden that now surrounds it was opened by Sir Laurence Olivier. Every year, on a Sunday near the actor's birthday in February, The Irving Society holds a ceremony to place a wreath on the plinth. As the plinth is rather tall, this involves the use of a stepladder and a good aim.

At the junction of Cranbourn St and Great Newport St is a very unusual memorial to best-selling crime novelist **Dame Agatha Christie** (1890–1976). Her bust is inside a giant book, which is covered in motifs from her books, including Hercule Poirot and Jane Marple, as well as images from film and television adaptations and, of course, a mousetrap. The memorial is the work of Ben Twiston-Davies, and it was unveiled in 2012 to mark the sixtieth anniversary of her record-breaking play *The Mousetrap*, which is still running at the St Martin's Theatre nearby.

The statue of Sir Henry Irving is right in the heart of Theatreland.

The memorial to Agatha Christie includes her most famous characters.

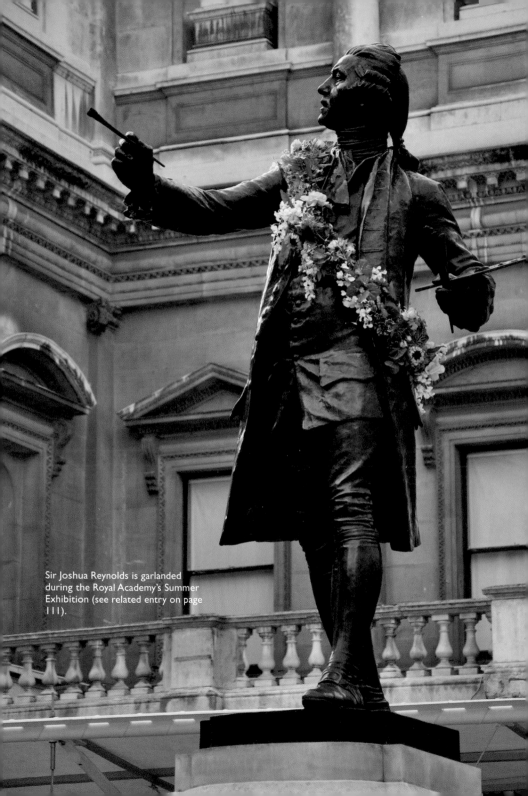

Sir Joshua Reynolds is garlanded during the Royal Academy's Summer Exhibition (see related entry on page 111).

MAYFAIR AND PARK LANE

O N A BUSY roundabout at the north end of Park Lane stands **Marble Arch.** It was designed by John Nash as a grand entrance to Buckingham Palace, which he was creating for George IV, but it was also a memorial to the nation's victories against Napoleon. Nash based his design on the Arch of Constantine in Rome, and it was made with white Carrara marble. It was to be lavishly decorated with sculpture, by Richard Westmacott and E. H. Baily, on military and naval themes to commemorate the victories at Waterloo and Trafalgar, and a bronze equestrian statue of the king

Marble Arch once housed one of London's smallest police stations.

was to stand on top. Work began in 1828, but two years later the king died, and the government insisted on economies being made on the work on the palace. Nash was sacked and replaced by Edward Blore who, to save money, ensured that little of the sculpture was installed on the arch, and George IV's statue was never to adorn it (it now stands in Trafalgar Square). Blore used some of Westmacott's sculpture to decorate the palace itself, and other pieces were used to adorn the new National Gallery, including Baily's Britannia, which stands over the east entrance.

The arch stood as an entrance to the courtyard of Buckingham palace for seventeen years, and then Blore was asked to enlarge the palace for Victoria's growing family. He added the east wing, enclosing the central courtyard, which meant that the arch no longer served any useful purpose. In 1851 it was re-erected at Cumberland Gate, in the north-east corner of Hyde Park, and for nearly sixty years it acted as a ceremonial entrance to the park. In 1908, a new traffic scheme left the arch isolated on an island in the middle of the road and, with the widening of Park Lane in 1960, the arch was marooned in the middle of a roundabout, the only access being via a network of subways. The area was refurbished again in 2009, and the subways were replaced by pedestrian crossings, so that it is now a more pleasant place to visit.

It is often said that the arch was moved because it was too narrow for the State Coach to pass through it, but this is quite untrue, as the Queen was driven through it at her coronation in 1953. In a parliamentary debate in 1850, the Chancellor of the Exchequer stated that the coach 'had passed through the arch where it stood now, and what it had done before it could do again'. It seems that the legend arose because in Nash's original design the arch was too narrow, though the error was spotted in time to be corrected.

Further down Park Lane, opposite Upper Brook Street, is the **Animals in War Memorial**. It pays tribute to the animals used by Britain in the wars of the twentieth century, including the many millions which died. It was the inspiration of the novelist, Jilly Cooper, who helped raise the money in a national appeal. The work was created by David Backhouse, and it was unveiled in 2004 by the Princess Royal. Two heavily laden bronze mules make their way towards a gap in a 70-foot curved wall of Portland stone, on which are carved animals such as camels, elephants and carrier pigeons. On the other side of the wall are bronze statues of a dog and a horse, who bear witness to the losses and walk towards a better future.

At the southern end of Park Lane is a bronze statue to the poet **Lord Byron** (1788–1824). During his lifetime Byron enjoyed great celebrity, but after his death his star waned, partly due to the many scandals associated with his private life. The Greeks have always revered him as a great patriot, as he died at Missolonghi fighting to free them from the Turks. In 1875 a committee was set up to consider a suitable memorial for the poet, and Richard Belt's design was chosen. In 1880 it was erected in the south-east corner of Hyde Park with an informal ceremony, as the 57-ton piece of *rosso antico* marble, which had been donated by the Greek Government for the base, had not yet arrived. The statue shows the poet sitting pensively on a rock,

The Animals in War Memorial in Park Lane.

accompanied by his favourite dog, Bo'sun. When Park Lane was widened into a dual carriageway in the 1960s, it swallowed up a huge slice of Hyde Park, and the statue was left isolated on the central reservation, ignored by most people and accessible only to the most intrepid.

Belt did not have a good reputation among his fellow sculptors, as they considered him to be an impostor, getting other people to carry out his work while he claimed the credit. Although the Byron statue carries his signature, in 1881 an article in *Vanity Fair* claimed that Belt was a fraud, suggesting that another sculptor, a Mr Verheyden, had designed and modelled the Byron statue. Another sculptor, Charles Bennett Lawes, repeated the accusation and in 1882 Belt took Lawes to court, accusing him of libel. The trial became a

Byron's statue stood in Hyde Park until Park Lane was widened in the 1960s.

major event and lasted two years. Although Belt finally won the case, controversy continued to follow him, as can be seen in his involvement with the statue of Queen Anne at St Paul's (see page 78).

Grosvenor Square has often been referred to as 'Little America', as it has had American connections since John Adams, the second President, lived at No. 9. The American Embassy has occupied the west side of the square since 1961, though it is due to move south of the river, when the embassy will become a luxury hotel. The square contains a number of important American memorials, all of which will remain after the embassy has moved. On the north side of the gardens is a bronze statue by Sir William Reid Dick of **President Franklin Delano Roosevelt** (1882–1945), the American President during the Second World War. It was unveiled in 1948 by Eleanor Roosevelt, his widow, who was accompanied by the American Ambassador, Clement Attlee, Winston Churchill and members of the royal family. The statue stands on a plinth of Portland stone, and the area around it was redesigned as a memorial garden. Roosevelt wears a long cloak and leans on a stick, suggesting the disability he suffered for much of his life. The memorial was the idea of The Pilgrims, an organisation that supported friendship between the two nations, and the money was raised from sales of a souvenir brochure to British citizens. The take-up was so great that the total cost was raised in just six days.

In the north-west corner of the square is a statue to **President Dwight D. Eisenhower** (1890–1969). During the Second World War, Eisenhower had his headquarters at nearby 20 Grosvenor

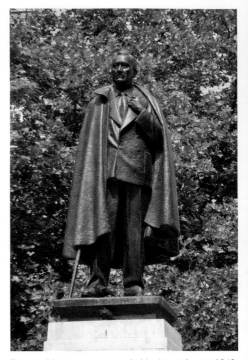

Roosevelt's statue was unveiled by his widow in 1948.

Square. The statue is by the American sculptor, Robert Lee Dean, and it was unveiled in 1989 by Prime Minister Margaret Thatcher and the American Ambassador, Charles H. Price. Eisenhower is shown in uniform, with hands on hips, in a typically informal pose. The statue was donated by the people of Kansas.

In the south-west corner is a 10-foot bronze statue of **Ronald Wilson Reagan** (1911–2004), the fortieth President of the United States. Reagan began his career as an actor, but later turned to politics, becoming a successful Governor of California before serving two terms as President, from 1981 to 1989. He is generally credited with helping to bring

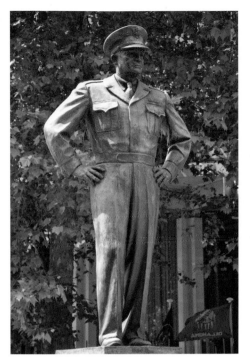

Eisenhower stands close to his Second World War headquarters.

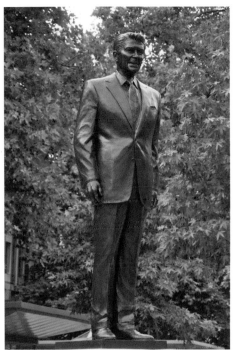

Reagan's statue was unveiled on Independence Day in 2011.

about the end of the Cold War. The statue is by Chas Fagan, an American sculptor who had already produced a statue of him for the US Congress. On a plaque are tributes from politicians of all persuasions, around a piece of the Berlin Wall, a potent symbol of the Cold War. The statue was unveiled on 4 July 2011, America's Independence Day and Reagan's one hundredth birthday.

On the south side of the square is the **Eagle Squadrons Memorial**, commemorating the American and British pilots who served in the RAF Eagle Squadrons in the Second World War. It is a tapering column of Portland stone, surmounted by a bronze eagle by Dame Elizabeth Frink, and was unveiled in 1986.

On the eastern side of the square is the **September 11 Memorial Garden**, which remembers the sixty-seven Britons who died in the terrorist attacks on the World Trade Centre in New York in 2001. It was opened by the Princess Royal in September 2003, on the second anniversary of the attacks.

On the south side of Hanover Square is Sir Francis Chantrey's fine statue of **William Pitt the Younger** (1759–1806), who was Britain's youngest ever Prime Minister at the age of twenty-four. His time in office coincided with the French Revolution and the start of the Napoleonic Wars, and he famously had a long-lasting political rivalry with Charles James Fox.

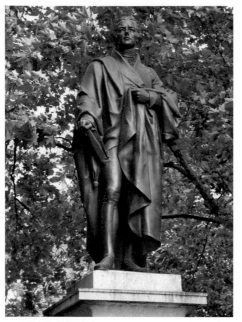

The statue of Pitt the Younger is said to be one of Chantrey's finest creations.

The statue was erected in 1831, during the disturbances of the Reform Bill; as Pitt was still considered to be the epitome of Toryism, Whigs tried to pull down the statue, but were prevented from doing so by Chantrey's workmen.

In New Bond Street, on the corner of Grafton Street, is an unusual statue called **Allies.** It consists of bronze figures of Franklin D. Roosevelt and Winston Churchill sitting on a bench having a friendly conversation. It was a gift from the Bond Street Association to the City of Westminster to commemorate fifty years of peace. The sculpture was created by Lawrence Holofcener and was unveiled in 1995 by Princess Margaret. It is one of London's most popular sculptures, as there is an inviting space between the two figures for people to sit and have their photograph taken.

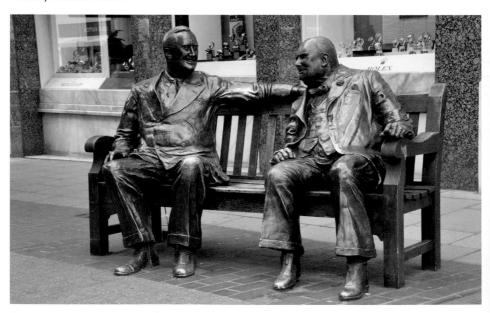

Allies in New Bond Street is one of London's most popular photo opportunities.

In the courtyard of the Royal Academy on Piccadilly is a bronze statue of **Sir Joshua Reynolds** (1723–92: see photograph on page 104). Reynolds was born in the village of Plympton in Devon, but rose to become the most sought-after portrait painter in London and became the first President of the Royal Academy in 1768. The sculpture is by Alfred Drury, who won the competition for the commission in 1917, but, as Drury was busy after the war creating memorials, it was not ready to be erected until 1931.

There was no formal unveiling, but it was installed on 10 December, which is the anniversary of the Royal Academy's foundation. The statue shows Reynolds in a rather theatrical pose, with palette and brushes in his left hand and another brush raised to put paint to canvas with his right hand.

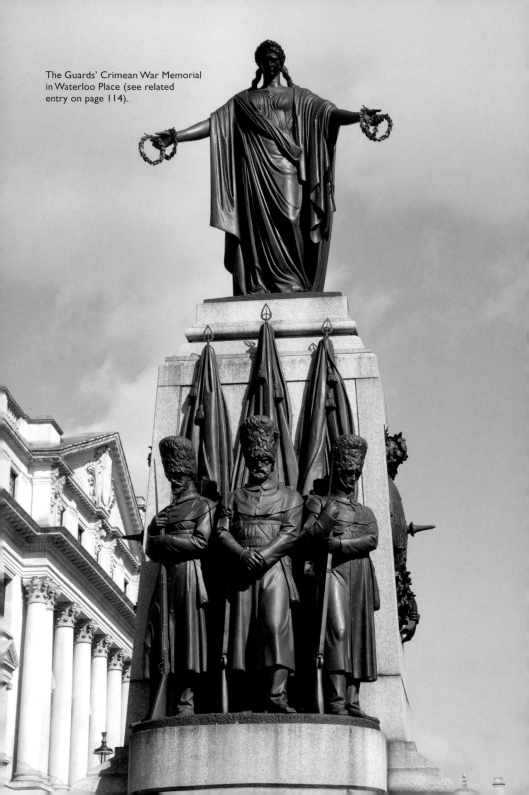

The Guards' Crimean War Memorial in Waterloo Place (see related entry on page 114).

ST JAMES'S

IN THE CENTRE of the gardens in St James's Square is a flamboyant equestrian statue of **William III** (1650–1702). Erecting a statue to the King was discussed several times during the century after his death, but nothing happened until 1794, when John Bacon the Elder was commissioned to produce a statue, using money left in the will of Samuel Travers. Bacon produced a model for the statue, but died in 1799, and the commission was completed by his son, John Bacon the Younger. It was installed, with no ceremony, in 1808. It is a splendid creation, and its Baroque style harks back to the seventeenth century, with the king in Roman armour, and the horse having the most luxuriant tail in London. The horse's left hind leg is raised above a small mound, which gives the effect of movement, but the mound has traditionally been called the molehill the horse tripped over at Hampton Court, causing the king's death. His opponents are said to have regularly toasted the health of the 'little gentleman in velvet'.

In 1975 the Libyan People's Bureau occupied No. 5 St James's Square, and it was the regular object of demonstrations. On 17 April 1984 there were around seventy protesters in the square, when there was a burst of gunfire from the second floor of the building and **WPC Yvonne Fletcher** fell to the ground. She was taken to hospital, but died soon after. After a ten-day siege,

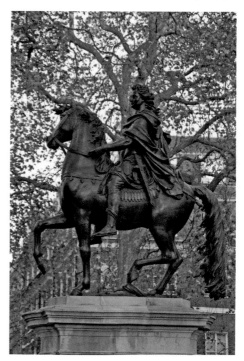

The flamboyant statue of William III in St James's Square.

There are always flowers by the memorial to WPC Yvonne Fletcher.

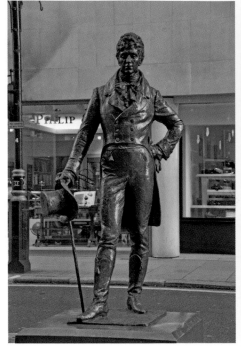

Beau Brummell flaunts his elegance in Jermyn Street.

those occupying the building were allowed to leave the country, and no one has ever been charged with the murder. In 1985 the simple memorial was unveiled by the Prime Minister, Margaret Thatcher, by the railings opposite No. 5. It was the first of a number of memorials to police officers killed on duty erected by the Police Memorial Trust.

In Jermyn Street, by the Piccadilly Arcade, is a statue of **Beau Brummell** (1778–1840). George 'Beau' Brummell was a dandy, a close friend of the Prince Regent and the greatest celebrity of his day. A leader of fashion, he dressed in an elegant, simple way and said, 'To be truly elegant one should not be noticed'. He lived in Mayfair, but shopped in St James's, at shops such as Lock's. His fall from favour at Court was sealed when he famously asked the person standing next to the prince, 'Who's your fat friend?' Gambling debts and excessive spending forced him to flee to France, where he died penniless. His statue, by Irena Sediecka, was unveiled in 2002 by Princess Michael of Kent.

In Piccadilly, over the door of a shop on the corner of Eagle Place, is a bust of **Sir Simon Milton** (1961–2011), who was leader of Westminster council from 2000 to 2008, before becoming Deputy Mayor of London, when he became responsible for city planning. The bust is by Alan Micklethwaite, and the background includes a relief of City Hall. Sir Simon lived here for a while, and one of his family's chain of patisseries, which he helped to run, was close by. He was considered to be a hugely influential politician, and this was the first of three monuments erected to him in London after his early death.

On the north side of Pall Mall, facing Waterloo Place, is the **Guards' Crimean War Memorial** (see photograph on page 112), which commemorates the 2,162 men from the Brigade of Guards who died

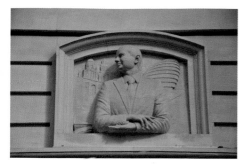

The bust of Sir Simon Milton in Piccadilly.

during the Crimean War in 1854–56. The sculptor was John Bell, and it was unveiled in 1860. The three figures of Guardsmen were cast from the metal of Russian guns and on the reverse of the plinth are real guns captured at Sebastopol. Surmounting the monument is the figure of Honour, her outstretched arms bearing wreaths. The memorial originally stood 30 feet further south, but in 1914 it was moved to allow the statues of Florence Nightingale and Sydney Herbert to be added.

Sydney Herbert, 1st Baron Herbert of Lea (1810–61) was Secretary for War when the Crimean War broke out. He soon became aware of the poor medical attention the soldiers were getting, and sent female nurses to help in the all-male hospitals, most famously Florence Nightingale. He is shown in his peer's robes, holding some papers and deep in thought. The plinth is particularly fine, made of grey and red granite, and with the Herbert coat of arms at its base. Around the plinth are three reliefs, showing Florence Nightingale visiting the Herbert Hospital, the Volunteer Force he set up and an Armstrong gun being manufactured. The statue, by John Foley, has not always stood here. In 1867

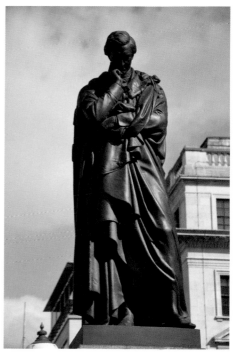

Lord Herbert's statue has been moved twice since it was unveiled in 1867.

it was unveiled by the Duke of Cambridge in front of the War Office in Pall Mall, but moved in 1903 to the new War Office in Whitehall, before finally being relocated here in 1915.

Florence Nightingale (1820–1910) is most famous for her important work at the hospital in Scutari, just outside Istanbul, during the Crimean War, where her sanitary improvements and good organisation saved many lives. She later founded a nursing school at St Thomas's Hospital, where there is a Florence Nightingale Museum, which tells her story. The statue is by Arthur George Walker, and shows her carrying a lamp, a reminder

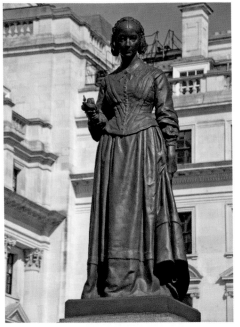

Florence Nightingale, the 'Lady of the Lamp'.

of her nickname 'The Lady of the Lamp', from when she walked the wards at night, though the lamp portrayed is quite unlike the type she would have used. Around the base are four reliefs: in one she stands at a door watching the arrival of wounded soldiers; in another she is working in a ward; in a third she meets senior officers; and the final panel shows her in old age surrounded by nurses.

The original plan for a National Monument to **Edward VII** (1841–1910) was for a massive architectural memorial, complete with symbolic sculptural groups, designed by the Australian-born sculptor, Bertram Mackennal. The scheme was abandoned on the advice of George V, and in 1912 Mackennal was commissioned to produce a more traditional equestrian statue to be set up in the centre of Waterloo Place, one of many erected nationally.

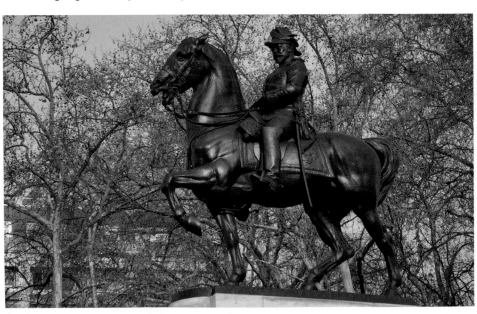

Edward VII's equestrian statue at the heart of Waterloo Place.

The space had been occupied by the statue of Lord Napier of Magdala since 1891 when, ironically, it was unveiled by the king when Prince of Wales, but it was moved to the north end of Queen's Gate to make way for the new statue. The production of the memorial to the late king was delayed by the First World War and the statue was not erected until 1921, when it was unveiled by George V.

Overlooking St James's Park is the impressive **Duke of York's Column**, a memorial to Prince Frederick, Duke of York and Albany (1763–1827), the second, and favourite, son of George III. In 1798 he was made Commander-in-Chief of the army in the war against Napoleon and, although he was not a great success in the role, he was popular with the soldiers, as he tried to improve their conditions. He will, however, be forever remembered as the 'Grand Old Duke of York' of the nursery rhyme, who 'marched his men to the top of the hill, then marched them down again'. The 112-foot granite column, designed by Benjamin Wyatt, was built from 1831 to 1834, and stands on the site of the Prince Regent's Carlton House. The statue, which weighs 7 tons, is by Sir Richard Westmacott and shows the duke in army uniform. The monument cost £30,000 and much of this was raised by docking every soldier in the army one day's pay. On his death, the Duke had massive debts, giving rise to the suggestion that he was put high up on a column to escape his many creditors, who were never paid what they were owed. The sculptor had originally wanted the statue to face Waterloo Place, but the Duke of Wellington insisted that, as Commander-in-Chief, he should be looking towards the

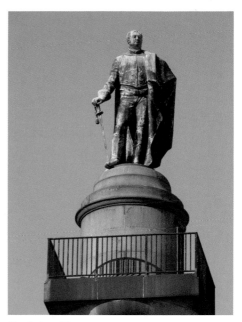

The Duke of York on top of his column.

War Office. On the park side there is a door which, until the 1870s, allowed people to climb to the top of the column, but since then it has been closed to the public.

On the eastern side of Waterloo Place, at the Pall Mall end, is a statue of the Antarctic explorer **Captain Robert Falcon Scott** (1868–1912). Scott had a successful expedition in the *Discovery* in 1900–4, but when, in 1910, he returned to Antarctica in an attempt to reach the South Pole, he discovered that Amundsen had got there before him, and he and his four colleagues perished on the return journey. The original choice for a memorial was a symbolic group of Courage sustained by Patriotism, but the task was then offered to the explorer's widow, Kathleen Scott. Her statue, showing him in a polar outfit, was unveiled in 1915 by Arthur Balfour,

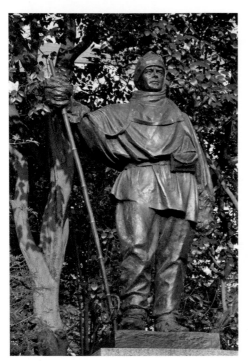

Captain Scott's statue was created by his widow.

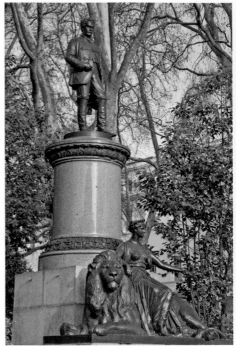

Clyde's claim to fame was the raising of the siege of Lucknow.

First Lord of the Admiralty. The original inscription only mentioned Scott, but in 1923 it was replaced by the current plaque, which gives the names of Wilson, Bower, Oates and Evans, who died with him.

Next is a memorial to **Colin Campbell, Lord Clyde** (1792–1863), an army officer who fought in the Peninsular War, the Crimea and India. He was most famous for raising the siege of Lucknow in 1857, an act which saved the British Empire in India. The statue is by Baron Marochetti and was erected in 1867. Campbell stands on a tall granite plinth, on which is the rather unusual sculptural group of Victory sitting on a lion, and holding an olive branch.

At the south-eastern corner is the statue of **John Lawrence, first Baron Lawrence** (1811–79), who dedicated his life to India. He played a major role in ending the Indian Mutiny, and was Viceroy of India from 1864 to 1869. The statue, by Sir Joseph Edgar Boehm, was erected in 1885, replacing an earlier controversial version installed in 1882. Boehm's original had Lawrence holding a pen in one hand and a sword in the other, based on a story that Lawrence had offered India the choice of how it should be governed. The original was sent to Lahore, where it proved equally unpopular, and it is now in Lawrence's old school, Foyle and Londonderry College, in Northern Ireland.

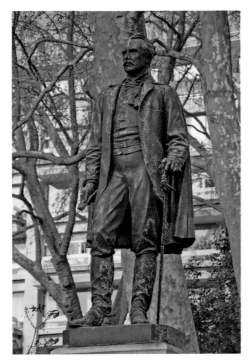

John Lawrence was Viceroy of India.

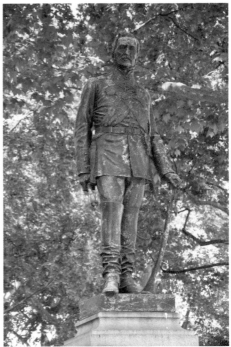

The St George and the Dragon on Burgoyne's baton is an early work of Alfred Gilbert.

On the opposite side of Waterloo Place is the statue of **Sir John Fox Burgoyne** (1872–71), an army officer and military engineer who fought in the Peninsular and Crimean Wars. His bronze statue, by Sir Joseph Edgar Boehm, was erected in 1877. Its inscription includes a quotation from Shakespeare's *Coriolanus*: 'How youngly he began to serve his country, how long continued'.

Backing on to the garden of the Athenaeum is the memorial to the Arctic explorer, **Sir John Franklin** (1786–1847). Franklin joined the Royal Navy at the age of fourteen and fought at the battles of Copenhagen and Trafalgar, but he is best known for his attempts to find the North-West Passage between the Atlantic and Pacific Oceans. He made two expeditions between 1818 and 1822, and wrote a best-selling book about the experience. In 1845 he set off on his last expedition and, although he was better equipped, with 128 men and two ships, after reaching Baffin Bay the ships were never seen again. Many expeditions were dispatched to find him, and what they eventually found told a story of extreme hardship, appalling weather and suggestions of cannibalism. The statue is by Matthew Noble and was erected in 1866. Franklin wears the uniform of a naval commander, covered by a fur overcoat, and he carries a telescope, compasses and a chart. On the two sides of the plinth are the names of the crew members who perished on the expedition, and at the front is a

bronze relief of Franklin's funeral on the ice. At the back, and today only visible from the garden of the Athenaeum, is a bronze chart showing the position of the two vessels, the *Erebus* and *Terror*. Some maintain that Franklin actually did discover the North-West Passage, and this is repeated in the inscription on the plinth.

Next to the Athenaeum is the statue of **Sir Keith Park** (1892–1975), the New Zealander who commanded the RAF squadrons that defended London and the South East during the Battle of Britain in 1940. He played a hugely important role in defeating the German efforts to bomb the country into submission, but until now he has been an unsung hero. The

bronze statue by Les Johnson, unveiled in 2010, shows him wearing a lifejacket and pulling on his flying gloves. For six months a fibreglass version of the statue stood on the fourth plinth in Trafalgar Square.

Outside 15 Carlton House Terrace is a marble statue by Sir Thomas Brock of **Queen Victoria** (1819–1901). Made in 1897, it originally stood in the Constitutional Club in Northumberland Avenue. Further west is a statue of **George Nathaniel Curzon, Marquess Curzon of Kedleston** (1859–1925), which stands almost opposite his home at 1 Carlton House Terrace. Curzon was talented, ambitious and a fine orator, though he never achieved the greatness he desired. He became an MP before the age of

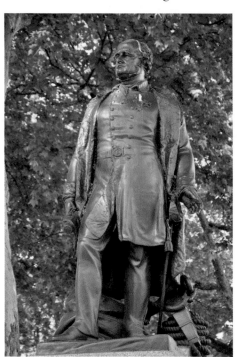

Sir John Franklin died searching for the North-West Passage.

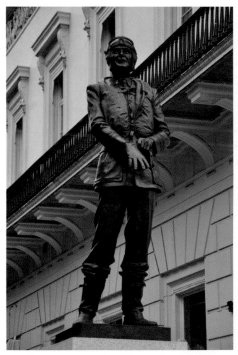

Sir Keith Park had to wait seventy years for recognition as a key player in the Battle of Britain.

Lord Curzon's statue stands near his home in Carlton House Terrace.

General de Gaulle stands close to his wartime headquarters.

thirty and was made Viceroy of India, where he carried out many reforms, but fell out with Kitchener over control of the Army. He was later a successful Foreign Secretary, but failed to become prime minister, which was a huge disappointment to him. The statue is the work of Sir Bertram Mackennal, and shows him in Garter robes. It was unveiled in 1931 by Stanley Baldwin, the prime minister.

In Carlton Gardens is a statue to **General Charles de Gaulle** (1890–1970), close to the wartime headquarters of the Free French Army at 4 Carlton Gardens, where he led the French resistance movement during the Second World War. On 18 June 1940, the day after he fled to England from France, he made a famous broadcast on the BBC urging the French to resist the German occupation. The French celebrate the broadcast every year in front of the statue on 18 June. The statue is the work of Angela Conner, and it was unveiled in 1993 by Queen Elizabeth the Queen Mother.

Black-cab drivers refer to the Queen Victoria Memorial as the 'wedding cake' (see related entry on page 127).

THE MALL TO
VICTORIA STREET

A T THE EASTERN end of the Mall, near the Admiralty Arch, is the **Royal Marines Memorial**, which was erected to commemorate the Marines who lost their lives fighting in the Boer War and in China during the Boxer Rebellion. The bronze sculpture and reliefs are the work of Adrian Jones, who, before becoming a sculptor, served for many years in the army. The sculpture is of two Marines, one lying wounded while the other stands over him with fixed bayonet, ready to face the enemy. Reliefs on the plinth depict a scene from the action at Graspan in South Africa, and the repulse of the Chinese assault on the Peking Legation. The memorial was unveiled in 1903 by the Prince of Wales (the future George V). In 2000 the memorial was restored, and unveiled by the Duke of Edinburgh as a national memorial to all Royal Marines who served during the twentieth century.

On the opposite side of the Mall is Sir Thomas Brock's statue of the great explorer **Captain James Cook** (1728–79). He is best known for his voyages to the Pacific, during which he surveyed New Zealand and Australia, claiming them for Britain. On his third voyage he was killed by natives

The Royal Marines Memorial at the eastern end of the Mall.

in the Sandwich Islands. The statue was unveiled by Prince Arthur of Connaught in 1914. The bronze statue is life-sized and portrays him standing in front of a capstan,

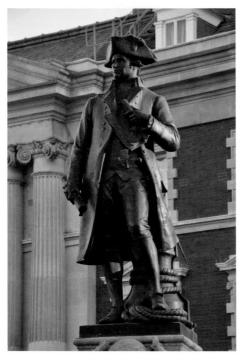

Captain Cook's statue is close to the Admiralty.

is a glass column, which is lit with a blue light like the lights outside police stations. The memorial was unveiled in 2005 by the Queen.

On the south side of the Mall, directly opposite the Duke of York's Column, is the **Royal Artillery South Africa Memorial**, which commemorates the men and officers of the Royal Artillery who died during the Boer War. It was inaugurated in 1910 using a rather unusual method. At a special service at St Paul's Cathedral the Duke of Connaught unveiled it using an electrical remote control device, though he did inspect the memorial after the service. The sculptor was William Robert Colton, and the central part of the memorial was paid for by officers and men of the regiment. On a high central plinth

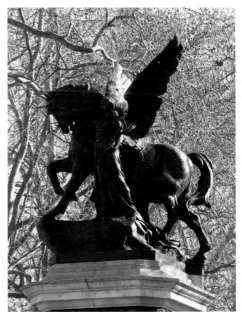

Peace controlling War on the Royal Artillery South Africa Memorial.

with his left foot on a coil of rope, and the plinth is carved with maritime symbols.

On a patch of grass by Horse Guards Road is **The National Police Memorial**, which commemorates the four thousand police officers who have died in the United Kingdom. Its erection was organised by the Police Memorial Trust, which was created by the film director, Michael Winner, to put up small memorials where police officers have died while carrying out their duty. The memorial was designed by Lord Foster and the Danish artist, Per Arnoldi. The black marble structure, which was built round an air vent on the Bakerloo Line, houses a book containing the names of nearly 1,600 officers, dating back to 1680. Alongside it

of Portland stone a winged female figure representing Peace is controlling the horse of War, and below the sculpture is a bronze frieze of the Mounted Artillery.

Overlooking the Mall at Carlton Gardens is the joint memorial to **George VI** (1895–1952) and his consort, **Queen Elizabeth the Queen Mother** (1900–2002). The statue of George VI was unveiled by the Queen in 1955. The statue is by William McMillan, who has depicted him with a Garter mantle over the undress uniform of an admiral of the fleet. The setting, with the statue at the top of a double flight of steps, was designed by Louis de Soissons. The Queen Mother's statue, by Philip Jackson, was unveiled by the Queen in 2009. She is shown at the age of 51, her age when the King died, and also wears Garter robes. The setting was adapted by Donald Buttress and Donald Insall to allow her memorial to stand below that of her husband. On either side are bronze reliefs by Paul Day depicting scenes from her long life. In one the king and queen are seen visiting Londoners bombed out during the war, while others show her enjoying a day at the races and relaxing at her castle in Scotland. The memorial was funded by sales of a £5 coin issued to celebrate the Queen's eightieth birthday.

On the wall of Marlborough House, overlooking the Mall at the corner of Marlborough Road, is a memorial to **Queen Mary** (1867–1953) with a bronze portrait relief. It is a copy of an original work by Sir William Reid Dick and was installed in 1967, the hundredth anniversary of her birth. When her husband George V died, she moved to Marlborough House, where she spent her last years.

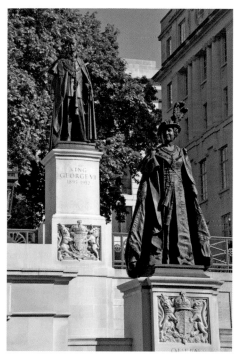

Queen Elizabeth the Queen Mother's statue joined her husband in the Mall in 2009.

In Marlborough Road, in the wall of Marlborough House, is Sir Alfred Gilbert's memorial to Edward VII's consort, **Queen Alexandra** (1844–1925). Marlborough House was their home as Prince and Princess of Wales, and she lived there again after the king died. She was a great beauty and very popular with the British public, especially because of her work for charity. Alexandra Rose Day, on which artificial wild roses are sold for charity in London, was founded in 1913 to raise money for hospitals and continues to operate in her memory. The memorial was unveiled by George V in 1932. Instead of a statue of the Queen, Gilbert produced

Queen Mary lived at Marlborough House after her husband's death.

in this late work a bronze sculpture full of symbolism. The three main figures are Faith, Hope and Love, which, according to the inscription, were the 'guiding virtues' of the queen. In the centre is the figure of a girl who is supported by Love, suggesting that Alexandra passed her virtues on to a new generation. Although George V had always disliked the sculptor, he conferred a knighthood on Gilbert after the unveiling.

The death of **Queen Victoria** (1819–1901) was the end of an era, so any memorial to her was going to be monumental. The original plan was to erect a memorial in front of Buckingham Palace, but this soon became part of a more grandiose architectural redesign of the whole area. Thomas Brock, who had produced many portraits of the queen, was invited to prepare designs for sculptural groups, including a statue of the queen. Architects were asked to put forward designs for the

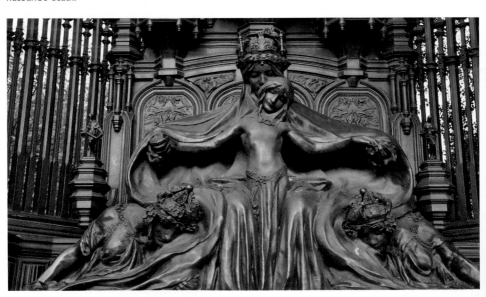

Sir Edward Elgar composed a special ode for the unveiling of Queen Alexandra's memorial.

western end of the Mall, as well as ideas for a grand eastern entrance, thus creating a new processional route. Aston Webb's design was chosen, and his later addition of Admiralty Arch is an integral part of the memorial. Construction began in 1906 and, although unfinished, the **Queen Victoria Memorial** was unveiled by George V in 1911. When Brock was presented to the king, he knighted him on the spot. The last sculptures were installed in 1924.

The Canada Memorial in Green Park.

The centrepiece is a seated figure of Queen Victoria, cut from one block of marble. All around her are symbols of her reign and what it stood for. Above her is the gilded figure of Victory with Courage and Constancy at her feet, and around the plinth are Truth, Justice and Motherhood. These were later described by Sir Osbert Sitwell as 'tons of allegorical females in white wedding cake marble, with whole litters of their cretinous children'! Around the edge of the pond are figures representing Painting, Architecture, War and Shipbuilding, and at the farthest corners are bronze figures with lions symbolising Peace, Progress, Agriculture and Manufacture. Also part of the scheme are the gateways around the gardens, with young men holding shields, accompanied by symbols of the countries of the Empire which donated them. These were carved by Albert Drury and Derwent Wood. The whole memorial, which cost £350,000, was paid for by public subscription, and enough money was donated to pay for the new façade of Buckingham Palace as well.

In the southern part of Green Park is the **Canada Memorial**, which remembers the almost one million Canadians who fought alongside the British in the two world wars, and in particular honours the more than 100,000 who died in service. It was designed by the Canadian artist, Pierre Granche, and was unveiled in 1994 by the Queen. It is a sloping structure of polished red Canadian granite, with inset bronze maple leaves. Water flows over it, which gives the impression that the maple leaves are floating in a stream. Despite signs asking people not to walk on the memorial, children are often allowed to use it as a slide.

Outside the Guards Chapel in Birdcage Walk is a statue to **Field Marshal the Earl Alexander of Tunis** (1891–1969). Alexander was a highly successful army officer who, aged only twenty-six, commanded a battalion in the First World War. In the Second World War, he organised the withdrawal from Dunkirk, leaving on the last launch. He was very popular with his men, as he spent as much time with them as in his headquarters. The statue is by James Butler and was unveiled in 1985 by the Queen. He is shown wearing the uniform he wore during the invasion of Italy in 1943.

In Queen Anne's Gate is a stone statue of **Queen Anne** (1665–1714), which stands on a pedestal in front of No. 15.

Alexander of Tunis organised the withdrawal from Dunkirk in 1940.

In the nineteenth century Queen Anne's statue was damaged by schoolboys who mistook her for Bloody Mary.

The street was built in 1704, and the statue may well have been erected in that year; it was first mentioned in 1708. The sculptor is unknown, though it bears some resemblance to Francis Bird's statues of her outside St Paul's Cathedral and in Kingston. There is a legend that, on the night of 1 August, the anniversary of her death, she steps down from her pedestal and walks three times up and down the street.

In Christchurch Gardens, by the junction of Victoria Street and Broadway, is a memorial erected in 1970 by the **Suffragette Fellowship** to commemorate the courage and perseverance of all those who fought for votes for women in the early part of the twentieth century. It takes the form of a scroll, made of bronzed fibreglass, and was created by Edwin Russell. On the

reverse of the scroll are two of the suffragette badges, the top one the Holloway Brooch, designed by Sylvia Pankhurst, and the other depicting Holloway Prison. The memorial stands close to Caxton Hall, where many suffragette meetings were held, and was unveiled by Lilian Lenton, a former suffragette and treasurer of the Fellowship.

On the other side of the gardens is a rather unusual memorial to **Henry Purcell** (1659–95), the great English composer, who was born in Westminster and was organist at Westminster Abbey. It was commissioned by Westminster City Council to commemorate the three hundredth anniversary of Purcell's death, and was unveiled by Princess Margaret in 1995. The sculpture, by Glynn Williams, is called *Flowering of the English Baroque*, which

A Suffragette memorial near Victoria Street.

The unusual Henry Purcell memorial.

explains the vegetation issuing from the composer's head.

Outside Westminster City School in Palace Street is a statue of **Sir Sydney Hedley Waterlow** (1822–1906). It is a replica of Frank Taubman's statue in Waterlow Park, except that he holds a document in his left hand instead of keys (see page 218). He was the first Chairman of the Governors of the school in 1873 and served for many years. The statue was erected in 1901.

Boehm's statue of Wellington, with the Wellington Arch in the background.

HYDE PARK CORNER

IN THE CENTRE of the roundabout at Hyde Park Corner is the **Wellington Arch**, which was commissioned from Decimus Burton in the 1820s as a commemoration of Britain's victory against the French in the Napoleonic wars. It was to be in the form of a Roman triumphal arch, covered in symbolic sculpture, including trophies, statues of guardsmen and with a four-horse chariot, or quadriga, on top, but money ran out and most of the ornamentation was never added. The arch was finished in 1830 and originally stood opposite Burton's Hyde Park Screen, and served as both an entrance to Green Park and a grand outer entrance to Buckingham Palace, George IV's new official residence. In 1838 it was decided that there should be a national memorial to the Duke of Wellington, and that it should stand on top of what was then called the Green Park Arch, as it stood close to the Duke's London residence, Apsley House. Matthew Cotes Wyatt was invited to produce an equestrian statue, but his design for a monumental 30-foot statue would cause much controversy. It took him six years to make, using bronze from captured French cannon. The arch had to be strengthened to take the sculpture, and the 40-ton statue was lifted into position in 1846, to much derision. It was considered to be completely out of proportion with the arch, and there were letters to the press and questions in Parliament. It was lampooned in *Punch*, and *The Times* described it some years later as being a 'monstrosity' and 'of portentous ugliness'. However, to remove it would have been an insult to the Duke, so it stayed there for many years. By the 1880s the volume of traffic had increased so much that a new road system was devised, and in 1883 the arch was dismantled and moved to its present position. The statue was not replaced and, as a suitable London location could not be found, it was nearly melted down, but it was finally decided to re-erect it near the army camp at Aldershot, where it can still be seen.

A new statue of the Duke was commissioned (see below), but the question of a new sculpture for the arch was left in abeyance until in 1891 the Prince of Wales saw a plaster of a sculpture called *Triumph* by Adrian Jones at the Royal Academy. He thought a version of the sculpture would be suitable for the top of the arch, but, although Jones was keen on the scheme, there were

The sculptor and his assistants had tea inside the plaster model of one of the horses of the Quadriga.

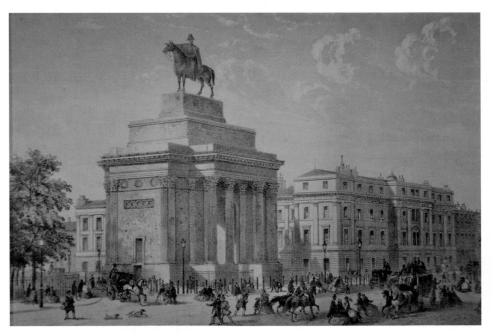

Wyatt's colossal statue of Wellington on top of the Wellington Arch in the 1850s.

no funds to pay for it. Jones worked on a scaled-up model, but it was not until 1907, when Lord Michelham offered to defray much of the cost, that things could move forward. It took the sculptor three years to produce a model of the whole group before the casting could begin in 1910. It was erected on the arch in 1912, but there was no official unveiling; King George and Queen Mary were driven to see the sculpture *in situ* and were introduced to the sculptor. Known as the Quadriga, it represents a boy driving four horses with the winged figure of Peace alighting in the chariot they are pulling. Jones had started sketching horses and their riders while in the Army, and they were always a speciality of his. The arch is now owned by English Heritage, who have restored it and opened it to the public. It houses displays about the arch's history, and there are good views from the roof.

On the north side of Hyde Park Corner, facing Apsley House, is the statue of **Arthur Wellesley, 1st Duke of Wellington** (1769–1852), which replaced the one on the arch. It was commissioned from Sir Joseph Edgar Boehm in 1884 and was unveiled by the Prince of Wales in 1888. The Duke wears the uniform of a Field Marshal and is mounted on his favourite horse, Copenhagen, as if on the field of battle. At the corners of the red granite pedestal are bronze statues of four soldiers, a British Grenadier, a Scottish Highlander, an Irish Dragoon and a Welsh Fusilier, all in uniforms of the early part of the century and representing regiments which fought under Wellington. The bronze came from guns captured from the French.

On the west side of the roundabout is the **Royal Artillery Memorial**, which was erected to remember the 49,076 men of the Royal Regiment of Artillery who died in the First World War. It is the work of Charles Sargeant Jagger, who himself saw action at Gallipoli and won the Military Cross. It was unveiled in 1925 by the Duke of Connaught. The memorial consists of a stone sculpture of a howitzer on a massive plinth, with four superb bronze figures around the sides, three of which depict an officer, a gunner and a driver. The fourth one, on the north side, is the poignant recumbent figure of a dead artilleryman, his face covered by a greatcoat. Around the memorial are rather

The Royal Artillery Memorial is considered to be Jagger's masterpiece.

weathered carved panels showing scenes of war and weapons. Jagger intended the memorial to be seen as a permanent record of the uniforms and weapons used in the war. The representation of a dead soldier was controversial at the time, as most war memorials idealised war, whereas Jagger wanted to show the horror and violence of a war he had experienced himself. In 1949 Princess Elizabeth unveiled three bronze plaques on the south side to commemorate the 28,924 artillerymen who lost their lives in the Second World War.

Curving round the south-west corner, like a boomerang, is the **Australian War Memorial**, which remembers the more than 100,000 Australians who lost their lives in the two world wars. The memorial, built with Australian granite, is etched with the names of thousands of place names recording the origins of those who served, and superimposed on them are the names of forty-seven battle sites where they fought. Water constantly falls over the names. The bronze insignias of the Royal Australian Navy, the Australian Army and the Royal Australian Air Force,

as well as the Australian coat of arms, feature prominently. The memorial was created by the architects Tonkin Zulaikha Greer and the artist Janet Laurence. It was unveiled in 2003 by the Queen. Anzac Day is celebrated here every April.

In the north-east corner of the roundabout is the **Machine Gun Corps Memorial**, erected to commemorate those soldiers of the Corps who died in the First World War. The Corps played an important part in the war, but was disbanded in 1922 as a cost-cutting exercise. The memorial, by Francis Derwent Wood, was unveiled in 1925 by the Duke of Connaught. On top of a marble plinth is a bronze statue of a naked David, leaning on

Derwent Wood's figure of David on the Machine Gun Corps Memorial.

The Australian War Memorial was made with Australian granite.

Goliath's sword. On either side are machine guns and helmets encircled by wreaths. Underneath the main inscription are the words, 'Saul hath slain his thousands but David his tens of thousands', which caused much controversy at the time, with letters to *The Times* and a debate in the House of Commons. In 1941 the bronze parts of the memorial were removed to Aldwych underground station for safe keeping, and returned in 1946.

At the eastern end of the roundabout is the **New Zealand Memorial**, which was dedicated by the Queen in 2006. The memorial commemorates the long-standing bonds between the UK and New Zealand and the shared sufferings of the two countries in times of war. It consists of sixteen cross-shaped bronze sculptures decorated with words, symbols and images which represent different aspects of New Zealand life and culture. The sculptures are in two groups, with ten in front, and six behind in the form of the Southern Cross. The memorial was designed by the New Zealand sculptor Paul Dibble and the architect John Hardwick-Smith. Like the nearby Australian memorial, it is the site for Anzac commemorations in April.

On the edge of Green Park, overlooking Hyde Park Corner, is the **Bomber Command Memorial**, which remembers the 55,573 RAF airmen who died on bombing raids during the Second World War. The memorial, designed by Liam O'Connor, consists of an 80-foot Doric colonnade, with a central pavilion

The New Zealand Memorial is the focus of the Annual Anzac commemorations.

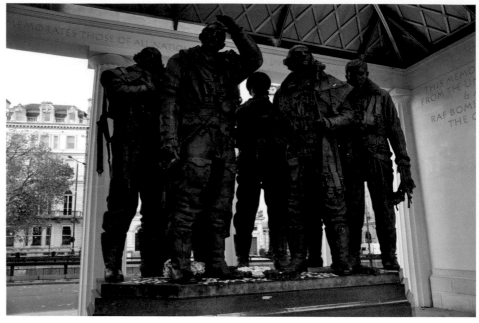

This sculpture of seven aircrew forms the heart of the Bomber Command Memorial.

housing a 9-foot sculpture of seven aircrew by Philip Jackson. The roof was built using metal from a Royal Canadian Air Force Handley Page Halifax which crashed in Belgium in 1944. The memorial was unveiled in 2012 by the Queen, in the presence of many veterans and relatives of those who died. After the ceremony there was a flypast of five Tornados and a Lancaster dropped thousands of poppies over Green Park. Erected 67 years after the end of the war, the delay was the result of the controversy over the blanket bombings of cities such as Dresden in the last months of the war. The memorial itself has been controversial, with some critics claiming it is too big and in the wrong place. It is certainly monumental and in a very prominent location, but it has to be accepted as a belated commemoration of the brave airmen who had to carry out the raids.

At the entrance to Constitution Hill are the **Commonwealth Memorial Gates**, which remember the nearly five million men from the Indian sub-continent, Africa and the Caribbean who served in the British Armed Forces during the two world wars. There are four piers of Portland stone, each one surmounted by a bronze urn, and with the names of Commonwealth countries inscribed on them. Alongside the gates is a pavilion, whose ceiling carries the names of seventy soldiers from those countries who won the Victoria and George Crosses. The memorial was designed by Liam O'Connor, and was dedicated by the Queen in 2002.

The Bomber Command Memorial in the corner of Green Park.

The Commonwealth Memorial Gates at the top of Constitution Hill.

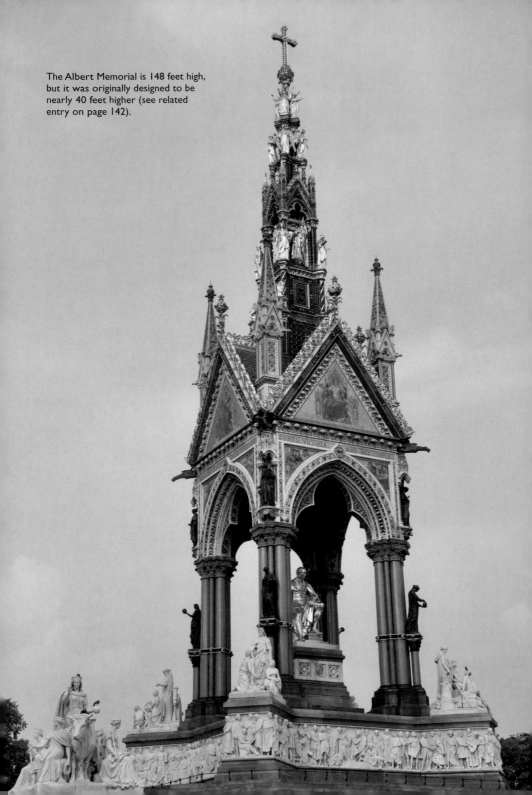

The Albert Memorial is 148 feet high, but it was originally designed to be nearly 40 feet higher (see related entry on page 142).

KENSINGTON GARDENS AND HYDE PARK

KENSINGTON GARDENS WERE originally the private gardens of Kensington Palace, created by Sir Christopher Wren for William and Mary in the 1690s, and on the south side of the palace is a bronze statue of **William III** (1650–1702). It was sculpted by Heinrich Karl Baucke, and is a copy of one of the statues of rulers of the House of Orange created for the Berlin palace of Kaiser Wilhelm. In 1907 it was presented to the British nation by the Kaiser, and accepted by his nephew, Edward VII, who approved the fitting location for the statue. It is said that the image of Captain Hook in J. M. Barrie's *Peter Pan* was inspired by the swaggering look of the statue.

To the east of Kensington Palace, overlooking Broad Walk, is a marble statue of **Queen Victoria** (1819–1901), who was born in the palace and lived there until she became queen. The statue shows her as a young woman at the time of her coronation, and was sculpted by Princess Louise, the sixth of the queen's nine children. Princess Louise was a somewhat progressive thinker and, among other things, supported the women's movement, much to the displeasure of the queen. She also had artistic talent and studied in the workshop

The flamboyant statue of William III was a gift from Kaiser Wilhelm.

of the sculptor Joseph Edgar Boehm, who helped her in creating this statue, which was erected in 1893. The queen was present at its unveiling by the Prince of Wales.

The statue of a young Queen Victoria was sculpted by her daughter, Princess Louise.

West of the Round Pond is G. F. Watts's powerful sculpture **Physical Energy.** It portrays a man who has just carried out a great deed and is shielding his eyes as he looks for his next challenge. It was installed here in 1907 and is a copy of the statue that forms part of the memorial to Cecil Rhodes in South Africa. A further copy was erected in Zimbabwe in 1960.

To the north is a granite obelisk commemorating the explorer **John Hanning Speke** (1827–64). Under the auspices of the Royal Geographical Society, Speke went on several expeditions to East Africa, and is famous for discovering Lake Victoria and the source of the Nile (though a recent expedition has found that its true source is in Rwanda). Sadly, on the eve of a debate with the explorer Richard Burton, he accidentally shot himself while out hunting.

G. F. Watts's *Physical Energy* is a copy of part of the Cecil Rhodes Memorial in South Africa.

The monument was sponsored by Roderick Murchison, President of the RGS, designed by Philip Hardwick and erected in 1866.

On the east side of the Italian Gardens at the head of the Long Water (as the Serpentine is called in Kensington Gardens) is a bronze statue of **Edward Jenner** (1749–1823), the surgeon who introduced vaccination against smallpox, which killed thousands of people in eighteenth-century England. He realised that people who handled cows rarely got smallpox and used cowpox as a vaccine against the disease. His statue, by William Calder Marshall, was erected in Trafalgar Square in 1858, but the authorities soon felt that the setting, among naval and military heroes, was inappropriate and suggested moving it. *Punch* published a satirical rhyme on the subject:

> England, ingratitude still blots
> The escutcheon of the brave and free;
> I saved you many million spots
> And now you grudge one spot to me.

After much deliberation, it was moved to its present, rather out-of-the-way location in 1862.

To the south, in a grassy area overlooking the Long Water, is **Peter Pan**, one of London's most popular statues and the best known work of Sir George Frampton. Peter was the creation of J. M. Barrie, who lived in Bayswater Road. The Darling family in his stories was inspired by the Llewellyn Davies family, whom he met in Kensington Gardens, and the books were later turned into a hugely successful play, which is still regularly

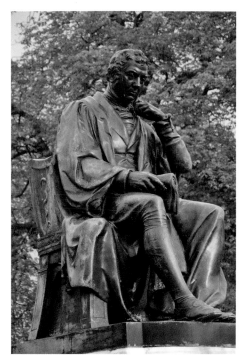

The statue of Jenner originally stood in Trafalgar Square.

performed today. In 1906 Barrie decided to create a statue of Peter Pan and took photographs of the young Michael Llewellyn Davies in costume, and commissioned Sir George Frampton to make it. In 1912 the statue was put up over two days behind curtains, which were removed overnight so that it seemed to have appeared as if by magic. Barrie put an announcement in *The Times* informing its readers, 'There is a surprise in store for the children who go to Kensington Gardens to feed the ducks in the Serpentine this morning.' There were complaints in Parliament about the author promoting his work in a public park, but the sculpture soon became a huge popular success, and copies

Peter Pan is Frampton's best-known sculpture and features on his memorial in St Paul's Cathedral.

(1819–61: see photograph on page 138). When he died of typhoid fever aged only forty-two, Queen Victoria was so grief-stricken that she was in mourning for the rest of her life. A month after the Prince Consort's death plans were set in train to find a way to commemorate him with a fitting monument, and a public subscription was announced. The first suggestion was for a 150-foot obelisk to be set up on the site of the Great Exhibition, but seven architects were then invited to offer designs for a memorial. Many of the designs were severely classical, but the one chosen by the queen was the Gothic scheme of George Gilbert Scott, which was based on medieval shrines, including the Eleanor Crosses.

can now be seen in Liverpool, Toronto, Brussels, New Jersey and Perth, Australia. The statue shows Peter playing his pipes on a tree stump surrounded by rabbits, mice, squirrels and fairies. From the shiny surface on the animals, where children have stroked them, the sculpture is clearly popular, but in 1928 it was tarred and feathered by a vandal and the pipes have been stolen on several occasions.

The most lavish of all London's monuments is the **Albert Memorial**, which stands opposite the Royal Albert Hall, close to the site of the Great Exhibition of 1851. It commemorates the life and work of Prince Albert of Saxe-Coburg-Gotha

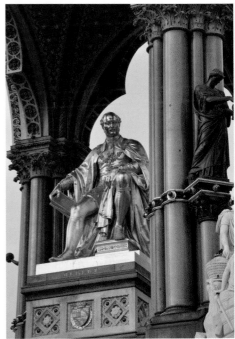

Foley's statue of Prince Albert is covered in 24-carat gold leaf.

The memorial has a complex iconography, based on Albert's interests and passions and, in particular, on the themes of the Great Exhibition, of which he was the prime mover. At the outer corners are sculptural groups of the continents of Europe, Asia, Africa and America, representing the nations which exhibited at the Great Exhibition, and the groups above the frieze are symbolic of Agriculture, Manufacture, Commerce and Engineering, the major themes of the Exhibition. The Parnassus frieze, which runs around the memorial, depicts those persons the Victorians considered to be the greatest figures in Western culture, thematically arranged by the subjects of poetry, music, painting, sculpture and architecture. The only living figure in the frieze was George Gilbert Scott himself, whom Queen Victoria insisted should be included, though only as a profile head. The mosaics in the gables and spandrels have figures relating to the arts; the figure of Architecture, on the north side, holds an elevation of the Albert Memorial. The bronze figures on the columns and in niches above the capitals are of intellectual pursuits, such as Geometry, Rhetoric and Philosophy, and above them all is an orb surmounted by a cross.

Work on the construction began in September 1864 and it took eight years to complete. The foundations consist of a complex system of 868 brick arches, built on a concrete and stone base. The decoration involved many artists and craftsmen. John Richard Clayton, of the Clayton and Bell stained-glass makers, designed the mosaics, which were created by Salviati. The sculptural decoration was commissioned from many of the greatest sculptors of the day, including Thomas Thornycroft, John Foley, William Theed and John Bell. The Parnassus frieze was created on site by Henry Hugh Armstead and John Birnie Philip. It was originally proposed to use Carrara marble for the sculpture, but because of the polluted air of Victorian London, the more hard-wearing Campanella marble was used for the frieze and the eight principal sculptures. Gilded bronze was used for the rest, including the figure of Albert, for which 72 tons of cannon barrels were provided by Woolwich Arsenal.

Although Scott had control over the construction, for the figure of Albert Victoria chose the sculptor Baron Marochetti, who produced two unsatisfactory designs before his death in 1867. The commission was then given to John Foley, who finished the giant statue in 1873, though he died before it was cast, and the work was completed by Thomas Brock. The gilded figure of the seated Prince shows him in Garter robes, and holding a volume of the Great Exhibition catalogue. The memorial was opened to the public in 1872, but without the Prince's statue, which was installed in 1875. Even then it was covered up again so it could be gilded, and it was finally unveiled in March 1876. Scott was knighted for his work on the memorial.

Over the years rain and London's polluted atmosphere caused serious damage to the memorial. The decision in 1914 to remove all the gilding, possibly to stop it becoming a target for the Zeppelins, only made matters worse. In 1940 it was damaged by anti-aircraft fire, which brought down the orb and cross, and when repairs were made in 1954 the cross was replaced facing in the wrong direction. Minor repairs were carried out from time to time, but when, in 1983, a piece of the lead cornice fell off, it

was realised a full restoration was necessary. For most of the 1990s the monument was covered in scaffolding while an £11.2m restoration was carried out. Much of the structure had to be taken down to be cleaned and repaired, and the angels on the spire and the figure of Albert were covered in 24-carat gold leaf. In October 1998 the Queen unveiled the newly resplendent monument to her great-great-grandfather, and it can now be fully appreciated as a magnificent monument to the Victorian artists and craftsmen who created it.

Hyde Park begins to the east of the West Carriage Drive, and here is the **Diana, Princess of Wales Memorial Fountain**. It was created by the American landscape artist, Kathryn Gustafson and opened by the Queen in 2004. It takes the form of a slightly tilted oval of Cornish granite, with water flowing down both sides, and is said to symbolise Diana's openness. There are plans to erect a statue of **Diana, Princess of Wales** in Kensington Gardens in late 2017, to commemorate the twentieth anniversary of her death.

A little further east is the Lido, a bathing area on the Serpentine which was created by **George Lansbury** (1859–1940) when he was First Commissioner of Works. On the wall of the cafeteria is a bronze plaque by H. Wilson Parker with a relief profile of Lansbury, which was unveiled in 1953 by Clement Attlee. Lansbury was keen to

Queen Caroline created the Serpentine Lake in Hyde Park.

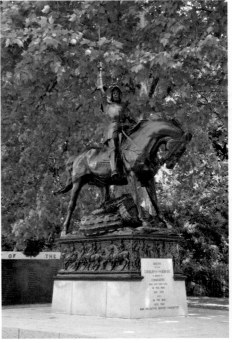

Adrian Jones's Cavalry Memorial features St George and a magnificent dragon.

144

improve the facilities in the Royal Parks, and the bathing place is usually referred to as 'Lansbury's Lido'.

At the south-east corner of the Serpentine is an elegant stone urn commemorating **Caroline of Anspach** (1683–1737), the queen consort of George II, who was responsible for creating the Serpentine and the Long Water, by having the Westbourne river dammed. It was unveiled by the Queen in 1990.

To the north of the Serpentine Road, on a patch of lawn to the east of the bandstand, is Adrian Jones's **Cavalry Memorial**, which commemorates the cavalry regiments that served in both world wars. It was originally erected at Stanhope Gate,

where it was unveiled by Field Marshal Lord Ypres in 1924. It was moved to its present location in 1961, when Park Lane was widened. The statue shows St George on a magnificent horse, slaying a splendid dragon, and it was cast from guns captured by the Cavalry in the First World War. Jones used an effigy of the Earl of Warwick for the armour and the horse and its trappings are based on an engraving of St George by Albrecht Dürer. Around the base is a frieze with scenes from cavalry life, and behind the statue is a plaque listing the names of the regiments and the commanders. Every year on the second Sunday in May there is a Cavalry Memorial Parade in Hyde Park, when a wreath is laid at the memorial.

Westmacott's controversial Achilles statue.

This detail from George Cruikshank's satirical print has William Wilberforce using his top hat to make Achilles decent.

7 JULY 2005
08:50
EDGWARE ROAD

7 JULY 2005
08:49
TAVISTOCK SQUARE

The simple and moving 7/7 Memorial.

In the south-east corner of the park is Sir Richard Westmacott's colossal statue of **Achilles.** It was erected in 1822 in honour of the Duke of Wellington and was cast from captured cannon from the Peninsular War and the battle of Waterloo. It is often referred to as the 'Ladies' Trophy' as its £10,000 cost was paid for by the women of England. The statue is so massive that, when it was installed, it was too big to go through the gate and part of the wall had to be dismantled. Westmacott based his sculpture on the ancient statues of the Horse Tamers on the Quirinal in Rome. The original was a naked figure, but the subscribers asked for it to be given a fig leaf. It was the first public nude statue in London and, even with its fig leaf, its nudity proved rather shocking, and it was much lampooned by the satirists, especially George Cruikshank. The fig leaf has been stolen on several occasions, most recently in 1961.

Slightly to the north is one of London's most poignant new memorials, erected in memory of the victims of the terrorist bombings on 7 July 2005. Known popularly as the **7/7 Memorial**, it was unveiled by Prince Charles two years to the day after fifty-two innocent people were killed by bombs detonated on three Tube trains, at King's Cross, Aldgate and Edgware Road, and on a bus in Tavistock Square. The memorial consists of fifty-two steel pillars, one for each of the victims, each one carrying the time, date and location of the bombing, but not the name of the victim. They are arranged in four groups to represent the four locations, and the names of the victims are inscribed on a nearby plaque. This simple and touching monument cost £1m and was created by Kevin Carmody and Andrew Groarke.

North of the Serpentine, and rather hidden away close to the West Carriage Drive, is a bird sanctuary with a memorial to the writer and naturalist **William Henry Hudson** (1841–1922). Hudson wrote many books about wildlife, as well as several works of fiction, and worked for the Royal Society for the Protection of Birds. The memorial takes the form of a relief by Jacob Epstein of **Rima**, the spirit of the forest from Hudson's novel, *Green Mansions*. The sculpture, depicting her in flight and surrounded by birds, overlooks a pond and is surrounded by trees. Lionel Pearson designed the whole ensemble, and the inscription was carved by Eric Gill. It was unveiled in 1925 by the prime minister, Stanley Baldwin. Epstein's work was often controversial and *Rima* was no exception, with letters to *The Times* both attacking and defending it. The subject was even discussed in Parliament, and at one time a policeman stood guard over the memorial. It has been vandalised several times, being painted green on one occasion and on another tarred and feathered. Today, sadly, it attracts little attention and few visitors.

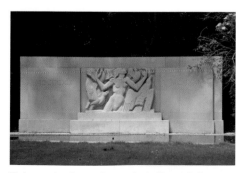

Today it is hard to understand why Epstein's *Rima* was once so controversial.

Belgravia was developed by Sir
Robert Grosvenor.

BELGRAVIA AND PIMLICO

IN THE NORTH-EAST corner of Belgrave Square is a statue of **Sir Robert Grosvenor, 1st Marquess of Westminster** (1767-1845), who developed Belgravia as the fashionable area it now is. The sculpture by Jonathan Wylder depicts him with his foot on a milestone, inscribed 'Chester 197 miles' (the distance to the Grosvenor estates) and studying plans of the new development. He is accompanied by a pair of talbots (hunting dogs, now extinct), which appear on the Grosvenor coat of arms. The statue was commissioned by Gerald Cavendish Grosvenor, the 6th Duke of Westminster, who unveiled it in 1998. Beneath the bronze Grosvenor crest is an apt quotation from John Ruskin: 'When we build, let us think we build for ever'. On the back of the plinth are bronze plaques of maps showing the area in 1821 and 1998.

In the private central garden of the square, on the west side, but visible from outside the railings, is a bust of **George Basevi** (1794–1845), the architect who designed the square. It is also the work of Jonathan Wylder.

On the north-east corner of the central garden is a bronze statue of **General Don José de San Martín** (1778–1850), one of four of the so-called Liberators of South America who have statues in London. All of them spent time here, but Britain also helped them in their fight against the Spanish. San Martín liberated Argentina from Spanish rule, and also helped free Chile and Peru, and his statue stands close to the Argentine Embassy. The rather stiff and formal statue is the work of Argentinian sculptor Juan Carlos Ferraro, and was the gift of the Argentine-British community in Argentina. It was unveiled in 1994 by the Duke of Edinburgh.

At the south-east corner of the square is a statue of **Simón Bolívar** (1783–1830), who was the greatest of the Latin American liberators, freeing Venezuela, Colombia, Ecuador, Perú and Panama, as well as founding Bolivia, which was named after him. The statue, rather wooden, like that of

San Martin and Bolívar, two South American liberators, stand in Belgrave Square.

San Martín, is by Hugo Daini, the Venezuelan sculptor, and was unveiled in 1974 by James Callaghan, the Foreign Secretary, along with the President of Venezuela. On the plinth is a quotation from Bolívar: 'I am convinced that England alone is capable of protecting the world's precious rights as she is great, glorious and wise.'

Continuing the Latin American theme, at the south-west corner there is a statue of the explorer **Christopher Columbus** (1451–1506) who, in 1492, sailing westwards to find a new route to the East Indies, ended up in the Caribbean, thus 'discovering' the New World. His voyage was financed by the Spanish monarchs, Ferdinand and Isabella, and the statue was given in 1992 by Spain, whose embassy is directly opposite, to commemorate the five-hundredth anniversary of his discovery. The sculpture, by the Spanish sculptor Tomás Bañuelos, shows a youthful Columbus sitting in a chair, holding a chart and pointing towards the Americas.

In the north-west corner of the square is a sculpture of the Portuguese **Prince Henry the Navigator** (1394–1460), opposite the Portuguese Embassy. Prince Henry was involved in the exploration of the African coast and sponsored various expeditions, including those that discovered the Azores and the Cape Verde Islands. The statue is by the Portuguese sculptor Simões de Almeida and was unveiled in 2002 by the Portuguese President.

At the junction of Hobart Place and Grosvenor Place is the **Rifle Brigade Memorial**, which remembers the more than eleven thousand men of the Rifle Brigade who lost their lives in the First

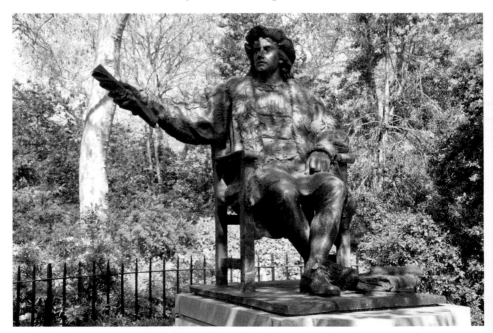

A young Christopher Columbus opposite the Spanish Embassy in Belgrave Square.

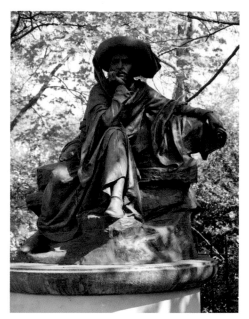

The Portuguese Prince Henry the Navigator.

World War. It is by John Tweed, and was unveiled in 1925. The central figure is a rifleman from the First World War, and on either side are an officer from Wellington's army in Spain and a rifleman from Sir John Moore's campaign in Portugal.

At the bottom of Grosvenor Gardens, opposite Victoria station, is the equestrian statue of **Marshal Ferdinand Foch** (1851–1929), Commander of the French Army and later Supreme Commander of the Allied Armies in the First World War. It is a copy of the statue by the French sculptor, Georges Malissard, at Cassel, his French headquarters. On the plinth are carved Foch's own words: 'I am conscious of having served England as I served my country'. It was unveiled in 1930 by the Prince of Wales (the future Edward VIII).

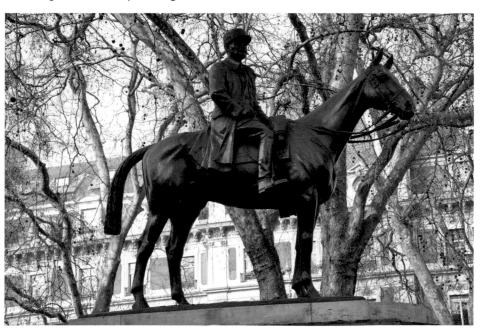

Marshal Foch's statue opposite Victoria Station.

In Orange Square, at the western end of Ebury Street, is a statue of **Wolfgang Amadeus Mozart** (1756–91). As a child prodigy, Mozart was taken by his father on a concert tour of Europe to show off his talents. Aged eight, he spent fifteen months in London, at 180 Ebury Street, and while living there composed his first symphonies. The statue is by Philip Jackson and shows him holding a violin. It was unveiled in 1994 by Princess Margaret.

In Pimlico, at the junction of Denbigh Street and St George's Drive, is an imposing sculpture of **Thomas Cubitt** (1788 –1855), one of London's greatest speculative builders. He built the east wing of Buckingham Palace and part of the Embankment, but he is best known for his development of Belgravia and Pimlico, which was nicknamed 'Mr Cubitt's District' and was where he had his building works. The statue, by William Fawkes, shows him standing by a pile of bricks, checking them for quality. The memorial was unveiled in 1995 by the Duke of Westminster.

In Pimlico Gardens on Grosvenor Road, opposite St George's Square, is a marble statue of **William Huskisson** (1770– 1830), MP for Liverpool. He was the first person to be killed in a railway accident, at the opening of the Liverpool to Manchester railway, a project with which he had been involved. Unfortunately, while stepping up into the Duke of Wellington's carriage, he fell into the path of the *Rocket* locomotive, and died later that day. The statue is by John

The statue of a young Mozart stands near the house where he composed his first symphony.

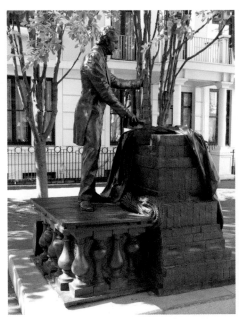

Thomas Cubitt stands in Pimlico, which he built in the early nineteenth century.

Gibson, who hated the new fashion for modern dress in statues and still worked in the rather old-fashioned classical style. He shows Huskisson wearing a Roman toga, prompting Robert Peel to comment that he had given the figure more grandeur than it deserved. In the twentieth century Sir Osbert Sitwell suggested that he looked more like 'boredom rising from the bath'. This is not the original statue, which Gibson created for Huskisson's mausoleum in Liverpool and is now housed in the Walker Art Gallery. In 1836 Huskisson's widow commissioned a second statue to stand in Liverpool's Customs House, but instead it was presented to Lloyds of London. It was displayed at the Royal Exchange for some years before moving to its present, rather isolated location, in 1915.

At the rear of Tate Britain on Millbank is a statue by Thomas Brock of **Sir John Everett Millais** (1829–96), one of the best known Victorian artists and one of the founders of the Pre-Raphaelite Brotherhood. He stands, brushes and palette in hand, in the act of painting. Millais was a friend of Henry Tate, and was closely involved in the creation of the new National Gallery of British Art, as the Tate was then called. In 1905 the statue was installed at the main entrance to the gallery on Millbank. In 1953 and again in 1962, the Director of the Tate, Sir Norman Reid, tried, but failed, to have the statue removed, calling it 'positively harmful'. However, in 2000 it was removed to its present location, relegated to a place next to the bicycle rack.

William Huskisson was the first person to be killed in a railway accident.

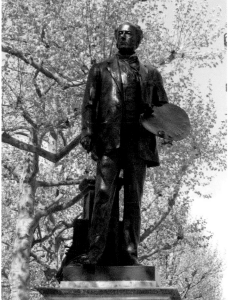

Millais stands behind Tate Britain, which he helped to create.

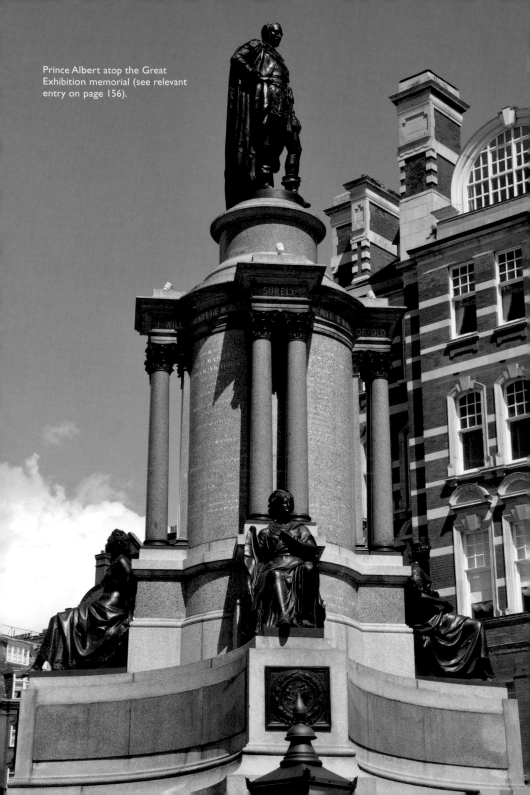

Prince Albert atop the Great Exhibition memorial (see relevant entry on page 156).

KENSINGTON

JUST OUTSIDE THE south entrance of South Kensington Underground station is a statue to the great twentieth-century Hungarian composer, **Béla Bartók** (1881–1945), looking down towards the house in Sydney Place where he stayed on several visits to London, and which now bears a Blue Plaque. The statue is a copy of the one by the Hungarian sculptor, Imre Varga, which stands in Budapest. It was unveiled in 2004 on a traffic island, but put into storage in 2009 while the road system was reorganised; it was re-erected in its new location in 2011.

In the garden of the Darwin Centre at the Natural History Museum, and only accessible via the museum, is the **Indian Ocean Tsunami Memorial**, which remembers the British people who died in the devastating tsunami in December 2004, killing nearly 250,000 people across the region. The simple memorial (see overleaf) consists of a 113-ton cube of granite with a corner cut away at an angle. It was designed by Carmody Groarke, the architects who designed the 7/7 Memorial in Hyde Park. The names of the 153 Britons who died in the disaster are inscribed on the memorial, which was unveiled in July 2011, when the Prince of Wales laid a wreath. Its location in the grounds of the museum is an appropriate reminder of the immense power of the forces of nature.

In Queen's Gate, at the junction with Cromwell Road, is the statue of **Robert, 1st Baron Baden-Powell of Gilwell**

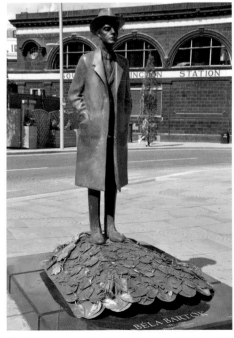

Bartók's statue stands close to the house he stayed in when visiting London.

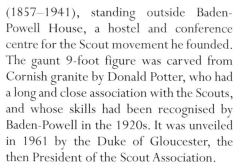

The Prince of Wales laid a wreath at the unveiling of the Indian Ocean Tsunami Memorial.

Unusually, Baden-Powell's statue is of granite.

(1857–1941), standing outside Baden-Powell House, a hostel and conference centre for the Scout movement he founded. The gaunt 9-foot figure was carved from Cornish granite by Donald Potter, who had a long and close association with the Scouts, and whose skills had been recognised by Baden-Powell in the 1920s. It was unveiled in 1961 by the Duke of Gloucester, the then President of the Scout Association.

At the top of Queen's Gate, facing Kensington Gardens, is the equestrian statue of **Robert Cornelis, 1st Baron Napier of Magdala** (1810–90), wearing tropical uniform and carrying a pair of binoculars. Born into a military family, he served in India and China, and in 1867 was sent to Abyssinia where, after a hard march over

difficult terrain, he captured Magdala, whose name he used in his title. The statue, by Sir Joseph Edgar Boehm, was unveiled in 1891 in Waterloo Place, but in 1920 it had to make way for the statue of Edward VII and was moved to Queen's Gate. In 2004 a student from the nearby Royal College of Art gained official permission to cover the statue in red duct tape as part of her graduation show. Despite being approved by the local council and English Heritage, the 'artwork' caused considerable controversy.

It may come as a surprise to find a statue of Prince Albert on the south side of the Royal Albert Hall, so close to the magnificent memorial to him in Kensington Gardens. However, this monument was actually put up to commemorate the **Great**

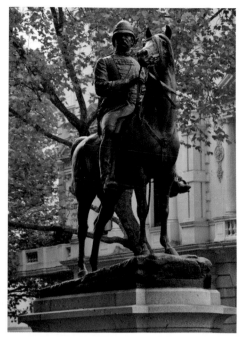

Napier's statue was moved to Queen's Gate from Waterloo Place in 1920.

Exhibition of 1851

(see page 154). The proposal for the memorial was put forward in 1853 and artists were invited to submit ideas to commemorate the event. Out of nearly fifty entries, Joseph Durham's design was selected, with the figure of Britannia standing above representations of the four corners of the globe. When a location in Hyde Park, close to the site of the exhibition, could not be agreed, the Royal Horticultural Society offered space in their new gardens to the south of the park, which were created using the surplus from the Great Exhibition and which Prince Albert had opened in 1861. When Albert died later that year the monument was redesigned with a statue of the prince, in honour of the important part he played in planning and organising the

event. It was given a dramatic setting, with water gushing from its base into a large basin. The memorial was unveiled in June 1863 in a ceremony attended by the Prince and Princess of Wales. By the 1880s the area was being developed to house museums and the Imperial Institute, so the gardens had to close and the memorial was moved to its present location in 1899. The 42-foot monument is of red and grey granite and Portland stone. Below the 10-foot bronze statue of Albert are bronze figures representing the four quarters of the globe, with bronze copies of the prize medals awarded at the exhibition. Around the base of the statue are two apposite biblical quotations including, from Isaiah, 'Let the nations be gathered together and let the people be assembled', reflecting the fact that, as well as showcasing the latest British artistic and scientific advances, the Great Exhibition had brought together people from all around the world.

Black-cab drivers refer to the junction of Kensington Gore and Exhibition Road as 'hot and cold corner', because on the outside of the Royal Geographical Society building are the statues of two explorers who travelled in Africa and the Antarctic. On the Exhibition Road façade is the bronze statue of **Sir Ernest Shackleton** (1874–1922), the Antarctic explorer whose 1915 expedition nearly ended in disaster. He made a heroic voyage with five companions to Georgia Island to get help for his crew, who were stranded on Elephant Island after the *Endurance* was trapped in the ice. He died at South Georgia on a later voyage. The statue, by Charles Sargeant Jagger, was unveiled in 1932, and shows Shackleton dressed in thick polar clothing, with bulky gloves hanging from his neck and wearing a balaclava.

On the Kensington Gore side is the statue of **David Livingstone** (1813–73), the famous missionary and explorer who, in his search for the source of the Nile, instead discovered the source of the Congo. His attempts to convert the natives were not a great success, but he was considered a great hero and, when his body was brought back to England, it lay in state in the Royal Geographical Society before being buried in Westminster Abbey. The statue, by Thomas Bayliss Huxley-Jones, was unveiled in 1953. It shows him in his familiar explorer's clothes, carrying a Bible and leaning on a stick.

In the courtyard of the Society is a memorial to **Sir Clements Markham** (1830–1916), who for twelve years was president of the RGS. It has a bronze bust by Frederick William Pomeroy, and was erected in 1921. It was presented by the Peruvian Government, in appreciation of Markham's contribution to the study of the geography, history and archaeology of their country. In 1860 he led an expedition to collect seeds of the cinchona tree, which were sent to India for the production of quinine, an important cure for malaria.

At the eastern end of Prince Consort Road is what was originally the Royal School of Mines, and is now part of Imperial College. On either side of the grand entrance arch are busts of **Alfred Beit** (1853–1906) and **Sir Julius Wernher** (1850–1912) by Paul Raphael Montford. Both were German mining magnates who made their money from South African diamonds. They both took British citizenship, became part of London society, and gave a lot of money

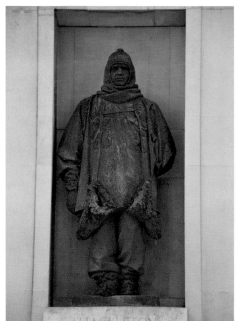
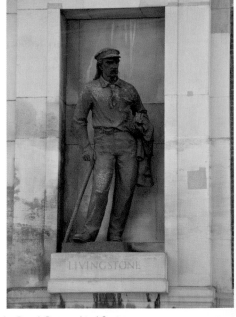

Explorers Shackleton and Livingstone on the outside of the Royal Geographical Society.

Sir Clements Markham was President of the Royal Geographical Society.

to charity. It was because of their bequests to the Royal School of Mines that they are commemorated there.

Close to the Brompton Oratory in Brompton Road is a marble statue of **Cardinal John Henry Newman** (1801–90) by the French sculptor, Léon-Joseph Chavalliaud, which was unveiled in 1896 by the Duke of Norfolk, the head of Britain's most important Catholic family. Newman studied and taught at Oriel College, Oxford, where he became involved with the Tractarian Movement. In 1845 he converted to Roman Catholicism and was ordained. In 1879 he was made a cardinal, and more than a hundred years after his death he is now a candidate for canonisation. He wrote the popular hymn *Lead, Kindly Light* as well as the poem *The Dream of Gerontius*. The statue stands under a very Italianate shrine

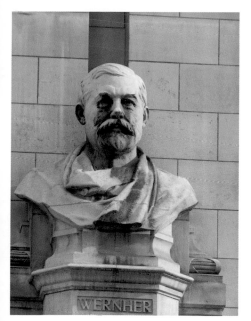

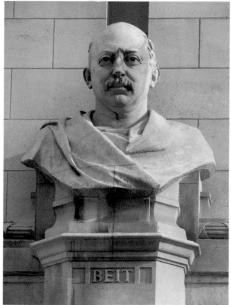

Busts of Wernher and Beit on a building they funded.

of Portland stone, surmounted by a figure of the Virgin and Child, and he is shown in his ecclesiastical robes and holding his biretta.

In Cromwell Gardens, a small garden opposite the Victoria and Albert Museum, is Angela Connor's **Yalta Memorial** (also known as **Twelve Responses to Tragedy**). On the top of a stone pedestal are powerfully expressive bronze faces, representing the innumerable men, women and children from the Soviet Union and other eastern European countries who were in German-occupied territory at the end of the Second World War and were repatriated after the Yalta Conference of 1945, only to be imprisoned and killed on Stalin's orders. The memorial was commissioned by members of all political persuasions from both Houses of Parliament and was dedicated in March 1982 by the Bishop of London. Sadly, it was soon damaged by vandals, but was replaced by the present sculpture in 1986.

In the front garden of the Norwegian Ambassador's residence in Palace Green is a statue of **Queen Maud** (1869–1938), the British-born Queen of Norway. She was the daughter of the future Edward VII and his Danish wife Alexandra, and she married Prince Carl of Denmark who, when Norway became independent, was elected King of Norway. The statue was made by the Norwegian artist Ada Madsen. The ceremony in 2005 was very much a family occasion, with the unveiling by King Harald of Norway in the presence of Queen Elizabeth II.

In Holland Park Avenue, at the junction with Holland Park, is a statue of **St Volodymyr** (*c.* 958–1015), the ruler of

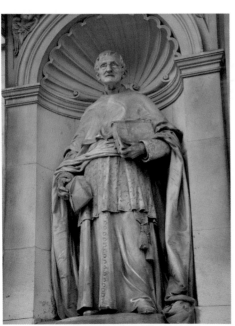

Cardinal Newman outside the Brompton Oratory.

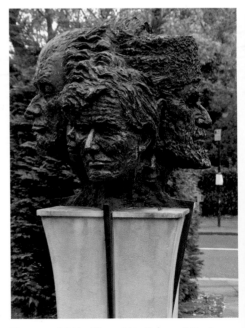

The powerful Yalta Memorial in Cromwell Gardens.

the Ukraine who introduced Christianity there in 988. The statue was commissioned by the Ukrainian community in London, and was unveiled in 1988 by the Mayor of Kensington to commemorate one thousand years of Christianity in Ukraine. It is the work of the Ukrainian sculptor Leonid Molodozhanyn (who shortened his name to Leo Mol, which is how he has signed the statue). The saint is shown as both a warrior and religious leader, with his left hand on a shield, and holding a cross in his right.

In the northern part of Holland Park, in the centre of a small pond, is a bronze statue of **Henry Fox, 3rd Baron Holland** (1773–1840) by G. F. Watts and Joseph Edgar Boehm. Watts created the clay model, and the casting was carried out by Boehm. Holland was a prominent Whig politician, and nephew of Charles James Fox, and the family seat, Holland House, was a meeting place for the political and literary greats of the period. He was also one of G. F. Watts's patrons. He is shown sitting comfortably in a chair, complete with walking stick. The cost of the statue was borne by the surplus money raised for his monument in Westminster Abbey, and was erected in 1870.

The **Queen Victoria Memorial** in Warwick Gardens was originally erected in the middle of High Street Kensington in 1904, to commemorate the late queen, who had been born in Kensington Palace. It was moved in 1934 when the High Street was widened. Half way up the red granite column is a medallion portrait of the queen. The monument was designed by H. L. Florence.

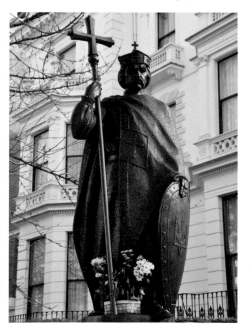

The statue of St Volodymyr in Holland Park Avenue.

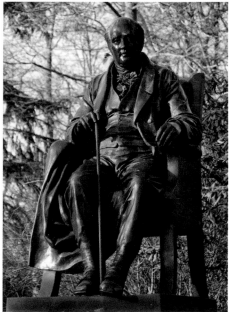

Henry Fox's statue in Holland Park is close to the family home.

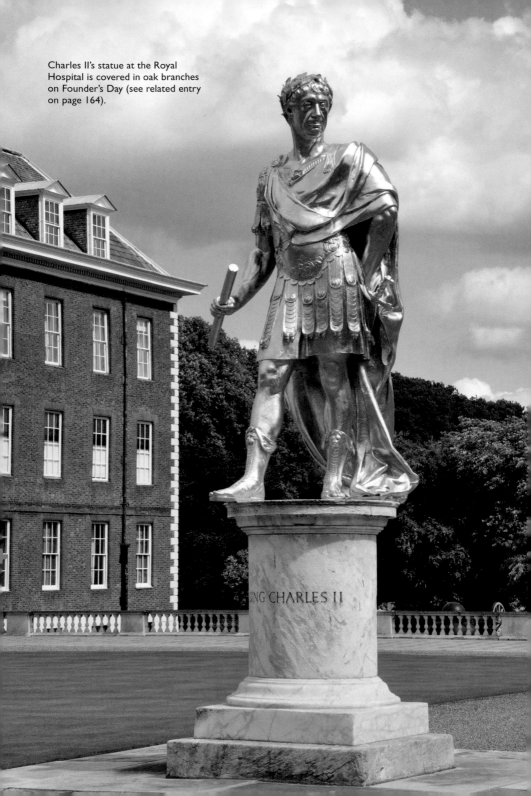

Charles II's statue at the Royal Hospital is covered in oak branches on Founder's Day (see related entry on page 164).

CHELSEA

In Duke of York Square, just off the King's Road near Sloane Square, is a statue of **Sir Hans Sloane** (1660–1753), the physician and naturalist who owned the manor of Chelsea, and whose name is remembered in many of its streets. The statue, by Simon Smith, is of Portland stone, and is a faithful copy of the Rysbrack statue which used to stand in the Physic Garden (see overleaf). For several years a replica used to stand in Sloane Square, and this new version, made in 2007, was due to be moved to a remodelled square, but the plans have now been abandoned, and the statue will remain here for the foreseeable future.

The Royal Hospital Chelsea was founded by Charles II to house veteran soldiers of his army, and the foundation stone of Wren's building was laid in 1682. Since then it has been home to up to four hundred pensioners, who are regularly seen in Chelsea and beyond wearing their instantly recognisable navy blue uniform. Until recently only men lodged there, but 2009 saw the arrival of the first two female pensioners. By the western entrance is a charming sculpture of a **Chelsea Pensioner**, by Richard Austin, who donated it to the hospital. It

is in full colour, showing the pensioner in the scarlet ceremonial uniform, sitting on a bench having a nap. Standing proudly on the north side of the building is a more formal bronze statue by Philip Jackson of

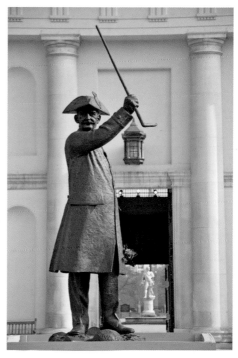

The Chelsea Pensioner salutes past comrades.

the Chelsea Pensioner, which was unveiled by the Duke of Westminster in 2000. He raises his stick to salute his past comrades and holds an oak branch in memory of the hospital's founder. Around the base of the statue is the soldier's prayer, a version of Sir Jacob Astley's words before the Battle of Edgehill in 1642: 'O Lord you know how occupied I shall be this day. If I forget thee do not forget me.'

In the Figure Court of the hospital is a bronze statue by Grinling Gibbons of **Charles II** (1630–85: see photograph on page 162), the hospital's founder. Like Gibbons's statue of James II in Trafalgar Square, he is shown with a laurel wreath on his head, dressed in Roman armour and holding a baton in his right hand. Both statues were commissioned by Tobias Rustat, who was Yeoman of the Robes. This statue was presented to the king in 1682 and installed here in 1685. It was originally gilded, but was bronzed in 1782. In 2002 it was re-gilded to commemorate the Queen's Golden Jubilee. Founder's Day is celebrated here every year on a day close to 29 May, Charles's birthday and the date of his restoration to the monarchy. On that day, also called Oak Apple Day, the pensioners parade in the Figure Court and are usually reviewed by a member of the royal family. They all wear sprigs of oak and the statue is also decked with oak branches, to commemorate the king's escape from the Parliamentary forces by hiding in an oak tree after the Battle of Worcester.

In the grounds of the hospital, towards the river, is a granite obelisk by Charles Robert Cockerell, erected in 1853 to commemorate the men of the 24th Regiment who died in the **Battle of Chillianwallah** in the Second Sikh War in 1849. The battle lasted all day and much of the night, before heavy rain brought it to an end, and both sides claimed victory. There is no access from the main part of the hospital, but it can be approached from the Embankment. During the month of May the memorial stands at the heart of the Chelsea Flower Show. Chelsea Physic Garden, entered from Swan Walk, was established in 1676 by the Apothecaries' Company, and at its centre stands a statue of **Sir Hans Sloane** (1660–1753), the physician and naturalist. Sloane, who was Lord of the Manor, presented the gardens to the Society of Apothecaries in 1722 on

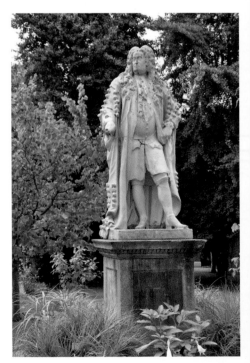

Sir Hans Sloane stands at the heart of the Chelsea Physic Garden.

condition that they supplied two thousand dried plants to the Royal Society. In 1732 the marble statue was commissioned by the Society from Michael Rysbrack, the leading sculptor of the day. It was installed in 1737 in a greenhouse, but in 1748 it was moved to the centre of the garden. Sloane is shown in a long wig, wearing the robes of the President of either the Royal Society or the Royal College of Physicians. Like so many of London's marble statues, the original deteriorated due to the polluted atmosphere, and in 1983 it was moved to the British Museum, though it is not currently on display. The museum produced a fibreglass replica for the garden, but within a few years this had to be replaced by a new copy, this time made of an artificial stone called jesmonite, but this has already begun to show signs of cracking.

In the eastern section of Cheyne Walk is a drinking fountain in memory of **Dante Gabriel Rossetti** (1828–82), the poet and painter, and co-founder of the Pre-Raphaelite Brotherhood. For twenty years he lived at Queen's House in Cheyne Walk, where he kept a menagerie of exotic animals, including a kangaroo, a wombat, and peacocks whose loud cries upset the neighbours. The fountain was designed by J. P. Seddon, and the bust is by Ford Madox Brown. It was unveiled in 1887 by William Holman Hunt, who was a co-founder of the PRB. The original bronze bust was stolen some years ago and replaced with a fibreglass copy.

Close by is **The Boy David** by Edward Bainbridge Copnall, which was erected in 1975 as a memorial to the men of the Machine Gun Corps who served in the First World War (see overleaf). David holds

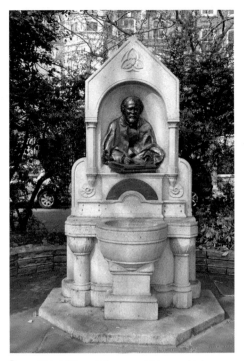

Dante Gabriel Rossetti's memorial is near his home in Cheyne Walk.

a sword and the head of Goliath lies at his feet. The sculpture, of bronzed fibreglass, stands on a polished granite column with a bronze capital. According to a badly worn plaque, it replaces Derwent Wood's original model for the figure of David for the Machine Gun Corps memorial at Hyde Park Corner, which was presented to the Council in 1963, but stolen shortly afterwards.

On the corner of Oakley Street, opposite the Albert Bridge, is David Wynne's striking **Boy with a Dolphin.** Wynne used his youngest son, Ronald, as a model, and it was erected here in 1975. Ronald died in 1999, aged thirty-five, and

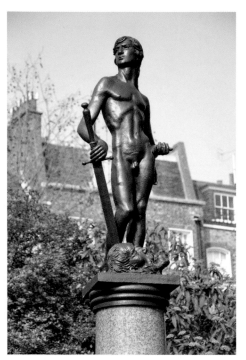

The Boy David commemorates the men of the Machine Gun Corps.

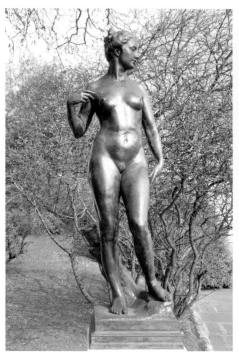

Derwent Wood's Atalanta is in memory of the sculptor, who lived in Chelsea.

the sculpture is now his memorial. On the western side of Albert Bridge is a bronze sculpture of **Atalanta** by Derwent Wood. In 1929 it was put up in the sculptor's memory by his friends in the Chelsea Arts Club. It was stolen in 1991, and has been replaced by a replica.

In the next section of garden is a fine statue of the writer and historian **Thomas Carlyle** (1795–1881), who lived in Cheyne Row for the last forty years of his life, and was often referred to as the 'Sage of Chelsea'. His house has been preserved as it was and is now a museum. The statue is by Sir Joseph Edgar Boehm, and it was unveiled in 1882. It

portrays Carlyle sitting comfortably in his armchair, wearing a dressing gown and looking pensive. It is a very good likeness, as Boehm modelled it from the life only a few years earlier.

In front of Chelsea Old Church is a statue of **Sir Thomas More** (1478–1535). It is a fitting location, as he once lived in a house nearby and worshipped in the church. Lawyer, scholar and writer, More was Lord Chancellor of England, becoming a close friend of Henry VIII. Because of his firm religious beliefs, he was unable to support Henry's divorce from Katharine of Aragon, and refused to accept him as Head of the Church in

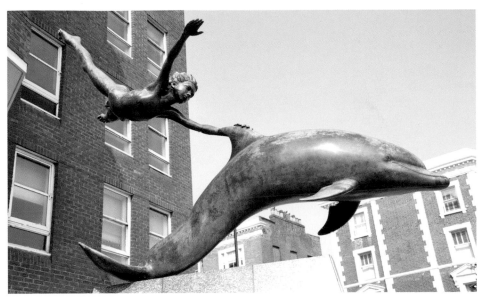

David Wynne's *Boy with a Dolphin* on Chelsea Embankment.

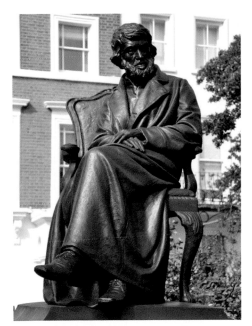

The statue of Thomas Carlyle is considered to be Boehm's finest.

England. For this he was executed, and his head was displayed on London Bridge. His actions against heretics have made him a controversial figure in recent years, but the Roman Catholic Church considers him to be a martyr. In 1935 he was canonised, and in 2000 he was made the patron saint of politicians. The statue, by L. Cubitt Bevis, was unveiled in 1969 by Dr Horace King, Speaker of the House of Commons, accompanied by representatives of the Anglican and Catholic churches. Although the statue is of bronze, it is unusual in being coloured. More sits on a stool, in a dark robe, and his face and hands are gilded, as are the chain of office on his knees and the crucifix round his neck. There was some controversy at the time about the statue, and Sir John Rothenstein, the highly respected art historian, resigned from the selection committee over the design, while

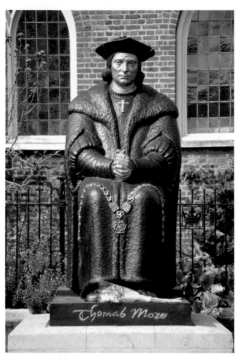

Sir Thomas More sits outside the church where he worshipped.

This sculpture by Epstein stands close to the sculptor's studio.

others felt a sitting figure was undignified, as he appeared to be sitting on the toilet.

Roper Gardens, on the other side of Old Church Street, is on the site of More's orchard. In it is a relief by **Jacob Epstein** (1880–1959), erected here to commemorate the years from 1909 to 1914 when he lived and had a studio near here. It was unveiled in 1972 by Admiral Sir Caspar John, son of the artist, Augustus John.

In a small garden alongside Battersea Bridge is a bronze statue of the artist **James Abbott McNeill Whistler** (1834–1903) by Nicholas Dimbleby. Whistler is closely associated with Chelsea, as he lived there

and helped found the Chelsea Arts Club. He painted views of the river, including many of old Battersea Bridge, and this part of the river is now known as Whistler's Reach. One of his loosely painted pictures of the Thames was criticised by Ruskin as 'flinging a pot of paint in the public's face', and Whistler sued him. Although Whistler won, he was famously awarded only a farthing in damages. Adapting Whistler's own loose painting style, Dimbleby has produced a rather impressionistic sculpture. Whistler is shown looking out at the river, sketchbook in one hand and pencil in the other, with a bag at his feet. It was hoped that the statue would be installed in 2003

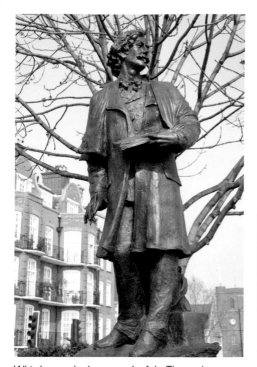

Whistler overlooks a stretch of the Thames he painted many times.

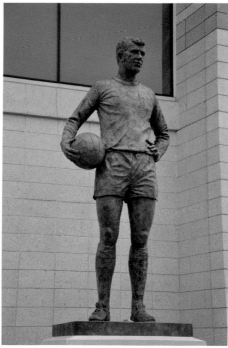

Peter Osgood played for Chelsea for fifteen years.

to celebrate the hundredth anniversary of Whistler's death, but there were problems getting planning permission and raising the funds, and it was finally unveiled in 2005 by Viscount Chelsea.

Further west, in the Fulham Road, is the Chelsea Football Club, Stamford Bridge. Outside the West Stand is a statue of **Peter Osgood** (1947–2006). Known as

'Ossie', Osgood was considered to be one of Chelsea's greatest players. He played 376 games for the club from 1964 to 1978, scoring 152 goals, but only played four times for England. His ashes are buried under the penalty spot at the Shed End of the pitch. The statue, by Philip Jackson, was unveiled in 2010.

PADDINGTON AND BAYSWATER

O N PLATFORM 8 of Paddington Station is a statue of **Isambard Kingdom Brunel** (1806–59), the great nineteenth-century engineer who built the station, as well as all the tunnels and bridges of the Great Western Railway it served. He is seated, and holds his trademark stovepipe hat in his left hand. The sculpture was

Isambard Kingdom Brunel's statue at Paddington Station.

Jagger's Great Western Railway War Memorial.

commissioned from John Doubleday by the Bristol & West Building Society and was unveiled in 1982 by the Lord Mayor of Westminster. It originally stood on the main concourse at the entrance to the Underground, but in 1998 it was moved to a less conspicuous location off Platform 1, and when work on Crossrail began in 2014 it was moved to this more visible site.

On Platform 1 is the **Great Western Railway War Memorial**, which was unveiled on Armistice Day 1922 by Viscount Churchill, Chairman of the company, to commemorate the company employees who died in the First World War. It was re-dedicated in 1949 to include those who lost their lives in the Second World War. Charles Sargeant Jagger's bronze statue of a soldier, greatcoat draped over his shoulders, and reading a letter from home, is one of his more modest war memorials, but is very moving. The memorial was designed by Thomas S. Tait, the Scottish architect, who worked with Jagger on a number of war memorials.

On Platform 1 is a statue of **Paddington Bear** by Marcus Cornish. It was unveiled in 2000 by Michael Bond, author of the immensely popular Paddington books, the first of which was published in 1958. It portrays the bear as he first appears, having found his way to Paddington Station from

Paddington Bear sits at the station after which he is named.

The statue of Sir Simon Milton is at the heart of the Paddington Basin development.

Sarah Siddons as the Tragic Muse.

regularly attended. She was best known as a tragedienne, and is portrayed here in a pose inspired by Reynolds's portrait of her as the Tragic Muse. The statue is by the French sculptor, Léon-Joseph Chavalliaud. It was unveiled in 1897 by Sir Henry Irving, and was the first statue in London to commemorate a woman who was not a member of the royal family.

In Inverness Terrace, at the junction with Porchester Gardens, is a bronze bust of **George Kastrioti Skanderbeg** (1405–68), an Albanian national hero. The work of Albanian sculptor, Kreshnik Xhiku, it was unveiled in 2012 to mark the one hundredth anniversary of Albanian independence. Skanderbeg, also known as Iskender Bey, won many battles against

'darkest Peru', sitting on a battered suitcase, wearing nothing but a hat and with a label round his neck saying, 'Please look after this bear. Thank you.' He is ever popular, and people love to have their photograph taken sitting next to him.

In Merchant Square, at the heart of Paddington Basin behind Paddington Station, is a life-size bronze statue of the politician **Sir Simon Milton** (1961–2011). The statue is by Bruce Denny, and Milton is sitting on a wall overlooking a fountain, looking around him at the major new development he was instrumental in creating.

On Paddington Green, on the north side of Harrow Road, is a marble statue of **Sarah Siddons** (1755–1831), the great actress, who lived at Westbourne Green and was buried in the churchyard of nearby St Mary's Church, which she

The bust of the Albanian hero Skanderbeg in Bayswater.

The Earl of Meath's memorial in Lancaster Gate.

the Ottomans, but to no avail, and Albania remained part of the Ottoman empire until 1912.

In Lancaster Gate, just off the Bayswater Road, is a memorial to **Reginald Brabazon, 12th Earl of Meath** (1841–1929), the politician and philanthropist who was responsible for the creation of Empire Day, which was renamed Commonwealth Day in 1958. The stone memorial, by Joseph Hermon Cawthra, has a relief portrait of the Earl on the front, and a badly-worn figure of a seated boy on top.

MARYLEBONE

IN GREAT CUMBERLAND Place, to the north of Marble Arch, is the statue of **Raoul Wallenberg** (1912–1947?), the Swedish diplomat who saved the lives of around 100,000 Hungarian Jews during the Second World War. It stands, fittingly, very close to the Western Marble Arch Synagogue and the Swedish Embassy. After the German invasion of Hungary in 1944, Wallenberg worked to prevent the Nazis sending Jews to the concentration camps. His main weapons were the *schutz-passes*, temporary Swedish passports he issued to the Jews, which he persuaded the authorities to recognise, and 'Swedish houses' where they could shelter. Even when the Jews were being deported in trainloads, Wallenberg risked his own life, distributing the passports and demanding the soldiers release the prisoners. When the Russians arrived in 1945 Wallenberg was arrested as a spy and taken to Moscow. He was never heard of again and the Russians claimed he died in prison, but recent revelations suggest he was killed on Stalin's orders. The statue is by Philip Jackson and was unveiled in 1997 by the Queen. The unveiling was attended by the Israeli President and the United Nations Secretary General, as well as five people who owed their lives to Wallenberg's bravery.

Wallenberg is shown standing in front of a wall, which is composed of 100,000 *schutz-passes* draped in the Swedish flag. A version of the memorial also stands in Buenos Aires in Argentina.

On the south side of the gardens in Cavendish Square is a bronze statue of **Lord William George Frederick Cavendish-Scott-Bentinck** (1802–48). Bentinck was

Raoul Wallenberg saved many lives in World War Two.

an influential politician, but he was also addicted to hunting, and would often arrive in Parliament straight from the hunt, with his pink coat under a topcoat. Another passion was racing, and his horses won many classic races. The statue, by Thomas Campbell, was erected in 1851, and depicts him wearing his habitual frock coat, covered by a long cloak.

In the centre of the square is London's less well-known empty plinth, though this one did once hold a statue. It was an equestrian statue in lead, by Sir Henry Cheere, of the **Duke of Cumberland** (1721–65), the second son of George II. He commanded the Army in various continental campaigns, but it was his defeat of the forces of the Young Pretender at Culloden which earned him the nickname 'Butcher', especially for his ruthless slaughter of Jacobites after the battle. In London, however, he was considered a hero, and Handel wrote 'The Conquering Hero' in his honour. The statue was erected in 1770, paid for by Lieutenant-General William Strode. In 1868 it was in poor condition and was taken down to be repaired, but it was never replaced, and was probably melted down.

Under the circular portico of All Souls Church in Langham Place is a bust of **John Nash** (1752–1835). Nash was the architect and town planner who worked closely with the Prince Regent to improve London's townscape, and his work can be seen all over London. He designed Regent's Park,

The immaculately dressed Bentinck in Cavendish Square.

The plinth which once held the statue of the Duke of Cumberland.

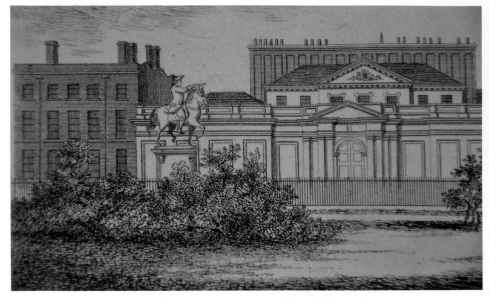

An engraving of 1808 showing what the statue of the Duke of Cumberland looked like.

and Regent Street was created to link it with the Prince Regent's palace, Carlton House, which overlooked St James's Park. He built All Souls Church, with its sharp spire, to create a vista up Regent Street, at the point where it takes a sharp bend into Portland Place. The bust, a copy by Cecil Thomas of an original by William Behnes, was erected in 1956.

At the bottom of Portland Place, on the central reservation, is a bronze statue of **Quintin Hogg** (1845–1903). Hogg was a merchant who made his money from sugar, but his legacy is in the world of education. He created the Regent Street Polytechnic in 1882, offering education opportunities to lower-middle-class men and women. It is now the University of Westminster. Sir George Frampton's memorial, erected in 1906, has a seated Hogg reading to two boys, one of whom is dressed for football. On the

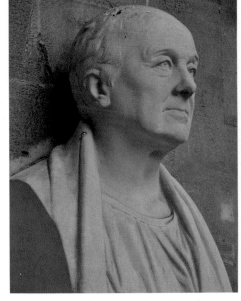

John Nash looks down Regent Street from the portico of All Souls Church.

western side of the plinth is an inscription to his wife, Alice, in memory of her contribution to the Polytechnic, and a later inscription on the eastern side of the plinth remembers members of the Polytechnic who died in the two world wars.

Further north, where Weymouth Street crosses Portland Place, is a bronze equestrian statue to **Sir George Stuart White** (1835–1912). White was a much-decorated army officer who fought in Burma and Afghanistan, but is best known as the 'hero of Ladysmith', which he defended when it was besieged for 118 days during the Boer War. The statue, by John Tweed, was unveiled in 1922 by Lord Derby.

North of Weymouth Street is a larger than life statue by Faith Winter of **General Władysław Sikorski** (1881–1943). After the German invasion of Poland in 1939 Sikorski was prime minister of the Polish

Quintin Hogg in Portland Place.

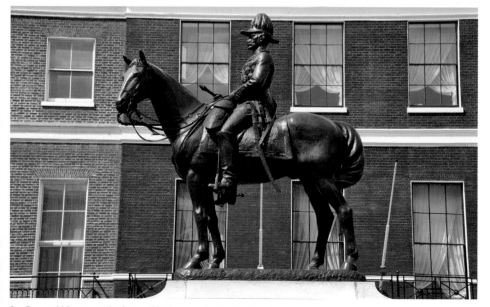

Sir George White was the hero of Ladysmith during the Boer War.

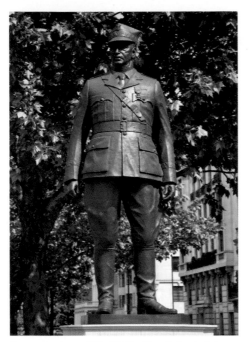

During the Second World War Sikorski headed the Polish Government in exile in London.

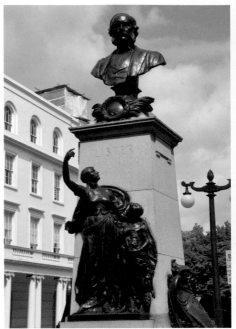

Lister's memorial was the last work of Sir Thomas Brock.

Government in exile and Commander-in-Chief of the Polish Armed Forces, based at the nearby Embassy. In 1943, returning from an inspection of Polish troops in the Middle East, his plane crashed after take-off from Gibraltar, killing all the passengers. During the war Polish airmen, soldiers and seamen fought bravely alongside Allied forces, and they are also commemorated here, as are members of the resistance. The statue was unveiled in 2000 by the Duke of Kent.

At the top of Portland Place is a memorial to the famous surgeon, **Joseph, Lord Lister** (1827–1912), whose most important work was the introduction of antiseptic surgery. He taught and operated in Edinburgh and Glasgow before becoming professor at King's College, London. In

1922 the commission for the memorial was given to Sir Thomas Brock, whose last work this was. It consists of a large bronze bust on top of a tall plinth, with the allegorical figures below of a young woman representing Humanity and a boy holding a garland of flowers. Under the bust on each side are the words Surgery and Science. It was unveiled in 1924 by the President of the Royal College of Surgeons, and stands close to Lister's home at 12 Park Crescent.

In Park Crescent, looking down Portland Place, is a statue of **Prince Edward, Duke of Kent** (1767–1820). The Duke was the fourth son of George III and had a mixed career in the Army. He had a number of mistresses, several illegitimate children, and was always short of money,

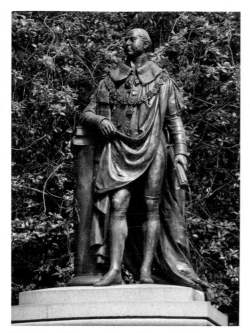

The Duke of Kent was Queen Victoria's father.

The bust of J.F. Kennedy stands beside the busy Marylebone Road.

but was said to have had great charm. He is best known as the father of Queen Victoria. The bronze statue, by the little-known Irish sculptor, Sebastian Gahagan, was erected in 1824, according to the inscription, by 'the supporters of the numerous charities he so zealously and successfully patronised'.

In Marylebone Road, just to the east of Park Crescent, in front of the International Student House, is a bronze bust of **John Fitzgerald Kennedy** (1917–63), the thirty-fifth President of the United States of America. The bust is by the Cubist sculptor Jacques Lipchitz. It was paid for by readers of the *Sunday Telegraph,* and was unveiled in 1964 by his brother, Robert Kennedy.

Outside Baker Street station, on the Marylebone Road, is a bronze statue of **Sherlock Holmes**, the famous fictional detective. It was commissioned by the Sherlock Holmes Society of London from John Doubleday, who had already produced a statue of the detective which was erected in Switzerland in 1988. It was paid for by public subscription and sponsorship by Abbey National who, until 2005, occupied the site nearest to the fictitious address of the detective, 221B Baker Street, and answered all mail addressed to him. The statue was unveiled by Lord Tugendhat, Chairman of Abbey National, in 1999. It is 9 feet tall, and shows the sleuth in his characteristic deerstalker hat and holding a meerschaum pipe.

Opening off the Inner Circle in Regent's Park are the peaceful and little known

John Doubleday's statue of Sherlock Holmes stands outside Baker Street Station.

The Goatherd's Daughter is in a 'secret' garden in Regent's Park.

St John's Lodge Gardens. Here is a bronze statue by C. L. Hartwell, **The Goatherd's Daughter**, which was erected in 1932 by the National Council for Animal Welfare in memory of Harold and Gertrude Baillie Weaver, who were firm supporters of animal rights. It depicts a young woman with a goat cradled under her arm, and the inscription on the plinth says 'To all protectors of the defenceless'.

At the north end of The Broad Walk in Regent's Park is the rather weathered Gothic **Readymoney Fountain**, erected in 1869. It was the gift of Sir Cawasji Jehangir, a wealthy Parsee from Bombay who wished to thank the English people for the protection given to the Parsees under British rule in India. Readymoney was a nickname given to the family, who adopted it as a surname.

The Readymoney Fountain in Regent's Park.

Guy the Gorilla lives on in London Zoo.

Sir Cawasji was made a Companion of the Star of India in recognition of his many donations to charity and he was known as 'The Peabody of the East'. The fountain was inaugurated by Princess Mary, Duchess of Teck (the mother of the future Queen Mary).

The northern part of Regent's Park is occupied by London Zoo, which contains several interesting memorials. Left of the entrance, in front of the café, is a statue of **Guy the Gorilla**, who was a bit of a celebrity in the 1960s and '70s, regularly appearing in television natural history programmes. Captured in the French Cameroons, he arrived at the zoo on 5 November 1947, and was named 'Guy' after Guy Fawkes. The sculpture, by William Timym, was put up in 1982.

Close by, outside the butterfly house, is the **London Zoo War Memorial**, which commemorates the zoo workers who died in both world wars. It was designed by John James Joass, and is a curious, minaret-like structure, based on a medieval *lanterne des morts* (lantern of the dead) in the cemetery at La Souterraine in France.

Near the big cats' enclosure is the **Ambika Fountain**, which was erected in memory of Ambika Paul (1963–68).

The unconventional London Zoo War Memorial.

Ambika died of leukaemia, but during her treatment she was regularly brought to the zoo by her family, and these were the best days of her short life. The fountain, with a sculpture of Ambika by Shenda Amery, was dedicated in 1994 by her parents, Swraj and Aruna Paul. In 1996 Swraj became a peer and in 2001 a bust of **Lord Paul of Marylebone** (1931–) was erected outside the entrance to the children's zoo he had funded in 1992.

Winnie-the-Pooh is, it would seem, a quintessentially British bear, but he was actually Canadian. In 1914 Lieutenant Harry Colebourn, on his way to join the Canadian Army Veterinary Corps in Quebec, bought a black bear cub from a hunter who had killed its mother. He called it Winnie, after his home town, Winnipeg and it became his regiment's mascot. Passing through

The short life of Ambika Paul inspired this fountain.

on the way to fight in France, he left the bear at London Zoo, asking them to care for it while he was away. When he returned after the war he found the bear was clearly happy there and donated her to the zoo, where she became a firm favourite, especially with children, who were allowed to stroke her. A.A. Milne often took his son, Christopher Robin, to the zoo, where he met Winnie, made friends with her and sometimes fed her condensed milk. He later named his own bear Winnie, and his father soon began to write the much-loved stories about the 'bear of very little brain'. There are two statues of Winnie in the zoo. Behind the reptile house is a statue of the bear by Lorna McKean, which was unveiled in 1981 by Christopher Milne. Behind the café of the Children's Zoo is a sculpture of Winnie with Lieutenant Colebourn by Canadian sculptor, Bill Epp, which was unveiled in 1995.

This Canadian bear was the inspiration for Winnie-the-Pooh.

BLOOMSBURY, EUSTON AND ST PANCRAS

I N BLOOMSBURY WAY is Nicholas Hawksmoor's St George's Church. Its unusual stepped spire is based on the Mausoleum at Halicarnassus, one of the seven wonders of the ancient world, and standing rather incongruously at its summit is a statue of **George I** (1660–1727) by an unknown sculptor. The King is dressed in Roman costume and has a lightning conductor sprouting from his head. The statue was presented by William Hucks, a brewer and MP for Abingdon, and has given rise to much hilarity ever since it was erected. Horace Walpole considered it 'a masterpiece of absurdity', and a wag penned the following verse:

> When Henry the Eighth left the Pope in the lurch
> The people of England made him head of the church
> But, much wiser still, the good Bloomsbury people
> 'Stead of head of the church, made him head of the steeple.

On the north side of Bloomsbury Square, looking up Bedford Place, is the bronze statue of **Charles James Fox**

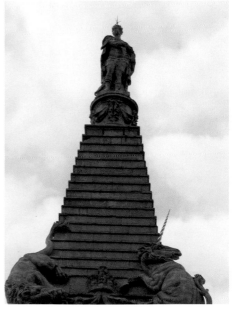

One of London's most curious memorials has George I standing on top of a church steeple.

(1749–1806). Fox was a formidable Whig politician, a superb debater, and an opponent of Pitt and George III. He supported the Americans in the War of Independence, opposed slavery, and was about to introduce a bill abolishing the slave trade when he died. He was a larger-than-

life figure in every way, a lover of women, a great drinker and an inveterate gambler. He was also the most caricatured politician of his age, instantly recognisable by his portly figure and bushy eyebrows. The statue is by Sir Richard Westmacott, the prolific neo-classical sculptor, and was erected in 1816. It was paid for with excess funds raised for his monument in Westminster Abbey, also by Westmacott. He is dressed in a toga like a Roman senator, and holds a copy of the Magna Carta, symbolising his love of liberty. The location for the statue was suggested by the 6th Duke of Bedford, as the area had Whig associations. Fox looks towards Russell Square and the statue of his friend, the 5th Duke of Bedford.

On the south side of Russell Square, the statue of **Francis Russell, 5th Duke of Bedford** (1765–1802) is one of the most delightful in London, but rather ignored amidst the noisy traffic. Russell was a Whig politician and great friend and supporter of Charles James Fox, but his greatest passion was agriculture and the management of his estates, both in the country and London. He was a founder member of the Board of Agriculture, the first president of the Smithfield Club and set up a model farm at Woburn Abbey, the family estate in Bedfordshire. Sir Richard Westmacott's statue, erected in 1809, follows the agricultural theme with great zest. The Duke stands with his right arm on a plough

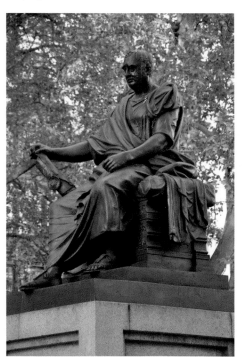

Westmacott depicted Charles James Fox seated, as it was said he would not look dignified standing.

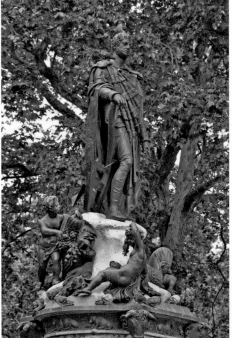

The Duke of Bedford's memorial is covered in agricultural references.

and holds ears of corn in his left hand, and below him are four young boys symbolising the four seasons. Around the cornice are cattle, sheep and pigs, at the four corners are the heads of oxen, and on two sides of the plinth are bronze bas reliefs of scenes from rural life.

On the west side of Russell Square, over a door at No. 30, now part of Birkbeck College, but originally the Institute of Chemistry, is a statue of **Joseph Priestley** (1733–1804). Priestley was a Presbyterian minister who later became a chemist, and he is best known for having identified several gases, including oxygen. The statue is the work of Gilbert Bayes and was erected in 1914.

In the gardens of Gordon Square is a bust of **Rabindranath Tagore** (1861–1941), the Indian poet and philosopher. Tagore is considered to be India's greatest writer, and in 1913 he was awarded the Nobel Prize for Literature, the first non-European to be honoured. Two of his songs are now the national anthems of India and Bangladesh. In 1915 he was given a British knighthood, but he returned it in 1919 in protest at the Amritsar massacre. Although anti-imperialist and an advocate of Indian nationalism, he also promoted international harmony. He supported Gandhi, whose monument is in nearby Tavistock Square, but was not politically very active, often preferring to withdraw from the world.

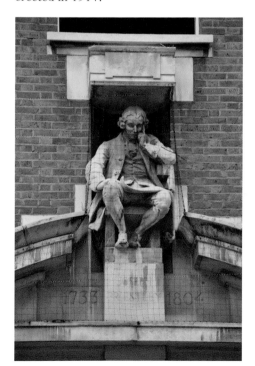

Joseph Priestley sits over a doorway in Russell Square.

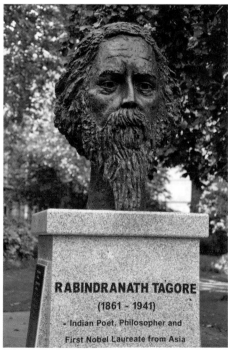

The bust of Rabindranath Tagore in Gordon Square.

The bust is the work of Shenda Amery, and was unveiled in 2011 by Prince Charles, very close to University College, London, where Tagore studied in 1878–9.

In the north-east corner of Gordon Square is a bust of **Noor Inayat Khan** (1914–44), an Indian writer and musician who became a secret agent with the Special Operations Executive. She was living in France when war broke out, and the family escaped just before the government surrendered to the Germans. In 1943 she was sent back to occupied France to work with the Resistance as a radio operator, using the codename Madeleine. Sadly, she was soon betrayed to the Germans, who

The bust of Noor Inayat Khan stands in a quiet corner of Gordon Square, where she liked to sit and read.

arrested and tortured her, though she gave them no information. She was later sent, with three other female agents, to Dachau, where they were all shot. She was posthumously awarded the George Cross and the Croix de Guerre for her bravery. Noor had lived in Taviton Street, off Gordon Square, and would often sit on a bench in the square, reading a book. Karen Newman's sculpture of her is located close to the spot. It was unveiled in 2012 by the Princess Royal.

In Gower Street, on the wall opposite University Street, is a memorial plaque to **Richard Trevithick** (1771–1833), the Cornish engineer. He was a pioneer in the development of steam engines and built several of the early steam locomotives, though he never made a commercial success of his inventions. In 1808 he set up a circular track near here on which his third locomotive, the *Catch Me Who Can*, offered rides to the public for one shilling, travelling at up to 12 mph. Although it was not a success, it was the first steam locomotive to carry passengers. The plaque, with a portrait of Trevithick and of the engine, was erected in 1933, the centenary of the engineer's death. It is by L. S. Merrifield.

On the corner of Fitzroy Street and Fitzroy Square is a statue of **Francisco de Miranda** (1750–1816), the Venezuelan revolutionary who, although he failed in his attempt to free his country from Spanish rule, began the process which was completed by Simón Bolívar. In 1811 he defeated the Spanish and declared Venezuelan independence, but was later captured by the Spanish and died in a Spanish prison. His London home, at nearby

Trevithick operated the first passenger train service near this plaque in Gower Street.

Miranda helped to free Venezuela from Spanish rule.

58 Grafton Way, is now the Venezuelan Embassy. The statue, the best by far of the four to Latin American Liberators in London, was made by Venezuelan sculptor Rafael de la Cova in 1895, and was unveiled in 1990.

By the western entrance to Euston Station is a statue by Marochetti of **Robert Stephenson** (1803–59), the great engineer. He is best known for the bridges he built, but he also worked with his father, George, in the construction of railways, including the London & Birmingham Railway, of which Euston Station was the terminus. Marochetti originally wanted his statue to stand in Parliament Square, but in 1871 it was erected between the two lodges that still stand in Euston Square. When the area was rearranged in the 1960s, following the controversial demolition of the Euston Arch, the statue was moved to its present location. A statue by Baily of Stephenson's father, which stood in the main entrance to the station, is now at the National Railway Museum in York.

On the busy main concourse of Euston Station, and rather lost among the crowds, is the statue of **Matthew Flinders** (1774–1814), the naval officer who surveyed most of the coast of Australia, and gave the island its name. He is a great hero in Australia, where he has a few statues, and his name has been given to several places, such as

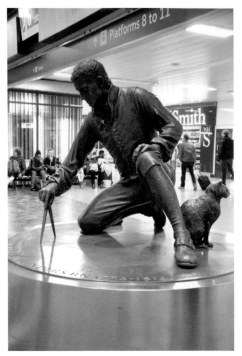

Robert Stephenson stands outside Euston Station.

Matthew Flinders with his cat Trim.

Flinders River. He was buried in the St James's burial ground in Hampstead Road, though the grave has been lost. It is even suggested that his remains lie somewhere under Euston Station, which explains the location of the statue. It is the work of Mark Richards, and shows Flinders working on a map, with his cat, Trim, beside him.

In the centre of Tavistock Square is a statue of **Mahatma Gandhi** (1869–1948). Gandhi was a great Indian leader, famous for his philosophy of non-violent protest. He studied law in London, and worked as a lawyer in South Africa, where he took up the struggle for Indian minority rights. He is shown sitting cross-legged in a dhoti, meditating. The statue is by Fredda Brilliant,

and it was unveiled in 1968 by the Prime Minister, Harold Wilson. The hollow plinth allows the memorial to be treated as a shrine, and flowers are often left there.

Close by is the **Conscientious Objectors' Stone**, which commemorates people around the world who refuse to go to war. The memorial, a great slab of slate with a simple plaque, was paid for with money raised by the Peace Pledge Union, and was unveiled in 1994 by the composer Sir Michael Tippett, who himself refused to fight in the Second World War.

In the south-east corner of the square is an unusual memorial to **Dame Louisa Brandreth Aldrich-Blake** (1865–1925), the first woman to qualify as a surgeon.

Gandhi sits in contemplation in the centre of Tavistock Square.

The unusual memorial to Dame Aldrich-Blake, with two identical busts.

During a long career she worked at three nearby hospitals, the Elizabeth Garrett Anderson Hospital, the Royal Free Hospital and the London School of Medicine for

Women. The memorial, which includes a seating area below, was designed by Sir Edwin Lutyens, and was unveiled in 1927. It incorporates two identical bronze busts by Arthur George Walker, based on a portrait by Sir William Orpen.

In the south-west part of the garden is a bronze bust of the writer, **Virginia Woolf** (1882–1941), one of the leading members of the Bloomsbury Group. It is close to the house where she and her husband, Leonard, lived and ran their publishing house, the Hogarth Press, from 1924 until 1939. It was here that she wrote many of her most important books. The memorial is a replica of the bust created by Stephen Tomlin in 1931, and was erected in 2004 by the Virginia Woolf Society of Great Britain.

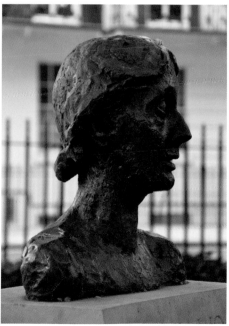

A bust of Virginia Woolf stands near her Bloomsbury home.

In Cartwright Gardens is a bronze statue of **John Cartwright** (1740–1824). Cartwright was a political reformer who advocated universal suffrage, opposed the slave trade and defended American independence. In 1821, at the age of eighty-one, he was arrested for sedition, and although he asked to be imprisoned, the judge was merciful and fined him instead. His statue, by the little known Birmingham sculptor George Clarke, was erected in 1831, opposite his house in Burton Crescent, and the street was renamed Cartwright Gardens in his honour.

The refurbished St Pancras Station reopened to much acclaim in 2007 as the Eurostar terminal. It had nearly

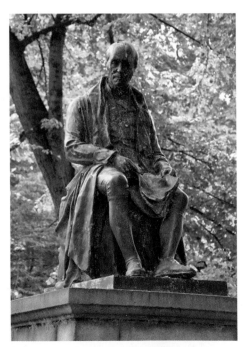

The political reformer John Cartwright in a street named after him.

been demolished in the 1960s, when High Victorian Gothic architecture was out of favour, but it was saved thanks to a campaign for it to be preserved. The person most instrumental in saving this iconic building was the poet, **Sir John Betjeman** (1906–84), and he is now remembered by a larger-than-life bronze statue at the heart of the station. The sculpture, by Martin Jennings, has the poet holding on to his hat and looking up at the magnificent roof of the train shed in wonder, as if he has just seen it for the first time. His coat flies in the wind and he holds a carrier bag full of books. It is a captivating and realistic sculpture and, as it stands on the ground and not on a plinth, it attracts the passing crowds in a way other statues do not.

On the main concourse of King's Cross station is a larger than life statue of **Sir Nigel Gresley** (1876–1941), the great railway and locomotive engineer. He worked for the Great Northern Railway and later the London & North Eastern Railway, both of which operated into King's Cross, and it was here that he had an office. He is most famous for his Pacific locomotives, including *Mallard*, which still holds the world speed record for a steam locomotive. The sculptor, Hazel Reeves, originally intended to include a mallard duck at Gresley's feet (referring not only to the locomotive, but also Gresley's interest in breeding ducks), but sadly members of Gresley's family objected, calling it demeaning. When the statue was unveiled in 2016 there was no mallard, though many onlookers brought toy ducks as a protest.

At the end of Brunswick Square, by the entrance to the Foundling Museum, is

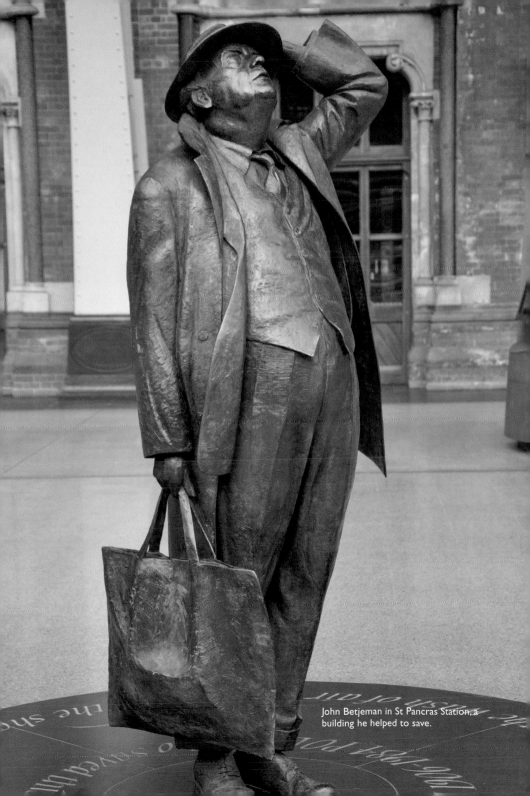

John Betjeman in St Pancras Station, a building he helped to save.

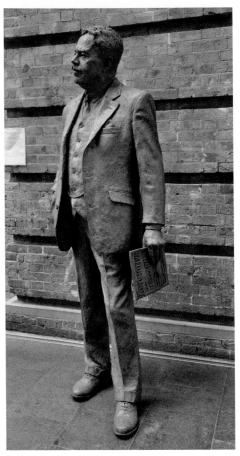

The larger-than-life statue of Sir Nigel Gresley in King's Cross station.

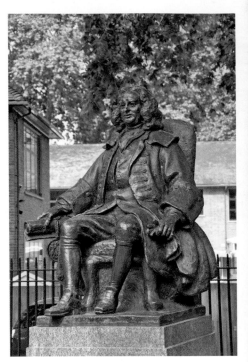

Thomas Coram's statue outside the Foundling Museum.

a statue by William McMillan of **Thomas Coram** (1668–1751). In 1742 Coram created the Foundling Hospital, where abandoned and illegitimate children were cared for and educated. It originally stood where Coram's Fields are today, but in 1926 the hospital moved out of London and the old building was demolished. In 1856 a statue of Coram by William Calder Marshall had been placed at the entrance

to the hospital, but this is now at its new site in Berkhamsted. McMillan's statue was erected in 1963, and was based on the famous portrait by Hogarth, which can be seen in the museum.

On the south side of Mecklenburgh Square is London House, the home of Goodenough College, a residential college for postgraduate students from around the world. It was founded in 1930 by the banker **Frederick Crauford Goodenough** (1866–1934), whose bust by William McMillan was erected in 1936 in a niche overlooking the central quadrangle. Due to strict security, it can only be viewed from the main gate.

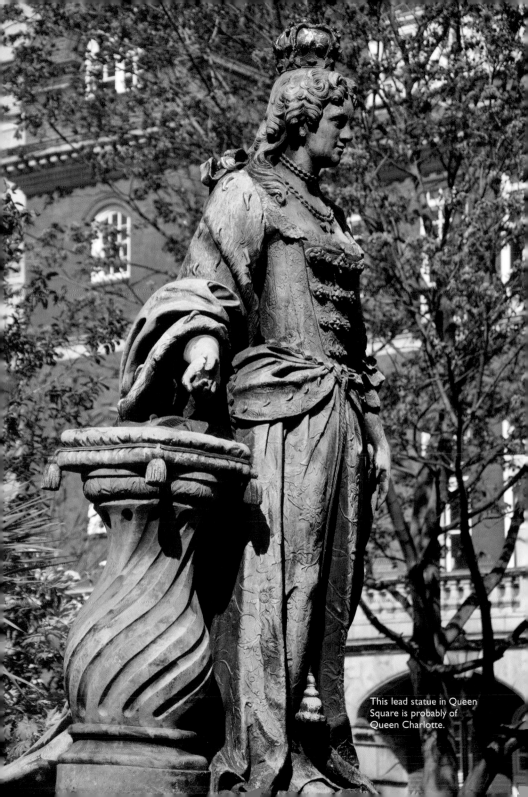

This lead statue in Queen Square is probably of Queen Charlotte.

At the north end of Queen Square is a lead statue once thought to be of Queen Anne, after whom the square is named, but is now considered to be of **Queen Charlotte** (1744–1818), the wife of George III. It was probably erected here in around 1775. In the centre of the square is a sculpture by Patricia Finch of a mother and child, bought by the Friends of the Children of Great Ormond Street Hospital and erected here in 2001 in memory of **Andrew Meller.**

In Great Ormond Street is the famous Great Ormond Street Hospital for Children. J. M. Barrie left the copyright to his best-known work to the hospital and in 2000 a statue of **Peter Pan** was unveiled outside its main entrance by Lord and Lady Callaghan. The sculpture was created by Diarmud Byron O'Connor, who added a tiny figure of Tinkerbell in 2005, which was unveiled by the Countess of Wessex.

A modern sculpture of Peter Pan outside the Great Ormond Street Hospital.

SOUTH BANK

A T No 4 Albert Embankment, the headquarters of the International Maritime Organisation, just south of Lambeth Bridge, is the striking **International Memorial to Seafarers** by Michael Sandle. It was unveiled on 27 September 2001, World Maritime Day, to commemorate all seafarers lost at sea. It takes the form of a monumental prow of a ship, which projects from the building, making it visible from all angles. It is surmounted by a seaman, who holds a line in his right hand. The whole memorial is of bronze, but the ship has been given a bluish patina, to contrast with the grey of the building.

In Lambeth Palace Road, opposite the entrance to Lambeth Palace, is the **Special Operations Executive Memorial**, which honours all those who served in the SOE during the Second World War. The SOE was created by Winston Churchill to recruit secret agents to work in countries occupied by the enemy, where they would commit acts of sabotage and send back intelligence from behind the enemy lines. The best known of the agents was **Violette Szabo** (1921–45), whose bust, by Karen Newman, adorns the plinth. She worked with the Resistance in France, but was captured by the Germans, tortured and executed. She was posthumously awarded the George Cross for her courage, as well as the Croix de Guerre. The memorial was unveiled in 2009 by the Duke of Wellington.

In the gardens in front of St Thomas's Hospital, and facing the Houses of Parliament,

The International Memorial to Seafarers on the Albert Embankment.

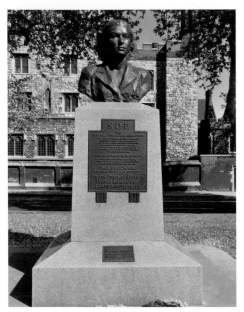

A bust of Violette Szabo features on the SOE Memorial.

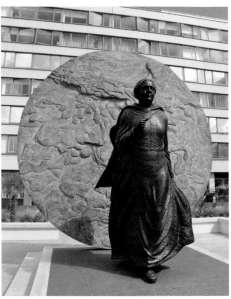

Mary Seacole strides out purposefully in front of St Thomas's Hospital.

is the impressive memorial to **Mary Seacole** (1805–81), the Jamaican nurse famous for her work in the Crimean War. She went to Crimea unofficially, having been turned down by the War Office, and set up a hotel which offered a canteen for the troops, and visited the battlefields to care for the wounded and dying soldiers. The statue, the work of Martin Jennings, was unveiled in 2016, after twelve years of campaigning. The 10-foot statue depicts Mary as a determined figure, striding out before a bronze disc, which was cast from Crimean rock. On the plinth are the words of Sir William Russell, the celebrated war correspondent of *The Times*, praising her work. The statue has sparked controversy, especially its location at a hospital traditionally associated with Florence Nightingale, but Mary Seacole deserves to be celebrated, as an important black icon.

Outside the main entrance to St Thomas's Hospital is a somewhat weathered statue of **Edward VI** (1537–53), who refounded the hospital in 1551, eleven years after it was closed by his father during the Dissolution of the monasteries. In 1682 it was placed above an archway at the hospital, which was then in Southwark. It is of Purbeck stone, and was made by Thomas Cartwright. In 1862 the hospital was forced to make way for a new railway development and reopened in Lambeth in 1871, when the statue was re-erected in the centre of the riverside colonnade. It was installed outside the entrance to the new north wing in 1976.

At the southern end of the north wing of the hospital, close to the Thames, is a marble statue of **Sir Robert Clayton** (1629–1707). Clayton was alderman, sheriff and Lord Mayor of London, a major

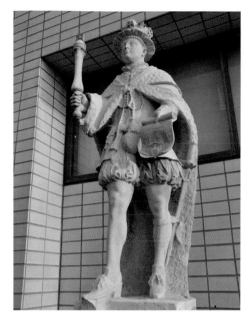

Edward VI re-founded St Thomas's Hospital in 1551.

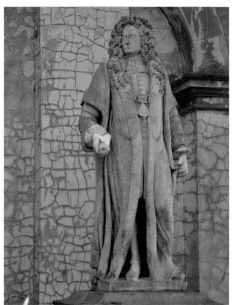

Sir Robert Clayton's statue is by Grinling Gibbons.

benefactor of St Thomas's Hospital, of which he was president for fifteen years. The statue was commissioned by the hospital from Grinling Gibbons, though much of the work was probably carried out by his workshop. It was originally set up in 1702 in a quadrangle at the Southwark site, but moved here when the hospital opened in 1871. It has occupied several locations since then, and was moved to its present site in 2000, when the small garden it stands in was opened by Princess Margaret. It has become very weathered, and the right hand and scroll are replacements, after a drunken medical student climbed on the statue.

In Jubilee Gardens, east of County Hall, stands the **International Brigade Memorial** by Ian Walters. It pays tribute to over two thousand British men who joined the Republicans in the fight against Franco's Fascists in the Spanish Civil War of 1936–9. It was unveiled in 1985 by Michael Foot MP. Each year in July there is a gathering by the memorial to mark the anniversary of the start of the Civil War. The memorial takes the form of four figures carrying a wounded fighter, the arms of the supporters raised like wings.

On the raised area on the south side of the Royal Festival Hall is a monumental bust of **Nelson Mandela** (1918–2013) by Ian Walters, who also made the statue of him for Parliament Square (see page 35). Walters, a politically committed sculptor who produced many memorials to left-wing figures, made a bronze resin version of the bust in 1982 to commemorate the seventieth anniversary of the African National Congress, at a time when Mandela was still in prison. He intended it to be used by the ANC at rallies and it was first shown publicly in 1983

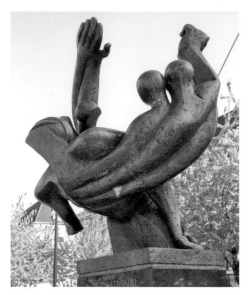

The International Brigade Memorial in the shadow of the London Eye.

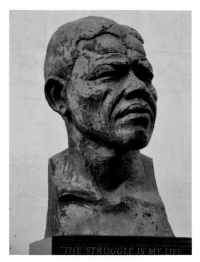

The bust of Nelson Mandela was first erected when he was still in prison.

at Alexandra Palace. In 1985 it was erected in its current location, under the auspices of the Greater London Council, and was unveiled by Oliver Tambo, President of the ANC and a close friend of Mandela. Sadly, the bust was vandalised several times and finally damaged beyond repair by arsonists. This bronze replica was erected, on a taller plinth, in 1988. The original short inscription was updated to include Mandela's release in 1990 and his subsequent elevation to President of the Republic of South Africa.

On the north side of the Royal Festival Hall is a sculpture commemorating the great Polish composer-pianist, **Fryderyk Chopin** (1810–49), who gave his last recital in London in 1848. The rather abstract work is by the Polish sculptor Bronislaw Kubica, and consists of the head of the composer emerging from a roll of music manuscript paper. The sculpture, a

This abstract sculpture of Chopin was re-erected outside the Royal Festival Hall in 2011.

gift from the Polish people, was unveiled in 1975 by Princess Alice, Duchess of Gloucester. It was removed in the 1980s for building work to take place and remained in storage for over twenty years, but in 2011 it was unveiled close to its original location by the Princess's son, the Duke of Gloucester.

Outside the Royal National Theatre stands a statue of **Sir Laurence Olivier** (1907–89), the great Shakespearean actor. The statue, by Angela Conner, shows him in the role of Hamlet. It was unveiled in 2007, on what would have been his hundredth birthday, in the presence of members of the original National Theatre company, of which he was the first director.

The main entrance of Waterloo Station was built as a **War Memorial Arch** to commemorate the 585 employees of the railway company who died in the First World War. To the left and right of the arch are sculptural groups symbolising War and Peace, and high up over the arch is the figure of Britannia. The names of the dead are listed on brass plaques under the arch, which was dedicated by Queen Mary in 1922, when the new station was officially opened.

On the upper retail level at Waterloo Station, facing Platform 8, is a memorial to the 24,000 Allied soldiers who died at the **Battle of Waterloo**. It was unveiled by the current Duke of Wellington in June 2015 to commemorate the two hundredth anniversary of the battle. Its key feature is an enlarged replica of the reverse of the Waterloo Campaign medal, featuring Nike, the Greek goddess of victory. The medal was the first to be given to every soldier irrespective of rank.

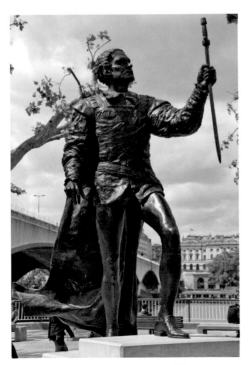

Olivier as Hamlet outside the National Theatre.

The memorial to those who died at the Battle of Waterloo.

SOUTHWARK

THE LONDON BOROUGH of Southwark stretches from the Thames to Dulwich, and this chapter describes the statues and monuments in the northern part of the borough. The southern half is covered in the South London chapter.

On a traffic island at the eastern end of Tooley Street is a larger-than-life bronze bust of **Ernest Bevin** (1881–1951), the distinguished trade unionist and politician. He created the Transport & General Workers' Union, was Minister of Labour during the Second World War, and Foreign Secretary after the war. His earlier work with the dockers earned him the name of 'the dockers' KC'. The sculpture is by Ernest Shone-Jones, and is an enlarged copy of a bust by Edwin Whitney-Smith, modelled in 1929, when Bevin was in his late forties. The memorial was unveiled in 1955 by Dame Florence Bevin; the inscription on the reverse of the plinth says the unveiling was carried out by the Mayor of Bermondsey but, on the day, he asked Bevin's widow to do it instead.

At the end of the same traffic island is a bronze statue of **Colonel Samuel Bourne Bevington** (1832–1907), the first mayor of Bermondsey, depicted in full mayoral regalia. His family's leather-making business was an important local employer, and he was also involved in many philanthropic schemes. The sculpture was made by Sydney March and was unveiled in 1911.

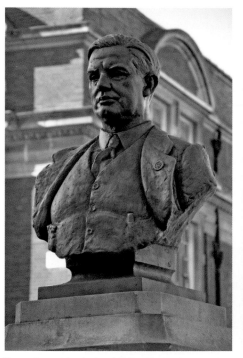

Ernest Bevin, 'the dockers' KC' in Tooley Street.

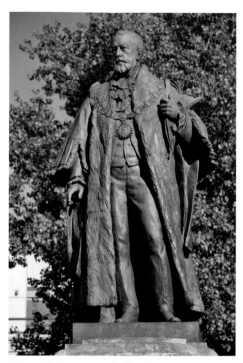

Colonel Bevington was the first Mayor of Bermondsey.

Sir Simon Milton sits looking out at City Hall, where he worked.

Outside One Tower Bridge, looking over to City Hall, is a seated statue, by Philip Jackson, of **Sir Simon Milton** (1961–2011) who was Deputy Mayor of London, based at City Hall. It is, remarkably, the third public memorial in London to this little-known but significant politician.

At the London Bridge end of Tooley Street, high up on the corner of Cotton's Lane, is a memorial to **James Braidwood** (1800–61), the Superintendent of the London Fire Brigade, who died while fighting a massive warehouse fire at Cotton's Wharf. The memorial, of Portland stone, was carved by Samuel Henry Gardiner, and erected in 1862. Within a wreath is

an inscription, and above it is a depiction of the blazing warehouses. On a ledge are a fireman's helmet, an axe and a rolled hosepipe.

In the main courtyard of Guy's Hospital, off St Thomas Street, is a statue of the hospital's founder, **Thomas Guy** (1644–1724). Guy was a printer and bookseller, and made his fortune by selling his South Sea shares before the bubble burst, enabling him to found the new hospital in 1722. The statue is by Peter Scheemakers, and was erected in 1734. It shows Guy as a young man, in the livery of the Stationers' Company and, surprisingly for the period, without a wig. Around the marble pedestal are four plaques, one with the inscription, one with the hospital's coat of arms, and the other two with reliefs representing Healing (*Christ at the Pool of Bethesda*) and Charity (*The Good Samaritan*). Both the statue and

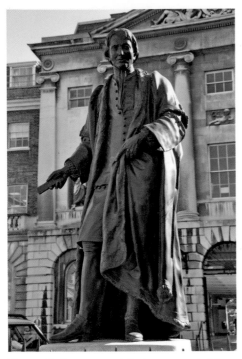

Thomas Guy's statue stands in the courtyard of the hospital he founded.

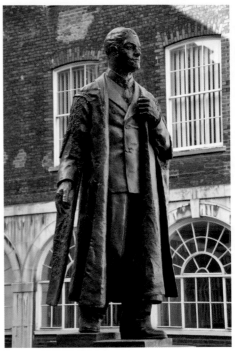

The industrialist Lord Nuffield made large donations to hospitals such as Guy's.

the plaques are, unusually, of brass rather than bronze.

In the right-hand part of the inner courtyard is a statue of **William Richard Morris, Viscount Nuffield** (1877–1963), perhaps the most important industrialist of his time. He began by repairing bicycles, then moved on to making cars, starting with the Morris Oxford. Nuffield spent much of his vast fortune on benefactions to colleges and hospitals, including Guy's. He also established the Nuffield Foundation, an important research charity. The statue is by Maurice Lambert, and was unveiled in 1949, paid for by subscriptions collected from the hospital staff. Nuffield is shown wearing the academic gown of Doctor of Civic Law (Oxford), one of the many honours he received.

In the opposite garden is an alcove from old London Bridge, which was set up here in 1861. It now contains a statue of **John Keats** (1795–1821), the famous poet, who trained as a surgeon at Guy's Hospital. He is shown sitting with a book in his hand and looking out in contemplation. The sculpture, by Stuart Williamson, was unveiled in 2007 by Andrew Motion, the Poet Laureate, and is the first statue of the poet anywhere in the world. It also commemorates Dr Robert Knight, who worked at Guy's, and was a lover of Keats's poetry.

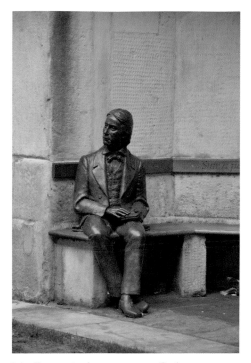

John Keats trained as a surgeon at Guy's.

This is traditionally considered to be a medieval statue of King Alfred.

In Trinity Church Square, off Trinity Street at the southern end of Borough High Street, is a statue said to be of **Alfred the Great** (849–99). Tradition has it that it is one of the medieval statues from Westminster Hall, making it the oldest outdoor statue in London. It is certainly very regal, with a crown, long beard and flowing cloak but, on stylistic grounds, it is not now considered to be of such antiquity. It is now thought to be the work of the minor sculptor James Bubb, and is probably of Coade stone. Bubb had made the statue to decorate the façade of the new Manchester Town Hall, but it was too large for its niche, and he made a new one, which can now be seen in Heaton Park, Manchester. It is not known how the original came to be erected here but, as Alfred was the founder of the English navy, it is appropriate that it is on land owned by Trinity House.

In 1991 a sculptural group called **Dr Salter's Daydream**, the work of Diane Gorvin, was installed at Bermondsey Wall, near Cherry Garden Pier. It consisted of Dr Salter (1873–1945) sitting on a bench, waving at his daughter, Joyce, leaning against the river wall, along with a cat sitting on the wall. Sadly, the sculpture of the doctor was stolen in 2011, probably for its scrap value. The good news is that

Dr Salter's Daydream at Bermondsey Wall.

enough money was raised locally for a replacement by the same sculptor, along with a new statue of the doctor's wife, Ada. It was erected in 2014 close to the Angel pub, which has CCTV, hopefully making it more secure. Dr Salter is now sitting on a granite bench, looking back at happier times, when his wife was younger and his daughter was still alive. Salter was a popular local doctor who dedicated his life to improving the living conditions of the poor, and later became MP for West Bermondsey. His daughter died of scarlet fever aged only nine, hence the title of the sculpture.

At the west end of St Mary the Virgin Church in Rotherhithe is a memorial to **Captain Christopher Jones** (*c.* 1570–1622), who is buried in the graveyard. Jones, who operated from Rotherhithe, was the master of the *Mayflower,* which took the Pilgrim Fathers from here to the New

The memorial to Captain Christopher Jones in Rotherhithe.

The bust of James Walker overlooks Greenland Dock, which he built.

World in 1620. The sandstone sculpture, by Jamie Sargeant, is of St Christopher and the Christ child, standing on a base in the form of a ship's prow. It was unveiled in 1995 to commemorate the 375th anniversary of the departure of the *Mayflower*. Unfortunately, it has suffered some vandalism.

At the eastern end of Brunswick Quay on Greenland Dock is a bronze bust of

James Walker (1781–1862) by Michael Rizzello. Walker was the civil engineer who built Greenland Dock as well as the first Vauxhall Bridge. The sculpture was commissioned by the London Docklands Development Commission, and was unveiled in 1990 by Professor Scott, President of the Institute of Civil Engineers.

George II was the last British king to lead an army into battle (see page 209 for related text).

GREENWICH AND WOOLWICH

AT MILLENNIUM QUAY in Deptford, in the Borough of Greenwich, is an elaborate and rather eccentric monument to the Russian Tsar **Peter the Great** (1672–1725). In 1698 Peter spent four months in Deptford studying the latest technology, including shipbuilding at the Royal Naval Dockyards. He and his entourage stayed

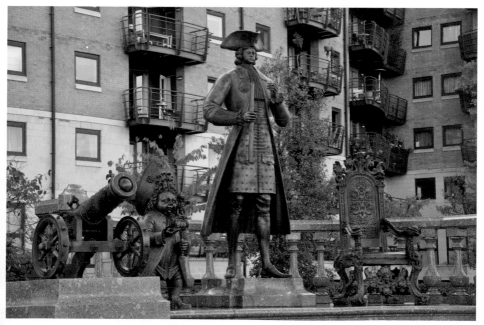

The eccentric memorial to Peter the Great in Deptford.

at Sayes Court, the house of John Evelyn, behaving so badly that they caused immense damage to both the house and the garden. On a raised granite platform are bronze figures of Peter, flanked by his dwarf and a throne. Peter, who was over 6 feet tall, is depicted as very thin with a rather small head, and carries a telescope and a clay pipe. The dwarf carries a model ship and a globe, and on the flanking piers are bronze cannon. The monument was designed by the Russian architect Viacheslav Bukhaev and the sculptor was Mihail Chemiakin, a Russian sculptor exiled in America. The monument was unveiled in 2001 by the Russian Ambassador and Prince Michael of Kent.

In the grounds of the Royal Naval College, next to Greenwich pier, is the **New Zealand War Memorial**, which was erected in 1864 to remember the men and officers of the Royal Navy who died during the so-called 'Maori Wars', when Maori tribesmen resisted occupation of their land by settlers. It consists of an obelisk, with plaques round the base listing the names of the dead and the ships on which they served.

Nearby is a life-size bronze statue by William McMillan of **Sir Walter Raleigh** (1552–1618), the courtier, explorer and favourite of Elizabeth I. It was commissioned to commemorate the

McMillan's statue of Raleigh originally stood in Whitehall.

Bellot was a Frenchman who died in the search for Sir John Franklin.

three hundred and fiftieth anniversary of the founding of Virginia, and was erected in front of the Ministry of Defence in Whitehall, where it was unveiled in 1959 by the American ambassador. In 2001 it was removed to make way for the statue of Lord Alanbrooke, and in early 2002 was installed in Greenwich.

A short distance to the east, outside the railings, is the **Bellot Memorial.** The red granite obelisk commemorates Joseph René Bellot, a French naval officer who died in 1853 on an expedition to find Sir John Franklin, who had gone missing in his search for the North-West Passage. The memorial, designed by Philip Hardwick, was erected in 1855.

In the centre of the main square of the old Royal Naval College is a marble statue of **George II** (1683–1760) by John Michael Rysbrack (see illustration on page 206). Typically for the period, the King is depicted in Roman dress, standing in front of a broken column, and holding an orb and sceptre. He was the last British king to lead an army into battle, at Dettingen in 1743. Sir John Jennings, Governor of the Greenwich Hospital, paid for the statue. The marble was intended to be used for a statue of the French king, Louis XIV, but was seized from a French ship and bought by the Hospital. The statue was unveiled in 1735. In the 1950s some Sandhurst cadets painted the statue with black stripes, and the solution used to clean it damaged the marble. Because of its poor condition, the statue is covered in winter to protect it from frost.

East of the Naval College, in Park Row, is the Trafalgar Tavern, once frequented by the likes of Gladstone and Dickens. Outside

This rather louche statue of Nelson stands outside the Trafalgar Tavern.

it is a modern bronze statue of **Lord Nelson** (1758–1805), a rather jauntier depiction than the one in Trafalgar Square. It is the work of local sculptor, Lesley Povey, and was unveiled in 2009.

In its own garden in the northwest corner of Greenwich Park by Croom's Hill, is a statue of **William IV** (1765–1837), which originally stood in King William Street in the City, to the north of London Bridge. The statue is over 15 feet high and stands on a high plinth. The king is dressed in the uniform of Lord High Admiral, with a long cloak, and wears the Order of the Garter. It was commissioned by the City Corporation in 1841 from Samuel Nixon,

who carved it in granite, the first London statue to be made of this material. The stone is very hard to carve, and it took the sculptor three years to create the work. It was unveiled in 1844, and stood on a massive circular plinth. In 1933 a pedestrian subway was planned, which would not take the weight of the statue, so it was moved to Greenwich, where it was installed in 1936. The move to Greenwich was highly appropriate, as William was known as the 'Sailor King', having spent over ten years in the Navy, and he was also the Best Man at Nelson's wedding.

High up on a terrace overlooking Greenwich Park, beside the Old Royal Observatory, stands the statue of **Major General James Wolfe** (1727–59), who defeated the French in Quebec by climbing the cliffs in the dark and taking them by surprise. In the ensuing Battle of the Plains of Abraham, Wolfe was fatally wounded, but this great victory meant the end of French rule in North America. Wolfe lived for a time at Macartney House in Greenwich, and is buried in nearby St Alfege Church. The statue is the work of the Canadian sculptor Robert Tait McKenzie, and was a gift from the Canadian people. It was unveiled in 1930 by the Marquis de Montcalm, who was descended from the French general defeated by Wolfe at Quebec.

The imposing statue of William IV originally stood in the City.

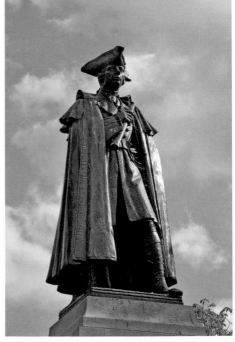

General Wolfe lived in Greenwich and is buried in St Alfege Church.

Outside the Royal Observatory is a statue of **Yuri Gagarin** (1934–68), the Russian astronaut who was the first man in space in 1961. The statue was a gift from Roscosmos, the Russian space agency, and was originally erected in the Mall in 2011 to mark the fiftieth anniversary of his historic voyage, and his visit to London, where he met the Queen at Buckingham Palace. The zinc statue is a copy of one in Lyubertsky, and is by Anatoly Vovikov. It shows Gagarin in his spacesuit standing on a globe. It was installed here in 2013, on what is now called Gagarin Terrace.

In front of Charlton FC's stadium, The Valley, in Harvey Gardens, is a statue

This statue of goalkeeper Sam Bartram stands outside Charlton stadium.

The statue of Yuri Gagarin, the first man in space, outside the Royal Observatory.

of **Sam Bartram** (1914–81) by Anthony Hawken. Bartram is considered to have been Charlton's finest footballer, playing in goal for the club for 22 years.

While Greenwich's maritime heritage is reflected in its statues and monuments, Woolwich has a strong military tradition, and several of its monuments have military connections. The Royal Artillery occupied Woolwich Barracks from 1776 until 2008, when they moved to Wiltshire, taking most of their memorials with them. The only one still remaining in the barracks, overlooking the parade ground, is the **Crimean Memorial** to the officers and men of the Royal Artillery who lost their lives in the

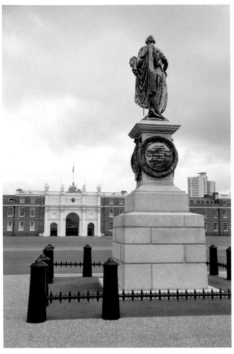

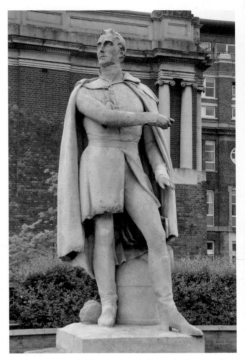

The Royal Artillery's Crimean Memorial overlooks the parade ground.

The statue of Wellington comes from the Tower of London, where he was Constable.

Crimean War. On a granite plinth, a bronze figure of Victory holds out a laurel wreath to crown the dead heroes. It was cast from Russian cannon captured at Sebastopol. The memorial, unveiled in 1860, is by John Bell, who also made the Guards Crimean War Memorial in Waterloo Place.

On the east side of the barracks, in Grand Depot Road, is the **South African Memorial** to those members of the 61st Battery Royal Field Artillery who died in the Boer War of 1899–1902. It is an obelisk of polished red granite.

The Royal Arsenal was a vast site where munitions and military equipment were manufactured, and once employed as many as eighty thousand people. It closed in 1994, and the site now consists of a business park, housing and a Thames-side walk. In the centre of Wellington Square, in the residential area, is a marble statue of the **Duke of Wellington** (1769–1852), who was Master General of The Ordnance, Royal Arsenal from 1818 to 1827. The statue is by Thomas Milnes, and was erected in 1848 in the Tower of London, where he was Constable from 1826 to 1852. The statue came to the Arsenal in 1863, and was unveiled in the square in 2005 by the Prince of Wales to commemorate the two hundredth anniversary of the Royal Arsenal.

Alexander McLeod was one of the founder members of the Royal Arsenal Co-operative Society.

At 125–161 Powis Street is the impressive façade of what used to be the Royal Arsenal Co-operative Society building. Standing proudly in a niche above the central arch is the statue of **Alexander McLeod** (1832–1902), one of the founders of the society, which was formed in 1868 by workers at the Royal Arsenal. McLeod was its Manager from 1882 until his death. The society offered shops and other services for its members, who were all paid a dividend, and its motto, 'Each for All and All for Each' can be seen in large letters above the statue. By the 1970s it found it could not compete with the supermarkets and it is now part of the Co-operative Wholesale Society, while the building today houses council offices. The statue, of terracotta or Coade stone, was created by Alfred Drury and was erected in 1903.

NORTH LONDON

In the south-east corner of Finsbury Square is a simple marble memorial to the 43 people who died in the **Moorgate Tube Disaster** on 28 February 1975, when a train failed to stop and ploughed into a wall. The unveiling in 2015 was attended by relatives of the victims.

In front of Wesley's Chapel in City Road is a statue of **John Wesley** (1703–91), the founder of Methodism. The Chapel opened in 1778 and he lived in the house alongside it. He is buried in the graveyard behind the chapel. The statue, by J. Adams Acton, was erected in 1891 to celebrate the anniversary of his death. On the base of the statue are the words, 'The world is my parish'. Wesley remained an Anglican clergyman until his

The simple memorial to those who died in the Moorgate tube disaster in 1975.

Wesley's statue stands outside his house in City Road.

dying day, but refused to be confined to one parish, so he preached all over the country, and it is reckoned that he travelled 250,000 miles, preaching forty thousand sermons.

In Angel Place, just north of the Angel crossroads, is an obelisk commemorating **Thomas Paine** (1737–1809) the revolutionary author of *The Rights of Man.* The obelisk bears a relief portrait of Paine, and each of the sides has quotations from his work. The memorial was created by Kevin Jordan, and was unveiled in 1991, the two hundredth anniversary of the publication of *The Rights of Man,* which Paine wrote while staying at the Angel Inn.

At the southern end of Islington Green, in Upper Street, is a weathered marble statue of **Sir Hugh Myddelton** (*c.* 1560–1631). Myddelton was a goldsmith with a successful business in Cheapside, but is best known as the man who created the New River Company, which brought fresh drinking water from Hertfordshire to London. The water was stored at reservoirs at New River Head in Clerkenwell, and wooden pipes took the water to householders who signed up with the company, the arrangement continuing into the nineteenth century. The statue, the work of John Thomas, was paid for by the MP and railway contractor Sir Samuel Morton Peto, and was unveiled in 1862. At the base are two cherubs carrying urns, from which water used to flow.

The memorial to Thomas Paine, the author of The Rights of Man, at the Angel.

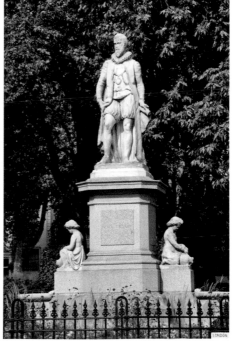

Robert Stephenson called Sir Hugh Myddelton 'the first English engineer'.

Around the perimeter of the Emirates Stadium in Drayton Park N7 are bronze statues of five of Arsenal's football heroes, erected in 2011 and 2014 to celebrate the club's 125th anniversary. They are all the work of MDM Ltd. At the end of the Ken Friar Bridge is a statue of **Ken Friar** (1934–), playing football as a boy of 12. He had accidentally kicked a ball under the car of the Arsenal manager, George Allison, who was so impressed by his passion for the game that he gave him a job as messenger on match days. He stayed with the club and later became Company Secretary and Managing Director, and he is still a board member. At the bottom of the steps is the statue of **Tony Adams** (1966–), who was

Tony Adams celebrating a goal.

The statue of Ken Friar as a boy outside the Arsenal stadium.

a defender for Arsenal for 19 years, 14 of them as the club's most successful captain, leading them to win many titles. He also won 66 caps for England. The statue replicates his pose after scoring a goal in 1998. Continue round the stadium in an anti-clockwise direction, and by the Clock End is the dramatic statue of **Dennis Bergkamp** (1969–), which shows him in mid-air going for a ball during a match in 2003. The Dutchman scored 120 goals during his 11 years at Arsenal, and is considered to be one of their greatest players. A little further round is the statue of **Thierry Henry** (1977–), depicted on his knees celebrating a famous goal in 2002. The Frenchman played for Arsenal for eight

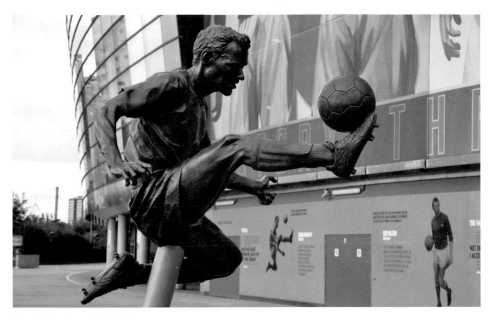

Dennis Bergkamp in full flight.

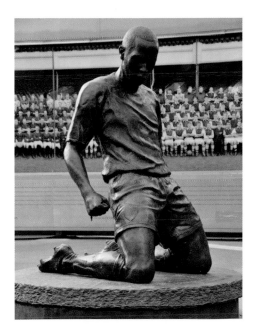

Thierry Henry celebrating a famous goal.

years and scored 226 goals, more than any other Arsenal player. By the Danny Fiszma Bridge is a statue of **Herbert Chapman** (1878–1934), who is considered to be the Gunners' greatest manager. He ran Arsenal from 1925 to his death, making it the most successful club in the country, winning many titles. He was a great innovator, introducing numbered shirts and floodlit matches, and he even managed to persuade London Underground to change the name of Gillespie Road station to Arsenal.

At the bottom of Highgate Hill is the **Whittington Stone**, at the spot where, according to legend, Dick Whittington heard the bells of London and returned to make his fortune. The first stone may have been part of a wayside cross, and the present stone is the third or fourth on the site, the previous ones having been

Under manager Herbert Chapman Arsenal won many titles.

The Whittington Stone on Highgate Hill.

damaged and replaced in 1795 and 1821. The inscription on the stone contains two errors. The real Richard Whittington was never knighted, and he was Lord Mayor four times, not three as stated. The bronze cat, another element of the legend, was added in 1964.

At the top of Highgate Hill is Waterlow Park. At the highest part of the park is a bronze statue of **Sir Sydney Hedley Waterlow** (1822–1906), who was a successful printer and celebrated philanthropist. He was Lord Mayor of London and became an MP, and acted as a commissioner for the 1851 Great Exhibition. In 1889 he donated his home, Lauderdale House, and the surrounding

estate to the London County Council, and these are now an arts centre and a public park. The statue, by Frank Taubman, was unveiled in 1900 by Princess Louise. It is the only London statue carrying an umbrella.

At the southern end of Camden High Street is a rather weathered marble statue of **Richard Cobden** (1804–65), a politician best known for his campaign to abolish the Corn Laws, which denied free trade and kept the price of corn artificially high. Cobden had no connection with Camden, but local admirers formed a committee soon after his death and W. and T. Wills were commissioned to create the statue. One of the major contributors

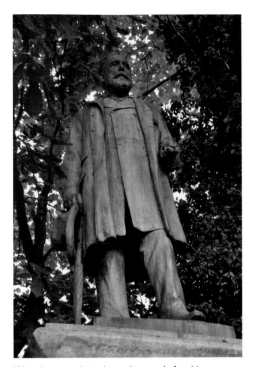

Waterlow stands in the park named after him.

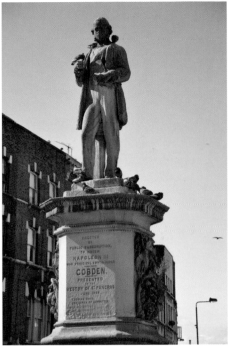

Richard Cobden's statue in Camden High Street.

was Napoleon III, whom Cobden had met in France when negotiating a free trade agreement. The unveiling of the statue in 1868 was attended by large crowds.

In St Martin's Gardens, off Camden Street, is a memorial to **Charles Dibdin** (1745–1814). Dibdin was an actor, theatrical impresario and composer, and was best known for his sea songs, most notably *Tom Bowling*. He spent his last years in Camden Town and was buried here when it was a cemetery. The cemetery was closed in 1879, but in 1889 it became a public garden, and this memorial was unveiled by the Countess of Rosebery when she opened the garden. It takes the form of a Celtic cross, with musical and nautical symbols carved on it.

In the Stables Market in Chalk Farm Road, Camden, to the right of the entrance, is a statue to the singer/songwriter **Amy Winehouse** (1983–2011). The award-winning artiste was often controversial, and her statue has also received much criticism. She was a highly talented musician, but she suffered from depression and addictions to drugs and alcohol. Her sad death at the age of only 27 was due to alcohol poisoning. The statue, by Scott Eaton, was unveiled in 2014, on what would have been her 31st birthday, by her friend, the actress Barbara Windsor. Amy is depicted wearing high heels, a Star of David necklace, and sporting her signature beehive hairstyle.

In St John's Wood, at the junction of

Fans regularly leave mementoes on Amy Winehouse's statue.

The memorial to Onslow Ford in Abbey Road.

Abbey Road and Grove End Road, is the memorial to the sculptor **Edward Onslow Ford** (1852–1901). Ford was part of the so-called New Sculpture movement, and was much influenced by Alfred Gilbert. He was very popular with his fellow artists, and his friends and colleagues were very keen to commemorate him. The memorial was erected in 1903 and unveiled by the artist Sir Lawrence Alma-Tadema. It takes the form of an obelisk, on the front of which is a bronze relief portrait of the sculptor, with a quotation from *Hamlet*: 'To thine own self be true'. It is by A. C. Lucchesi, who had worked as Ford's assistant. On the reverse is a copy of Ford's *Muse,* which adorns

his monument to Shelley in the chapel of University College, Oxford.

In Fitzjohn's Avenue, Swiss Cottage, on the corner of Belsize Lane, is a statue by Oscar Nemon of **Sigmund Freud** (1856–1939). Freud, the founder of psychoanalysis, left Vienna in 1938 after it was annexed by the Nazis, and, with his daughter, Anna, set up house at 20 Maresfield Road, where he died the following year. The house is now the Freud Museum, which contains many of his possessions, including the famous couch. Nemon met Freud in Vienna in 1931, when he made a plaster statue of him, but it was nearly forty years before the money could be found to pay for a bronze

Freud's statue is close to his last home.

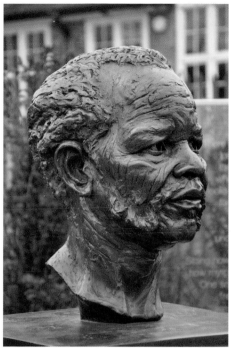

Oliver Tambo lived in exile In Muswell Hill for thirty years.

version. In 1970 the statue was unveiled at an inconspicuous site behind the Swiss Cottage Library, but was moved to this more prominent location in 1992.

In the Albert Road Recreation Ground, in Durnsford Road, Muswell Hill, is a bust of **Oliver Reginald Tambo** (1917–93), the anti-Apartheid leader. He was a close friend and comrade of Nelson Mandela, and was President of the African National Congress until 1991, when Mandela was elected to the position. From 1960 until 1990 he lived with his family in exile in Haringey, and he was awarded the freedom of the borough. The bust is by Ian Walters, who also made the statue of Nelson

Mandela in Parliament Square. It was unveiled in 2007 by Zanele Mbeki, the wife of the South African President, and Jack Straw, the Justice Secretary.

In Regent's Park Road, close to the junction with the North Circular, is **La Délivrance**, a striking Art Deco bronze of a female nude, standing on a globe with arms held high, one of which holds a sword. Known locally as 'The Naked Lady' or 'Dirty Gertie', the statue commemorates the defeat of the Germans in the First World War and, in particular, the first Battle of the Marne in 1914, when the Germans were prevented from reaching Paris. It is by the French sculptor Emile Guillaume, and this

copy was presented to Finchley by Viscount Rothermere, who had been impressed by the original when he saw it at the Paris Salon in 1920. Although it is not officially a war memorial, the council wanted to treat it as such and hoped to place it at the entrance to the recreation ground, but Rothermere insisted it be erected at its present location so that he could see it when he travelled to Totteridge to visit his mother. When he unveiled the memorial in 1927, David Lloyd George described it as, 'This quivering figure of beauty'.

In 2014 a bronze statue of **Spike Milligan** (1918–2002) was unveiled in the gardens behind Stephens' House, 17 East End Road N3. Created by John Somerville,

The striking *La Délivrance* in Finchley.

it has the popular author and comedian sitting on a rather surreal bench, talking to whoever sits next to him. The bench is decorated with all sorts of references to his life, including his fellow Goons. He lived in Finchley for 19 years and was the first President of the local amenity group, The Finchley Society, who helped to raise the funds for the unusual statue.

Outside the Peel Centre of the Metropolitan Police Training Centre, at the eastern end of Aerodrome Road in Hendon, is the much-travelled statue of **Sir Robert Peel** (1788–1850) by William Behnes. It was originally erected in 1855 at the western end of Cheapside in the City, but was removed in 1935 as it was obstructing the traffic. It was passed to the Bank of England, who planned to display it, but it spent the war at their printing works. In 1952 it was erected in Postman's Park, before finally reaching Hendon in 1972. The statue can just about be seen from the road, but it is impossible to appreciate it from such a distance.

Taking pride of place at the entrance to the new Wembley Stadium is a 20-foot statue of **Bobby Moore** (1941–93), captain of the England football team which won the 1966 World Cup at the old Wembley stadium. An East End legend, Moore played for West Ham for many years, and was capped for England 108 times, ninety of them as captain. The statue is the work of Philip Jackson and was unveiled in 2007. On the front of the plinth is a bronze relief of the 1966 World Cup squad, and on the sides are bronze copies of caps from the 1966 and 1970 World Cups.

To the left of the Moore statue is the **Rugby League Legends** memorial,

Spike Milligan sits on a bench waiting for your company.

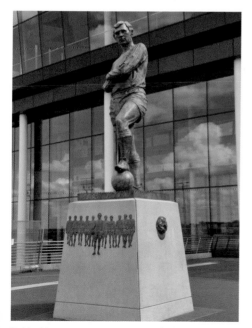

Bobby Moore commemorated at Wembley.

which is a group statue of five of the sport's heroes. The work of Stephen Winterburn, it includes **Martin Offiah** (1965–), the English winger nicknamed 'Chariots' Offiah, because of his speed, **Alex Murphy** (1939–), the English half back, **Gus Risman** (1911–94), the Welsh three-quarter, **Billy Boston** (1934–), who scored 571 tries in a long career, and **Eric Ashton** (1935–2008), who captained the hugely successful English side in the 1960s. The memorial was unveiled in 2015 to mark the 120th anniversary of Rugby League.

At the junction of West End Road and Western Avenue, close to the RAF aerodrome at Northolt, is the **Polish War Memorial**, which commemorates the 2,165 Polish airmen who died during the Second World War. Around seventeen thousand Polish men and women, exiled

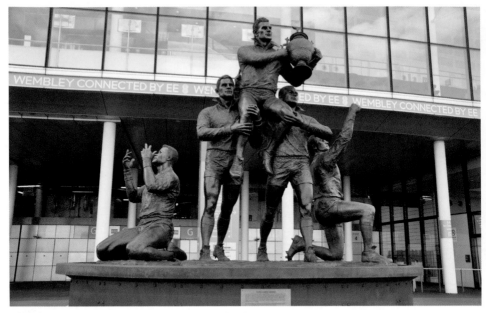

Five Rugby League legends are commemorated at Wembley.

after their country was invaded in 1939, served in the Polish Air Force, whose main base during the Battle of Britain was at RAF Northolt. The memorial is by Mieczyslaw Lubelski, who had himself been imprisoned in a labour camp. It consists of a square column of Portland stone topped off with a bronze eagle, the emblem of the Polish Air Force. On the shaft are the names of the RAF squadrons in which the Poles served, and in a sunken area at the rear are inscribed the names of all the airmen who lost their lives. The memorial was unveiled in 1948 by Lord Tedder.

The Polish War Memorial is a landmark on the A40 into London.

WEST LONDON

IN A MEMORIAL garden in Canal Way, at the north end of Ladbroke Grove, is the **Ladbroke Grove Rail Disaster Memorial**, which overlooks the site of the rail crash in October 1999 in which thirty-one people lost their lives on a train approaching Paddington Station. The simple memorial, carved by Richard Healy, was unveiled in 2001 by three young children orphaned by the tragedy. All the names of the victims are carved on the monument, and the ashes of two of them are buried beneath it.

The Ladbroke Grove Rail Disaster Memorial.

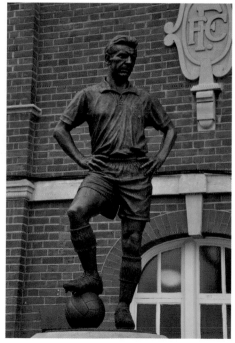

Johnny Haynes stands outside Craven College.

Outside Fulham Football Club at Craven Cottage in Stevenage Road is a statue to **Johnny Haynes** (1934–2005). Between 1952 and 1970 he played 658 times for Fulham, scoring a total of 158 goals. He also played fifty-six times for England, the last twenty-two of them as captain. The statue, by Douglas Jennings, was unveiled in 2008.

Chiswick House was built by Lord Burlington in the 1720s in the style of Palladio, the great sixteenth-century Italian architect. It is therefore apt that on either side of the external staircase are stone statues by Michael Rysbrack of the two sources of Burlington's inspiration, both made in *c.* 1730. On the left is

Andrea Palladio (1508–80), and on the right stands **Inigo Jones** (1573–1652), the English architect who first introduced the Palladian style of architecture to this country.

In Chiswick High Road, near the junction with Turnham Green Road, is a bronze statue of one of Chiswick's most famous residents, **William Hogarth** (1697–1764). The great artist spent the last fifteen years of his life in a cottage close to Chiswick House, and is buried in the local parish church of St Nicholas. The statue is the work of Ealing-based sculptor Jim Mathieson, and was unveiled in 2001 by Ian Hislop and David Hockney, a very appropriate combination of satire and

Rysbrack's statue of Inigo Jones at Chiswick House.

Hogarth with his pet dog in Chiswick High Road.

art. The life-size statue depicts Hogarth with his palette and brushes in the act of painting, and he is accompanied by his dog, Trump.

In the High Street in Brentford, at the junction with Alexandra Road, is the **Brentford Monument**. This is a column of red granite with inscriptions relating to important events in Brentford's history. The two pieces of stone were originally the bases for lamps on the old Brentford Bridge. The monument was the idea of the local historian, Sir Montague Sharpe. It originally stood on the wharf at the bottom of Ferry Lane, where it was unveiled in 1909 by the Duke of Northumberland. Over time it was covered by coal being loaded at the wharf and in 1955 it was moved higher up Ferry Lane. In 1992 it was moved to its present location, next to the County Court.

On the northern edge of Heathrow Airport, outside what used to be the Visitor Centre, next to the Renaissance Hotel on Bath Road, is the splendid double statue of **Sir John Alcock** (1892–1919) and **Sir Arthur Whitten Brown** (1861–1948). Alcock and Brown were the first men to fly across the Atlantic non-stop in 1919, flying a Vickers Vimy biplane from Newfoundland to Ireland in just under sixteen hours. They won a £10,000 prize donated by the *Daily Mail* and were both knighted for their achievement. The limestone statue, by William McMillan, was commissioned in 1954 to commemorate the thirty-fifth anniversary of the event. It shows the two men in their aviator's clothes, with caps and goggles, and on the back of the sculpture are clouds, waves, a dove and a hand holding a trident. The statue has been

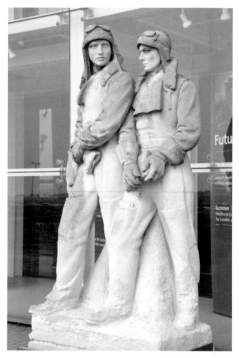

Alcock and Brown outside the old Heathrow Visitor Centre.

moved several times, and sadly now stands in a particularly inconspicuous location, as the Visitor Centre is now closed.

Outside the visitor centre of the London Wetlands Centre in Barnes, is a statue of **Peter Scott** (1909–89), the naturalist and artist. He was the founder of the Wildfowl and Wetlands Trust, which opened the centre in 2000. The bronze statue, by Nicola Godden, shows him in action, making notes on the threatening behaviour of a swan.

On the thames towpath just to the north is an obelisk, which is a memorial to **Steve Fairbairn** (1862–1938), the Australian rower. He rowed for Cambridge

Peter Scott's statue outside the
London Wetlands Centre.

Steve Fairbairn's memorial acts as the first mile point of the University Boat Race.

John Colet's memorial outside St Paul's School in Barnes.

in the University Boat Race four times in the 1880s, but was best known as a highly successful coach. The obelisk, which carries a bronze relief portrait by George Drinkwater, is exactly one mile from the start of the course of the boat race from Putney.

In Lonsdale Road, Barnes, is St Paul's School, which originally stood at the east end of St Paul's Cathedral. In 1884 it moved to Hammersmith, and the statue of its founder **John Colet** (1467–1519) was erected there in 1902. In 1968 it moved with the school to its present site. Colet was Dean of St Paul's Cathedral and founded the school in 1509, dedicating it to the

Virgin and the Christ Child. The memorial was presented to the school by Edward Howley Palmer, a Director of the Bank of England and a school Governor, and is the work of Sir (William) Hamo Thornycroft. The Dean sits under an ornate Gothic canopy teaching two pupils. At the top of the columns are six gilded angels and the canopy is surmounted by a figure of Christ in the arms of his mother, a reference to the school's dedication.

In Queen's Ride, Barnes, is a bust of **Marc Bolan** (1947–77), the songwriter and singer with the rock band T-Rex. He was a passenger in a car that went out of control and crashed into a tree, killing him instantly.

MARC BOLAN
25th Anniversary
16th September 2002
Sad to see
Them mourning you
When you are here
Within the
Flowers & the Trees
Donated to TAG
by Fee Warner

A bust of Marc Bolan marks the spot
where he died in a car crash.

The 'Bolan tree' very soon became a shrine and a place of pilgrimage for his many fans. In 2002 a bronze bust was unveiled by the singer's son, Rolan, to mark the twenty-fifth anniversary of his death. It was made by the Canadian sculptor, Jean Robillard. Bolan was a flamboyant performer, and the bust is usually draped in a feather boa, an accessory he often wore on stage.

In a garden off Bridge Street, overlooking Richmond Bridge, is a bust of **Bernardo O'Higgins** (1778–1842), the Chilean general who liberated Chile from the Spanish and became the country's first President. He was of Irish descent, and his father was Governor of Chile when it was ruled by Spain. O'Higgins was educated in Peru, but also spent three years studying in Richmond. The bust, by an unknown sculptor, is a copy of a type found throughout Chile, and was unveiled in 1998. The setting was designed by the Chilean architect, Marcial Echenique.

Just inside Gate 1 of The Stoop, the Harlequins ground in Langhorn Drive, Twickenham, is a statue, by Nathan David, of **Nick Duncombe** (1982–2003), the Harlequins scrum-half. He was a promising star of the game who won two caps playing for England before his shockingly early death at a training week on Lanzarote.

In Cannizaro Park, off Wimbledon Common, in a clearing to the right of the aviary, is a rather unexpected bust of

The bust of Bernardo O'Higgins in Richmond.

The statue of Nick Duncombe, the Rugby Union star who died tragically young.

Haile Selassie's statue in Cannizaro Park.

Fred Perry commemorated at Wimbledon.

Haile Selassie (1896–1975), Emperor of Ethiopia from 1930. In 1935 the Italians invaded Abyssinia (as it was then called) and he was exiled for five years in England. He began his exile in Wimbledon, where he stayed with the Seligman family. While he was there, Hilda Seligman sculpted the bust, which was later erected in the park.

At the All England Lawn Tennis Club, visible from Gate 4 in Church Road, is a bronze statue of **Fred Perry** (1909–95), who won the Wimbledon men's singles championship three times in the 1930s, the last British man to do so until 2013, when Andy Murray won his first title. The statue, by David Wynne, is one-third life-size, and shows Perry executing an elegant forehand,

playing with a wooden racquet and wearing long trousers, a far cry from today's tennis outfits. The statue was unveiled in 1984 by the Duke of Kent.

In the Market Place, Kingston, high up on the Market House, is a gilded statue of **Queen Anne** (1665–1714). Made of lead, it is by Francis Bird, who also made the original statue of the queen outside St Paul's Cathedral. It was installed in 1706 on the Tudor Guildhall which once stood on this site. Also in Market Place is a drinking fountain in memory of **Henry Shrubsole**, a local banker who was three times Lord Mayor, and who died in office in 1880. On a granite plinth stands a marble figure of a woman, with an urn on her

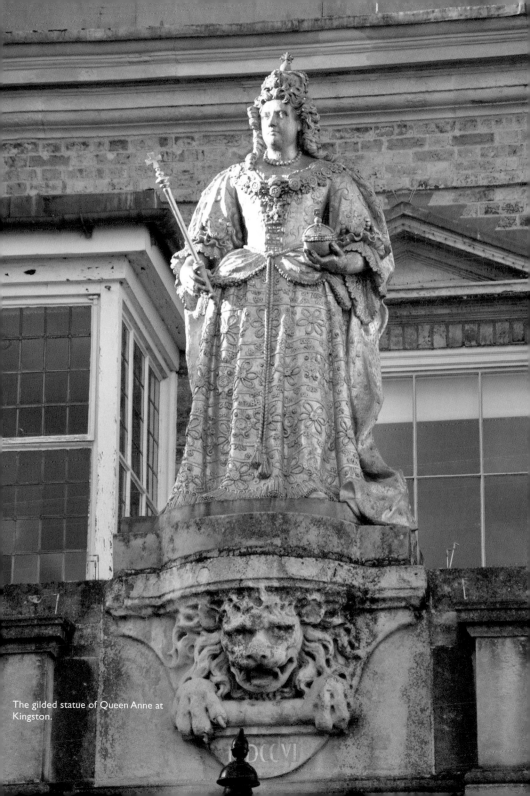

The gilded statue of Queen Anne at
Kingston.

shoulder, and holding the hand of a child, who is gathering water in a bowl. On one side is a bronze relief portrait of Shrubsole. It is the work of Francis John Williamson, and was unveiled in 1884 by the Duke of Cambridge.

In Camm Gardens, off Church Road to the east, is a curious memorial to **Sir** **Sydney Camm** (1893–1966), who was the chief designer for Hawker Aircraft in Kingston from 1923 until his death. He is most famous for designing the Hurricane, which played such an important part in the Battle of Britain. The memorial, which consists of part of a Hurricane propeller, was unveiled by his daughter in 1984.

The unusual memorial to Sir Sydney Camm in Kingston..

SOUTH LONDON

JUST INSIDE THE Hobbs Gate of the Oval Cricket Ground in Harleyford Road, Kennington, is an unusual memorial to the great Yorkshire and England cricketer **Sir Leonard Hutton** (1916–90). The work of Walter Ritchie, it is a brick sculpture, depicting the cricketer in action during his record-breaking innings of 364 for England in the 1938 test match against the Australians. Hutton was involved in a campaign to redevelop the Oval ground in 1988, and people were invited to contribute to the fund by buying a brick for the sculpture. He did not live to see it finished, and it was unveiled in 1993 by his widow.

In St Stephen's Terrace, Stockwell, on the corner of Wilkinson Street, is the **Tradescant Family Memorial**, which commemorates the John Tradescants, father and son, who were gardeners to Charles I and who had a house and garden in the area. They are buried in the churchyard of St Mary's Lambeth, now the Garden Museum. The memorial was created by Hilary Cartmel, who worked with the pupils of St Stephen's

Len Hutton's unusual memorial at the Oval.

The Tradescants remembered in Stockwell.

School. It is in the form of a vase of flowers, and around the bowl she has added birds, fish, flowers and faces based on the children's drawings. The memorial was unveiled in 1988 by the botanist, David Bellamy.

In Brixton Hill, in front of Brixton Central Library, stands a memorial to **Sir Henry Tate** (1819–99), the sugar refiner who introduced the sugar cube to this country. He gave money to create the National Gallery of British Art (now Tate Britain), and also funded a number of libraries in south London, including the one in Brixton, which still bears his name. The bronze bust, by Sir Thomas Brock, stands on a pedestal of Portland stone, and was erected in 1905.

In the eastern part of Battersea Park is a small group of memorials. The principal one is the **24th Division War Memorial**, erected in 1924 to commemorate the thousands of men of the army division who

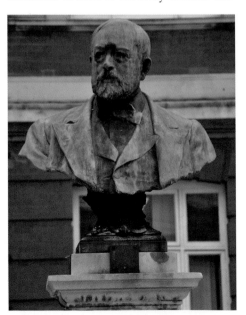

Henry Tate's bust in Brixton.

lost their lives in the First World War. It is the work of Eric Kennington, who refused to accept payment for his work. Kennington was a painter rather than a sculptor, and the result is unconventional and unlike any other war memorial of the period. It is of Portland stone and takes the form of three soldiers standing in a compact group and all facing in the same direction to show their unity of purpose. A serpent, representing war, is entwined around their feet. The models for the soldiers were all people Kennington knew, including Robert Graves, the poet, who posed for the figure on the left. The memorial was unveiled by Field Marshall Lord Plumer, who had commanded the regiment for a time. Nearby are two smaller memorials, one to Australian and New Zealand soldiers who lost their lives in 1915 at the **Anzac Battlefield** in Gallipoli, erected in 1990, and the other, put up in 1995, to the 5,397 **Australian Air Crew** who died in action during the Second World War.

In Spencer Park, Wandsworth, is the **Clapham Rail Disaster Memorial**, overlooking the railway line where the train crash happened in 1988, killing thirty-five people and injuring more than a hundred. The simple memorial, by Richard Healy, was erected in 1989, and consists of an upright stone slab, with an inscription on one side, and a carving of two clasped hands on the other, symbolising the work of the rescue services.

Outside the entrance to Tooting Broadway Underground station stands a statue of **Edward VII** (1841–1910) by Louis Fritz Roselieb. In 1910 a national memorial was proposed to commemorate the late king, but Wandsworth decided to produce its own, and the statue was

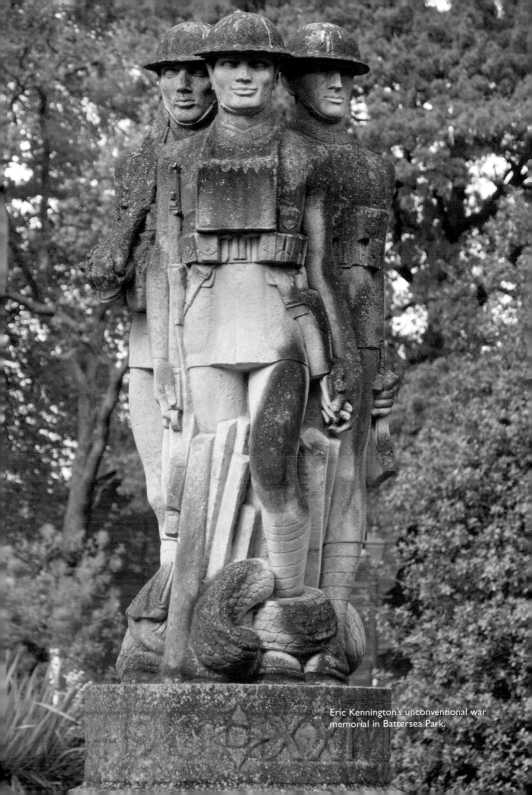

Eric Kennington's unconventional war memorial in Battersea Park.

erected in 1911. The king is shown wearing ceremonial robes, with a baton in his right hand, and on the pedestal are bronze reliefs of Peace and Charity. Roselieb was of German descent, but he was born in Britain and was working in the borough when the statue was proposed. During the war he changed his name to Louis Frederick Roslyn, and produced many war memorials.

Outside the Hambledon Wing of King's College Hospital in Bessemer Road, off Denmark Hill, is the weathered marble statue of **Robert Bentley Todd** (1809–60). Todd was an important physician who was involved in setting up King's College Hospital, then located in Portugal Street near Lincoln's Inn Fields. The statue, by Matthew Noble, was originally installed on the main staircase of the hospital in 1862 and, when the hospital was moved to Denmark Hill in 1913, it was set up outside the main

entrance of the hospital, overlooking the main road, where it has been damaged by London's polluted atmosphere.

On the grass in front of the William Booth Memorial Training College in Champion Park, Denmark Hill, are statues by George Edward Wade of **William Booth** (1829–1912) and **Catherine Booth** (1829–90). The Booths met through the Methodist church, and both were revivalist preachers. William founded the Christian Mission in Whitechapel, later renamed the Salvation Army, whose aim was to save souls and improve the conditions of the poor. It was run along military lines and he was called General, while Catharine was known as the Army Mother. The statues were unveiled in 1929 by the Duke of Kent. They are both shown in the act of preaching, and the granite plinths were designed by Giles Gilbert Scott, the architect of the College.

Edward VII's statue in Tooting.

Bentley Todd stands outside King's College Hospital.

On the lawn in front of the Old College in Dulwich, now used as almshouses, is a lively statue of **Edward Alleyn** (1566–1626), the famous actor-manager who bought the manor of Dulwich in 1605 and in 1619 founded the College of God's Gift, which later became Dulwich College. The sculpture, by Louise Simson, depicts Alleyn with a young scholar and pointing towards his foundation. Alleyn was famous as an interpreter of the plays of Christopher Marlowe, and on the plinth is a plaque with a few lines from the playwright's *Tamburlaine the Great*. The statue was commissioned by the Dulwich Society to commemorate the four hundredth anniversary of the actor's purchase of the land, and it was unveiled in 2005 by Tessa Jowell, the local MP.

In the garden of Haberdashers' Aske's School in Lewisham, on the corner of Pepys Road and Vesta Road, is a Coade stone statue of **Robert Aske** (1619–89) by William Croggon. Aske, a Haberdasher, left money in his will to build almshouses and a school in Hoxton, which opened in 1693. A statue stood over the main entrance, but by the nineteenth century it was in poor condition, and was replaced by the present statue in 1826. In 1875 a new school was built here and in 1898 the statue was re-erected in front of it.

In Crystal Palace Park is a monumental bust of **Joseph Paxton** (1803–65), designer of the Crystal Palace, which housed the Great Exhibition of 1851 in Hyde Park. In 1854 the building was rebuilt in Sydenham, where it was a popular entertainment venue until it burnt down spectacularly in 1936. Various remains can still be seen in the park, much of it fenced off and in poor condition.

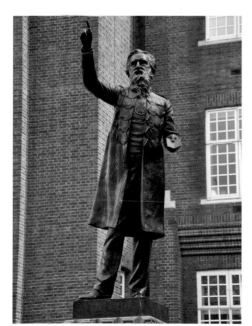 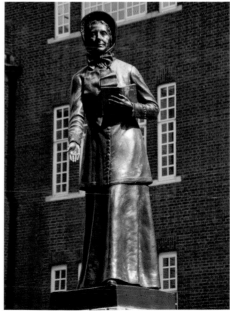

According to their inscriptions, William and Catherine Booth have been 'promoted to glory'.

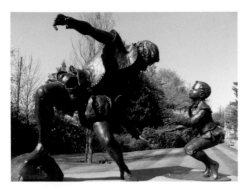

Edward Alleyn's theatrical statue in Dulwich.

The bust, by William Frederick Woodington, is of Carrara marble, and was unveiled in 1873 by Lady Frederick Cavendish. It originally stood on the main approach to the palace, on a pedestal 31 feet high. It survived the conflagration, and was moved to a new location, but in 1981 it was moved to a more inconspicuous site, overlooking the car park

of the National Sports Centre, where it stands on a modern brick plinth.

In a clearing in the Willett Memorial Wood near Chislehurst stands an unusual memorial to **William Willett** (1856–1915), the inventor of British Summer Time. It is in the form of a granite column with a sundial on one side, set to Summer Time, as the Latin inscription states (it translates as 'I will only tell the summer hours'). Willett, a successful builder, spent the last twenty years of his life in Chislehurst, and he claimed the idea for daylight saving came during his early morning rides through Petts Wood, when he saw so many houses with their curtains still drawn. He wrote a pamphlet, *Waste of Daylight,* and gathered support from many quarters, including Winston Churchill, but he did not live to see the measure initiated. In 1916 it was introduced to boost wartime production,

Robert Aske stands outside a school named after him.

Paxton's monumental bust in Crystal Palace.

William Willett's memorial in Petts Wood.

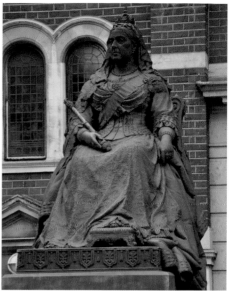

Queen Victoria sits in splendour outside Croydon Library.

and in 1925 the Summer Time Act was passed, making it a permanent fixture. After the First World War there were plans to tear down Petts Wood for housing, but an appeal was launched in 1926 to save it. Part of it was renamed the Willett Memorial Wood, and the memorial, designed by G. W. Miller, was unveiled in 1927.

To the right of the entrance to Croydon Library in Katharine Street is a bronze statue of a seated **Queen Victoria** (1819–1901) by Francis John Williamson, erected in 1903. Said to be Queen Victoria's favourite sculptor, Williamson produced many statues of her, but this is his only one in London.

To the left of the entrance is the **Croydon War Memorial**. It is a particularly fine memorial and is the work of Paul Raphael Montford. On either side of the central column are two poignant bronze figures, a soldier bandaging a wound and a woman carrying a child. The memorial was unveiled in 1921 by Lord Ashcombe.

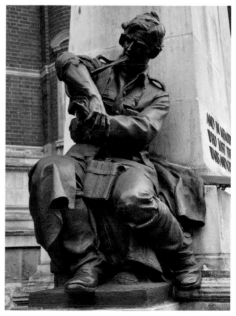

Paul Montford's figure of a Tommy on Croydon's war memorial.

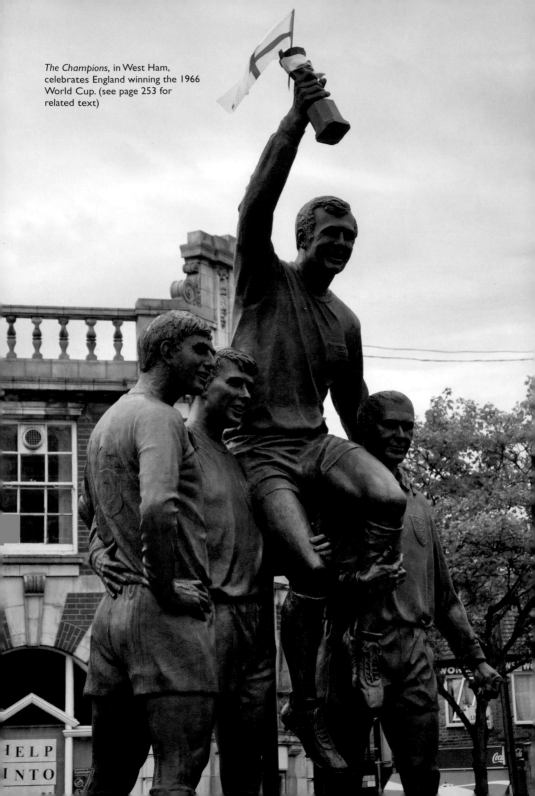

The Champions, in West Ham, celebrates England winning the 1966 World Cup. (see page 253 for related text)

EAST LONDON

A<small>T</small> S<small>PIRIT</small> Q<small>UAY</small> in Wapping, overlooking what is left of the London Docks, is a bust of **John Rennie** (1761–1821) by John Ravera, erected in 1992. Rennie was a great engineer, who designed three London bridges (Southwark, Waterloo and

John Rennie's bust in Wapping.

London) and also played an important part in the development of the London, East India and West India Docks.

In Shadwell, where Glamis Road crosses The Highway, is the King Edward VII Memorial Park, which replaced the old fish market and was opened in 1922 by George V as a memorial to the late king. Overlooking the park from the upper terrace is a granite and Portland stone monument to **Edward VII**, which once functioned as a drinking fountain. It also carried a bronze portrait medallion of the king by Bertram Mackennal, but this was stolen in 2007.

By the riverside in the park is the **Navigators' Memorial**, also erected in 1922. The porcelain plaque commemorates the many navigators who set sail from this part of the Thames in the sixteenth century to explore unknown lands across the Atlantic.

In Poplar Recreation Ground, on East India Dock Road, is what is known as the **Children's Memorial**, which remembers the eighteen children, most of them aged six or under, who were killed on 13 June 1917 when the Upper North Street School was hit by bombs dropped by Gotha

The Children's Memorial in Poplar remembers eighteen children killed by a bomb in 1917.

schools. The statue was paid for by public subscription and he was so popular that a huge crowd turned up for the unveiling in 1866. It is the work of Edward William Wyon, and shows Green seated in a relaxed pose, accompanied by his Newfoundland dog, Hector. On two sides of the plinth are bas reliefs showing scenes of shipbuilding. Unusually, instead of giving Green's dates, the plinth gives the year of the statue's unveiling. In 1967 the dog lost its right ear. Boys leaving the baths were fooling around and one had his trunks thrown onto the statue. He got stuck trying to retrieve them, and the only way the firemen could free him was to cut off Hector's ear.

In Langdon Park, next to Langdon Park DLR station, is the statue of a local hero, the boxer **Teddy Baldock** (1907–71). Known as 'The Pride of Poplar', Baldock won the World Bantamweight title in 1927, aged only 19, the youngest ever British world boxing champion. Sadly, after injuring his hand in the ring, he had to give up the sport and he fell into a decline, dying penniless. The bronze statue is unusual for its use of colour, and is the work of Carl Payne. It stands next to the Langdon Park Community Sports College, which is on the site of his boyhood home.

At Jamestown Way, overlooking the Thames, is the **Virginia Settlers' Memorial**, which commemorates the departure in 1606, in three small ships, of the first successful English settlers to build a permanent colony in America, founding Jamestown in Virginia. The bronze plaque on the front of the present memorial was originally unveiled in 1928 by the American ambassador, on the wall of a building slightly to the west. In 1951 it was unveiled

aircraft in the first daylight raid of the First World War. Money was raised locally for the memorial, which was unveiled in 1919. It is of granite and Sicilian marble and is by the local undertaker A. R. Adams. The names and ages of the children are listed on the side panels, and the memorial is surmounted by an angel.

A little further east along East India Dock Road, in front of the Poplar Baths, is a statue of **Richard Green** (1803–63), a local ship-owner and philanthropist. He ran a successful shipping business at nearby Blackwall, but he was also an important local benefactor, giving to charities and founding Poplar Hospital and several local

Richard Green's dog is missing an ear.

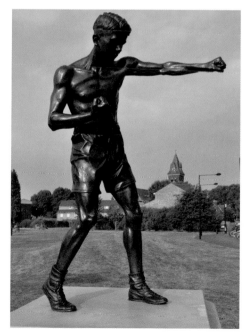

Boxer Teddy Baldock, the 'Pride of Poplar'.

again, this time using stones from the old quay and topped off with a sculpture of a mermaid. The mermaid was later stolen, and in 1999 it was replaced by an astrolabe, and unveiled a third time, again by the American ambassador.

Outside Whitechapel Underground station, opposite the Royal London Hospital, is the **Edward VII Memorial Drinking Fountain**, which is rather difficult to appreciate, as it is usually surrounded by market stalls. It was erected in 1911 and paid for by 'Jewish inhabitants of East London', when Whitechapel had a large Jewish population. The bronze sculpture, by William Frith, includes a portrait medallion of the King on the road side. On either side are the figures of Justice with her scales, and Liberty, accompanied by cherubs, one holding a ship, the other a car of the period. The fountain was unveiled

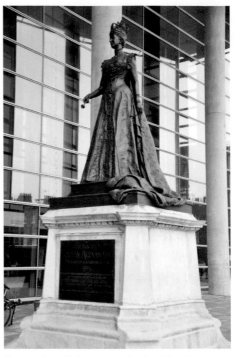

The Virginia Settlers' Memorial overlooking the Thames at Blackwall.

Queen Alexandra's statue at the Royal London Hospital in Whitechapel.

by the Hon Charles Rothschild, a member of the famous banking family.

The old Royal London Hospital building opposite Whitechapel station is being redeveloped, and the new hospital buildings are behind it. Opposite the entrance in Stepney Way is a statue of Edward VII's consort, **Queen Alexandra** (1844–1925) by George Edward Wade. It shows her in coronation robes and holding a sceptre in her right hand. Alexandra spent a lot of her time doing charity work; she was a regular visitor to the London Hospital, as it was then called, and became its president in 1904. She persuaded the authorities to introduce the Finsen ultra-violet light cure for lupus (tuberculosis of the skin), and gave the hospital its first lamp, which proved to be a great success. The plaque on the back of the plinth shows the king and queen watching an operation using the lamp at the hospital. The statue was unveiled in 1908 by Lord Crewe, Chairman of the hospital.

Further east on the northern side of Whitechapel Road, within a hundred yards of each other, are two monuments to **William Booth** (1829–1912), founder of the Salvation Army, both by George Edward Wade, and both marking the site of his earliest meetings. At the junction with Cambridge Heath Road is a bust, which

The bust of William Booth marks the site of his first Salvation Army meetings.

of the Eastern District of London'. Edward VII was himself Grand Master of the English Freemasons. The king was recognised in his lifetime as a peacemaker, and below his name is the apt quotation from Milton, 'Peace hath her victories, no less renowned than war'.

Outside the Library of the Queen Mary campus in Mile End is a statue of **Clement Attlee** (1883–1967) by Frank Forster. Attlee gave up a legal career to work in the East End, where he became Mayor of Stepney. He was MP for Limehouse for nearly thirty years, became Leader of the Labour Party in 1935, and was prime minister from 1945–51, during which time he laid the foundations of the Welfare State. In his right hand Attlee holds a copy of the National Assistance Act of 1948, which finally abolished the Poor Law. The statue was originally erected outside Limehouse Library in Commercial Road, where it was unveiled in 1988 by Sir Harold Wilson. In 2005 it was badly vandalised and for several years it was boxed up to keep it from further damage. It has now been repaired and was erected in its new location in late 2010.

was erected in 1927. About a hundred yards further on is a fibreglass copy of Wade's statue at Denmark Hill (see page 238), which was installed in 1979 to mark the 150th anniversary of his birth. The statue was originally meant to replace the bust, but as that was listed, both remain to mark the spot where Booth began his work. In 2015 he was joined by a replica of the Denmark Hill statue of his wife, **Catherine Booth** (1829–90), to mark the 150th anniversary of the founding of the Salvation Army.

A little further east is a bust of **Edward VII** (1841–1910) by an unknown sculptor. It was erected in 1911 by 'a few freemasons

In Bow Road, at the junction with Harley Grove, is a small memorial to **George Lansbury** (1859–1940), which was erected here in 1955, on the site of the house he lived in for twenty-three years. It consists of a block of granite with a bronze plaque. Lansbury was an influential socialist politician who held many local and national government posts, including five years as leader of the Labour Party. He was a very popular figure, especially in the East En and A. J. P. Taylor called him 'the r lovable figure in modern politics'.

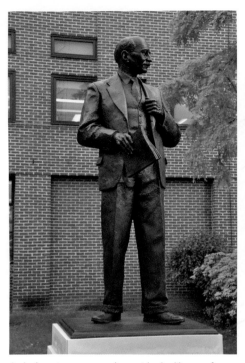

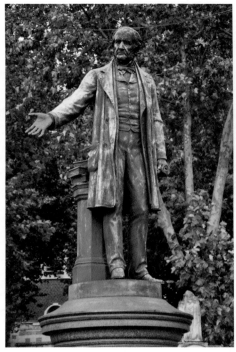

Attlee's statue now stands outside the library of Queen Mary, University of London.

Gladstone's statue in Bow was erected in his lifetime.

In the middle of Bow Road, in front of St Mary's Church, is a statue by Albert Bruce-Joy of **William Ewart Gladstone** (1809–98), the great nineteenth-century politician. It is unusual in that was erected in Gladstone's lifetime; it was unveiled in 1882 by Lord Carlingford. His right hand has often been painted red, because the donor of the statue was Theodore H. Bryant, co-owner of the infamous Bryant & May match works in Bow, whose poor working conditions caused many female workers to develop 'phossy jaw', a disease that led to an early death for many of them. In 1888 there was a mass walkout, by Annie Besant, which led to an improvement in working conditions. Even today, long after the factory's closure, the statue is regularly daubed in red paint, as its donor had 'blood on his hands'.

In Twelvetrees Crescent, in a small wood opposite the rusting remains of the Bromley-by-Bow gas works, is a bronze statue by A. G. Walker of **Sir Corbet Woodall** (1841–1916). He wears an academic gown and holds a pair of spectacles in his right hand. Woodall was one of the leading gas engineers of his time, and from 1906 was Governor of the Gas, Light and Coke Company, which was then the largest gas company in the world. The statue was originally erected

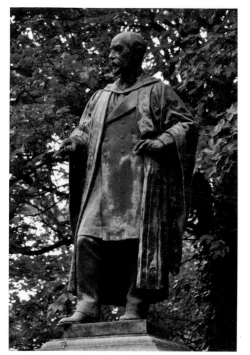

Sir Corbet Woodall once ran the biggest gas company in the world.

Bradley Stone's statue stands outside the gym where he trained.

near the Beckton gasworks, but when that closed in 1969 the statue was moved to its present location. In the same garden is the **Gas Light and Coke Company War Memorial**, which honours the employees of the company who died in the two world wars. The main memorial is a stone column surmounted by a still functioning gas lamp, an unusual version of the 'eternal flame'.

In Caxton Street North, off Victoria Dock Road, is a memorial to **Bradley Stone** (1970–94). Stone was a young boxer who died two days after winning a fight in Bethnal Green, which had won him the British Super Bantamweight title. The sculpture, by Ann Downey, stands in front of Peacock's Gym, where Stone trained. It was unveiled in 1995 by his trainer, Jackie Bowers.

On the north side of the Royal Victoria Dock, outside the western entrance of the ExCel conference centre, is the sculpture **Landed** by Les Johnson, which pays tribute to the men who used to work in the Royal Docks. It depicts three men, all modelled from life, loading cargo off a hoist onto a barrow, and was unveiled in 2009 by the Mayor of Newham, Sir Robin Wales. It is a fitting reminder to future generations of the work once carried on here.

In the Broadway, in the centre of Stratford, is the memorial to **Samuel**

Landed is a reminder of the work of the dockers in the Royal Victoria Docks.

Gurney (1786–1856), a respected local banker, Quaker and philanthropist, who lived at Ham House, Upton, which is now West Ham Park. Among his many good deeds was his work with his sister, Elizabeth Fry, to reform the prison system. The 42-foot granite obelisk was erected in 1861. At each corner are cast-iron lanterns, and it has two drinking fountains, which is appropriate, as in 1859 his son, also Samuel, was a founder of the Metropolitan Drinking Fountain and Cattle Trough Association.

Close by, in the churchyard of St John's Church, is the **Martyrs' Memorial**, erected in 1878 to commemorate the thirteen Protestants from the area who were burnt at the stake in 1555–56. It takes the form of a Gothic shrine, with canopies and spire, all of terracotta. Around the main column are inscriptions with details of victims, and on one side is a plaque depicting the burnings.

Outside the Library in The Grove, Stratford, is a memorial to the poet **Gerard Manley Hopkins** (1844–89), who was born at 87 The Grove. The memorial is a simple block of stone, with a plaque which carries lines from his most famous poem, *The Wreck of the Deutschland*.

Close by is a monument to **Edith Kerrison** (1850–1934), who was the first woman to be elected to West Ham council. On a Portland stone plinth is a bronze plaque with a relief portrait in the centre, and gambolling children on each side, reflecting her interest in child welfare. Sculpted by Christine Gregory, the memorial was erected in 1936.

The Martyrs' Memorial in Stratford.

Outside the Theatre Royal Stratford, in Gerry Raffles Square, is a statue of **Joan Littlewood** (1914–2002), the celebrated theatre director who ran the theatre for 26 years. She founded the Theatre Workshop, a left-wing group which toured the country before finding a permanent base in Stratford. She put on plays ancient and modern in her own unique style, and several of her productions transferred to the West End. She is best known for plays with music, such as *Fings ain't what they used to be* and the Great War play *Oh What a Lovely War!*, which was made into a successful film. The statue, by Philip Jackson, was unveiled in 2015.

Outside the University of East London in Water Lane, Stratford, is a statue of **William Shakespeare** (1564–1616). It is made of Coade stone and was created in *c.* 1840 for the Opera House Haymarket,

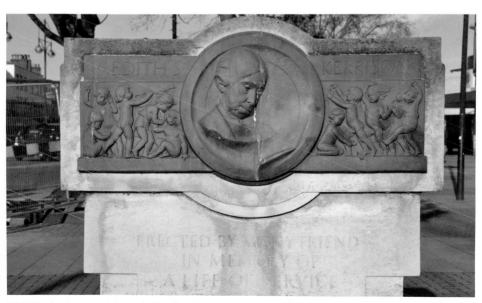

Edith Kerrison's memorial outside Stratford Library.

The statue of Joan Littlewood outside the Theatre Royal Stratford, which she ran for 26 years.

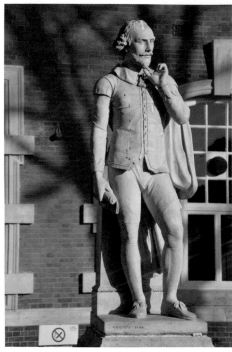

William Shakespeare outside the University of East London.

now Her Majesty's Theatre. It was presented to Stratford in 1925 by J. C. Carroll, a local councillor, and placed here when the building was a library.

In the Broadway in Barking is a bronze statue of **Job Henry Charles Drain** (1895–1975) by a local sculptor, Steven Hunter. Drain was a local hero who, aged eighteen, won the Victoria Cross for an act of bravery during the First World War. Along with two other men, who also won the VC, he rode very close to the German lines to recapture a field gun. The statue depicts him as a young man, and a plaque on the reverse of the plinth, by Mark Barnett, depicts the heroic act.

It was unveiled in 2009 by two of Drain's grandsons.

Outside the Museum of London Docklands at West India Quay is a statue of **Robert Milligan** (1746–1809), a merchant and ship-owner who was the inspiration for the construction of the West India Docks, which opened in 1802. The statue, by Richard Westmacott, was erected in 1813, and portrays him leaning on a column and holding a scroll in his right hand. A bronze relief on the front of the plinth (a copy of the original, based on Westmacott's design), shows Britannia receiving Commerce, with a sailing ship in the background. The statue originally

Local hero, Job Drain, in Barking.

Robert Milligan outside the sugar warehouse, now the Museum of London Docklands.

stood here, by the sugar warehouse, but was moved several times before being placed in storage, and was only returned to its original location in 1997.

In Cabot Square, Canary Wharf, is a memorial to **Michael von Clemm** (1935–97), the American investment banker who first saw the potential for London's Docklands to be developed for offices. He was the inspiration for the Canary Wharf development, which was financed by his bank, Credit Suisse First Boston. The stone memorial has a portrait relief by Gerald Laing, and was unveiled in 1998 by Eddie George, the Governor of the Bank of England.

In Barking Road, at the junction with Green Street, and close to Upton Park, home of West Ham United Football Club, is a dramatic bronze sculpture by Philip Jackson called **The Champions**, which commemorates England's famous victory in the final of the 1966 World Cup. West Ham and England captain Bobby Moore holds the trophy and is carried aloft by fellow West Ham players Martin Peters and Geoff Hurst, along with Everton defender Ray Wilson. When Bobby Moore died in 1993 it was felt there should be a memorial to him in Newham, and much of the cost was borne by the football club. It was unveiled in 2003

Michael von Clemm was the inspiration for Canary Wharf.

Sͭ Roᵬ Geffryes Knͭ Alderman and Ironmonger Founder of this Hospitall

Sir Robert Geffrye at the museum named after him.

by the Duke of York, as President of the Football Association.

The Geffrye Museum in Kingsland Road occupies almshouses built in 1715 by the Ironmongers' Company with money left for the purpose by **Sir Robert Geffrye** (1613–1704), who had been Master of the Company and Lord Mayor of London. Over the main door of the chapel is a copy of his lead statue by John van Nost, erected here in 1723. When the almshouses moved to Mottingham in Kent, the original went with it. He is shown in full regalia, in a full-bottomed wig and accompanied by a ceremonial sword.

Off Tanners Lane in Barkingside is Barnardo's Village, all that remains of the Girls' Village Home founded by **Thomas John Barnardo** (1845–1905) to house destitute girls. Short of stature, but possessed of unlimited energy, he was a fervent Christian and founded a boys' home in the East End to look after their spiritual and physical well-being. When he died he was buried at the Girls' Village Home in Barkingside, and his funeral attracted huge crowds. In 1908 George Frampton's impressive memorial was unveiled there by the Duchess of Albany. On the top of the granite plinth stands the bronze figure of Charity protecting two

TO ME
EN

MVCH AS YE D
THESE MY BRETH

I HOPE TO DIE AS I HAVE LIVED
IN THE HVMBLE BVT ASSVRED FAITH OF
JESVS CHRIST
AS
MY SAVIOVR MY MASTER AND MY KING

Dr Barnardo's memorial in
Barkingside.

WE LOVE HIM
BECAUSE

children, and at the base are three seated girls, also in bronze, modelled from girls living in the village. On the front of the plinth is a bronze relief portrait of Dr Barnardo himself. Frampton did not charge for his work in producing the memorial. The Girls' Home closed in the 1980s and the cottages are now private retirement homes, but it is possible to visit the memorial.

At the southern end of Woodford Green, by Broomhill Walk, is a bronze statue of **Sir Winston Churchill** (1874–1965) by David McFall, which commemorates Churchill's long service as MP for Wanstead and Woodford. The original model was criticised for showing

him as an old man, but the final version depicts him as he was in 1944. Churchill was present when it was unveiled in 1959 by Field Marshal Montgomery.

In the High Street, Wanstead, is a bust of **Churchill** (1874–1965) by Luigi Froni. It stands in front of what was once the local Conservative Club. It was unveiled in 1968. The plinth was once part of the old Waterloo Bridge.

At the heart of Abney Park in Stoke Newington, close to the ruined chapel, is a stone statue of **Isaac Watts** (1674–1748). Watts was a non-conformist preacher and prolific hymn-writer, perhaps best known for *O God, our help in ages past*. By 1845, when the statue

Churchill's statue on Woodford Green.

The bust of Churchill in Wanstead.

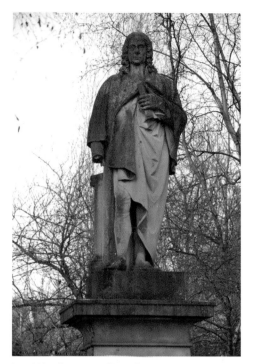

Isaac Watts's statue in Abney Park.

A bust of Edgar Allan Poe in Stoke Newington, where he went to school.

was erected, Abney Park was already a cemetery for Dissenters, but Watts is buried in Bunhill Fields. A statue here was proposed because Watts had lived and died here, having spent more than thirty years in the home of dissenter Sir Thomas Abney. The statue is by Edward Hodges Baily, who is best known for his statue of Nelson in Trafalgar Square.

On the front wall of the Fox and Pie pub at 176 Stoke Newington Church Street opposite Woodlea Road, is a bust by Ralph Perrott of **Edgar Allan Poe** (1809–49), the American poet and short-story writer. Orphaned at the age of three, Poe was adopted by John Allan, and the family lived from 1815 to 1820 in England. For three years the young Poe attended Manor House School, which used to stand on this site. The bust was unveiled in 2011 by the actor, Steven Berkoff.

FURTHER READING

Beattie, Susan. *The New Sculpture*. Yale, 1983.

Blackwood, John. *London's Immortals*. Savoy Press, 1989.

Bullus, Claire and Asprey, Ronald. *The Statues of London*. Merrell, 2009.

Cavanagh, Terry. *Public Sculpture of South London*. Liverpool University Press, 2007.

Gunnis, Rupert. *Dictionary of British Sculptors 1660–1851*. The Abbey Library, 1960.

Read, Benedict. *Victorian Sculpture*. Yale, 1982.

Sumeray, Derek and Sheppard, John. *London's Plaques*. Shire Publications, 2010.

Ward-Jackson, Philip. *Public Sculpture of the City of London*. Liverpool University Press, 2003.

Ward-Jackson, Philip. *Public Sculpture of Historic Westminster*, Vol. 1. Liverpool University Press, 2011.

Whinney, Margaret. *Sculpture in Britain 1530–1830*. Penguin Books, 1988.

INDEX